THE YEAR ONE

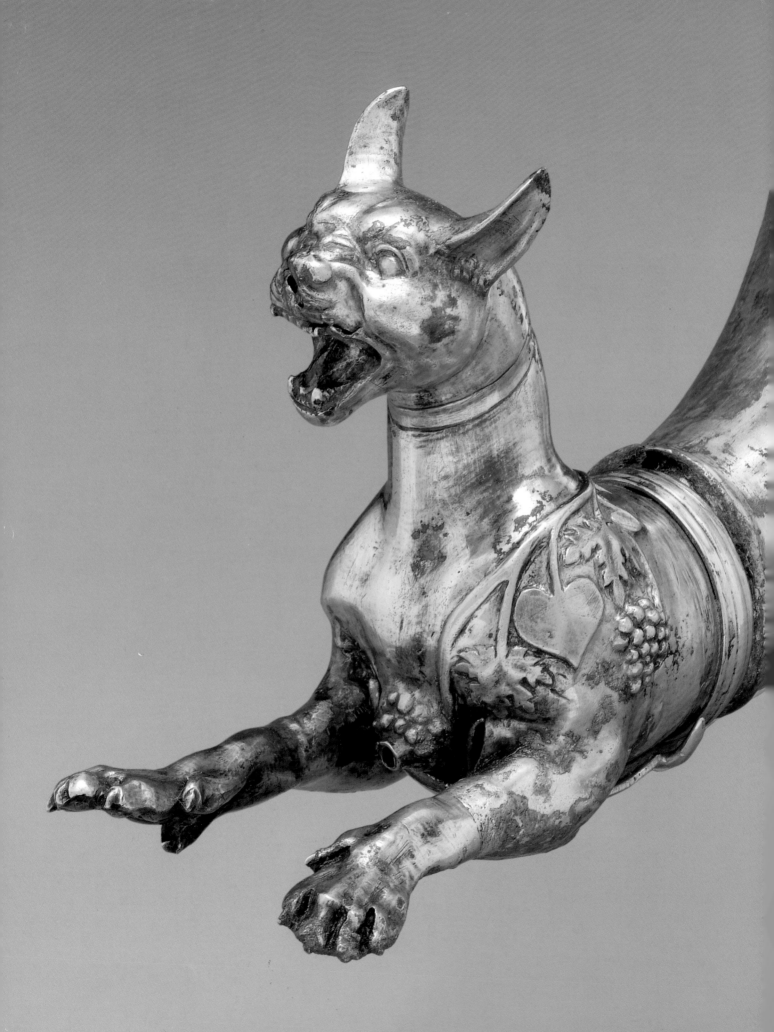

THE YEAR ONE

Art of
the Ancient World
East and West

Edited by Elizabeth J. Milleker

The Metropolitan Museum of Art

Yale University Press

This catalogue is published in conjunction with the exhibition "The Year One: Art of the Ancient World East and West" held at The Metropolitan Museum of Art, New York, October 3, 2000–January 14, 2001.

This publication is made possible by the Samuel I. Newhouse Foundation Inc.

Published by The Metropolitan Museum of Art, New York

John P. O'Neill, Editor in Chief
Ruth Lurie Kozodoy, Editor
Tsang Seymour Design Inc., Designer
Elisa Frohlich, Production
Minjee Cho, Desktop Publishing

New photography by Joseph Coscia Jr., Anna-Marie Kellen, Oi-Cheong Lee, Paul Lachenauer, and Juan Trujillo, the Photograph Studio, The Metropolitan Museum of Art

Maps made by Anandaroop Roy
Bibliography edited by Jean Wagner

Color separations by Professional Graphics Inc., Rockford, Illinois
Printed and bound by CS Graphics PTE Ltd., Singapore

Library of Congress Cataloging-in-Publication Data

Metropolitan Museum of Art (New York, N.Y.)
 The year one: art of the ancient world east and west / edited by Elizabeth J.
 Milleker; with contributions by Joan Aruz . . . [et al.].
 p. cm.
 Catalog of an exhibition held at the Metropolitan Museum of Art from Oct. 3, 2000
 through Jan. 14, 2001.
 Includes bibliographical references.
 ISBN 0-87099-961-3 (hc.) — ISBN 0-300-08514-1 (Yale)
 1. Art, Ancient—Exhibitions. 2. Art—New York (N.Y.)—Exhibitions.
 3. Metropolitan Museum of Art (New York, N.Y.)—Exhibitions. I. Milleker,
 Elizabeth Johnston. II. Title.

N5335.N4 M486 2000
709'.01'50747471—dc21 00-055443

Front jacket illustration: *Portrait Statue of a Boy,* Roman, Augustan period, late 1st century B.C.–early 1st century A.D., detail; see figure 15

Back jacket illustration: *Torso of a Bodhisattva,* Pakistan (ancient region of Gandhara), Kushan dynasty, late 1st–2nd century A.D; see figure 104

Frontispiece: *Rhyton with Forepart of a Wild Cat,* Parthian, Iran, 1st century B.C., detail; see figure 94

CONTENTS

DIRECTOR'S FOREWORD

To celebrate institutionally the Year 2000 the Metropolitan Museum is bringing together more than 150 masterpieces from its collections, objects produced some two thousand years ago in the period just before and after the Year One. Drawn from seven departments of the Museum and augmented by several loans from private collections, these works come from regions all around the globe, including western Europe, the Mediterranean, the Near East, India, China, Southeast Asia, and the Americas. The exhibition not only features these magnificent and distinctive works but also highlights the interconnections that existed between the widely separated parts of the world in which they originated. Some links between cultures were established as empires expanded, spreading ideas, beliefs, and customs among heterogeneous peoples, and other connections occurred with the development of overland and maritime trade routes that provided East and West with tantalizing glimpses of each other. Artistic traditions and religious beliefs moved freely over these global networks, along with such luxury goods as Roman glass, Chinese silk, and Indian pepper.

An in-house exhibition of this sort could only be attempted at the Metropolitan, with its encyclopedic collections, and the range of material presented in both the exhibition and this book is astonishing. Roman art in the age of Augustus, the first Roman emperor (r. 27 B.C.–A.D. 14), reached an extraordinary level of sophistication both in the public sphere, where a new imperial iconography was developed, and in the private sphere, where wealth was poured into the decoration of lavish villas. The Roman Empire expanded as the lands occupied by Celtic tribes in western Europe became provinces and when Egypt fell to Rome with the suicide of Cleopatra in 30 B.C. Two recently acquired masterpieces of Celtic metalwork, a bronze sword and a silver-and-gold brooch, are high points of the exhibition; an arresting mixture of traditional Egyptian iconography with Hellenistic and Roman styles marks the many works of art from Egypt on display, which include a magnificent black stone statue that may represent Caesarion, eldest son of Cleopatra. Interesting pieces from great centers of trade in the Near East—Palmyra, Nabataean Petra, and South Arabia—are juxtaposed with treasures from the lands within the Parthian Empire, which stretched across the area of modern Iraq and Iran.

Ancient Gandhara (roughly present-day Afghanistan and Pakistan) was at the westernmost end of the multiple trade routes that traversed the steppes and mountains of Central Asia. The art produced there under the rule of the Kushan dynasty incorporated elements from both West and East, and a towering

stone torso of a Buddhist bodhisattva is one of the most important works in the exhibition. The vast Han Empire in China (221 B.C.–A.D. 220) was administered by a specially trained scholarly elite, whose members, along with the aristocracy and wealthy merchants, equipped lavish tombs for use in the afterlife. Among the objects such tombs contained were bronze and lacquer vessels and terracotta sculptures of attendants and entertainers. An elegant dancer, captured in a moment of ethereal stillness, is one of the loveliest objects in this exhibition. Korea and Japan are represented by powerful ceramics and a monumental ceremonial bronze bell. Centuries-old traditions of bronze working also unite the various cultures of peninsular and island Southeast Asia, which are noted for their production of splendid weapons, jewelry, and vessels. From the Americas, which had no known contacts with the rest of the world at this time, the exhibition presents a selection of forceful works: a carved stone Maya vessel from Mesoamerica, a gold mask from the area of modern Colombia, an extraordinary ceramic figure from the Tolita culture on the Pacific coast of South America, and a dramatically decorated drum produced by the Nasca in southern Peru.

Bringing together such a range of masterpieces, usually isolated in widely separated parts of the Museum building, has been an exciting enterprise. Elizabeth J. Milleker coordinated the complex exhibition and this most interesting catalogue, which she wrote together with a number of other members of the curatorial staff: Joan Aruz, Jean M. Evans, Marsha Hill, Melanie Holcomb, Julie Jones, Steven Kossak, Donald J. LaRocca, Denise Patry Leidy, and Christopher Lightfoot.

We are grateful, as always, to friends of the Museum for their generosity in lending works. I wish to thank Shelby White and Leon Levy for helping us give a fuller picture of the arts of Nabataea and South Arabia by lending two sculptures in their collection, Charlotte C. Weber for her long-term loan of a Chinese *fang hu* (square jar), and an anonymous lender for the long-term loan of two Celtic torques and a number of coins. Our gratitude also goes to the Estate of Samuel Eilenberg. We acknowledge as well the generous assistance of the Samuel I. Newhouse Foundation in making this publication possible.

Philippe de Montebello
Director, The Metropolitan Museum of Art

ACKNOWLEDGMENTS

The Year One project has involved seven curatorial departments within the Metropolitan Museum and has drawn on the wisdom, expertise, effort, and encouragement of many people. The list begins with Philippe de Montebello, the Museum's Director, who conceived the idea for the exhibition and gave crucial support, as did Mahrukh Tarapor, Associate Director for Exhibitions.

Almost a third of the objects included in the exhibition come from the Department of Asian Art. Denise Patry Leidy assumed responsibility for their selection and installation and wrote the lengthy Asian section of this catalogue. Thanks are also due to many other members of that department. Steven Kossak contributed two object descriptions for the catalogue and participated in numerous discussions of South and Southeast Asian works; James C. Y. Watt, Miyeko Murase, and Martin Lerner read drafts of the entries. Hwai-ling Yeh-Lewis, Michael Rendina, Damien Auerbach, Beatrice Pinto, and Alyson Moss were expert in the logistics required for the photography and installation of the objects. I am especially grateful to James Watt for sharing his extensive knowledge about relations between China and Central Asia, which helped me in writing the opening essay. Donald J. LaRocca of the Department of Arms and Armor contributed the entry on a sword from Central Asia and helpful advice on the Indonesian ax head, and Eric Kjellgren of the Department of the Arts of Africa, Oceania, and the Americas advised on the standing figure from Indonesia. In the Department of Greek and Roman Art, Christopher Lightfoot wrote part of the Roman section for this publication and was also a constant source of support and valuable assistance. Additional aid was provided by Patricia Gilkison, who organized diverse aspects of the exhibition, and by William M. Gagen, John F. Morariu Jr., and Jennifer Slocum Soupios. Special thanks go to Professor David F. Grose of the Department of Classics at the University of Massachusetts, Amherst, for advising on the choice of Roman glass and for sharing his expertise.

Joan Aruz and Jean M. Evans selected the objects belonging to the Department of Ancient Near Eastern Art and wrote the chapter in this book entitled "West and Central Asia." They benefited from discussions with Prudence O. Harper, the assistance of Elisabetta Valtz-Fino, and further help from Shoki Goodarzi, Melanie Hatz, Shawn Osborne, and Cynthia Wilder. Marsha Hill was responsible for choosing the works from Roman Egypt and wrote that section of the catalogue. She is grateful for discussions and work with Dorothea Arnold, particularly on the mummy portraits from this period. Melanie Holcomb of the Department of Medieval Art and The Cloisters contributed the entries on Celtic art from Gaul, Britain, and Pannonia. She thanks Peter Barnet,

Barbara Drake Boehm, Helen C. Evans, and Charles T. Little for their support and advice and Christine E. Brennan and Thomas C. Vinton, who helped with the photography and installation. Works from Mesoamerica and South America were selected and discussed by Julie Jones of the Department of the Arts of Africa, Oceania, and the Americas.

Conservation of the objects and their preparation for exhibition was undertaken by James H. Franz, Richard E. Stone, Dorothy H. Abramitis, Pete Dandridge, George Wheeler, Linda Borsch, Lisa Pilosi, Ann Heywood, Kendra Roth, Sarah McGregor Howarth, Dora Henel, Jeffrey W. Perhacs, and Fred A. Caruso. Linda M. Sylling's coordination of all aspects of the exhibition was essential for its success. Jeffrey L. Daly is responsible for the design of the exhibition, Sue Koch for the graphic design, and Zack Zanolli for the lighting; all were handsomely conceived and executed. The beautiful new photography in this book is the work of Joseph Coscia Jr., Anna-Marie Kellen, Oi-Cheong Lee, Paul Lachenauer, and Juan Trujillo, all of the Museum's Photograph Studio, and was carried out with the knowledgeable oversight of Barbara Bridgers.

In the Editorial Department, special thanks are due to John P. O'Neill for his vision and constant support of the project. Ruth Lurie Kozodoy was a superb editor, and Elisa Frohlich ably managed the production of the book. Patrick Seymour and Arlene Lee of Tsang Seymour Design Inc. are responsible for the book's elegant design. The skillful maps are the work of Anandaroop Roy. Minjee Cho efficiently handled the desktop publishing. Peter Antony oversaw the entire production process. Joan K. Holt and Ellyn Childs Allison performed valuable additional editorial work. Jean Wagner edited the bibliography; Kathleen Friello compiled the index.

To all these people and to others not named here whose contributions made "The Year One" possible, I would like to express my gratitude.

Elizabeth J. Milleker

AUTHORS AND THEIR CONTRIBUTIONS

All authors are members of the curatorial staff of
The Metropolitan Museum of Art, New York.

Elizabeth J. Milleker, Associate Curator,
Department of Greek and Roman Art: pages 3–23, 28–53

Christopher Lightfoot, Associate Curator,
Department of Greek and Roman Art: pages 25–27, 54–67

Melanie Holcomb, Assistant Curator,
Department of Medieval Art and The Cloisters: pages 68–77

Marsha Hill, Associate Curator,
Department of Egyptian Art: pages 78–101

Jean M. Evans, Hagop Kevorkian Curatorial Fellow,
Department of Ancient Near Eastern Art: pages 104–21

Joan Aruz, Acting Associate Curator in Charge,
Department of Ancient Near Eastern Art: pages 122–27

Denise Patry Leidy, Associate Research Curator,
Department of Asian Art: pages 129–58, 160–86, 188–89

Donald J. LaRocca, Curator,
Department of Arms and Armor: page 159

Steven Kossak, Associate Curator,
Department of Asian Art: pages 187, 190

Julie Jones, Curator in Charge,
Department of the Arts of Africa, Oceania, and
the Americas: pages 193–203

NOTE TO THE READER

Almost all the works of art included in this catalogue are in the collection of The Metropolitan Museum of Art, New York. Complete credit lines will be found in the Checklist of Works Illustrated, which begins on page 205.

The maps in this publication are intended to show certain aspects of the world in the centuries just before and after the Year One. Every town, city, political entity, or geographical indication that appears on the maps either is mentioned specifically in the text or has been included to help orient the reader. Ancient place-names have been used whenever possible, but some modern names have been employed when the ancient name is unknown or is less familiar than the modern equivalent.

Sources drawn on by the authors in preparing this catalogue are named in Sources and Selected Bibliography, which begins on page 211.

THE YEAR ONE

Art of
the Ancient World
East and West

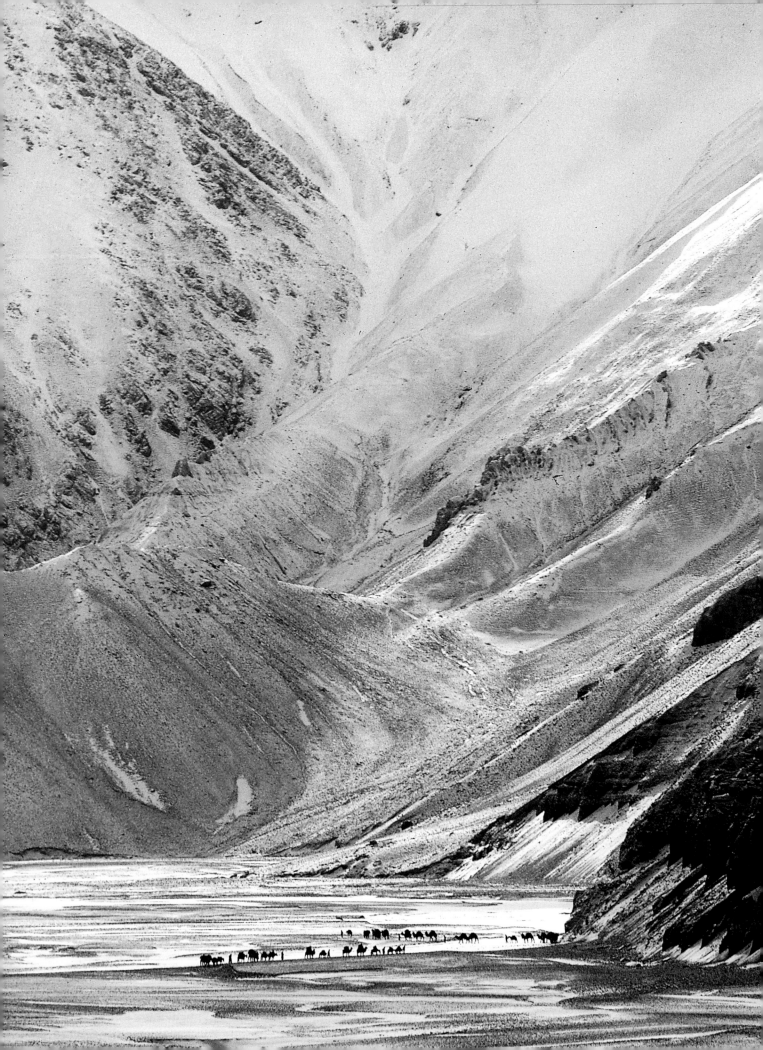

THE YEAR ONE: EMPIRES AND TRADE ROUTES ACROSS THE ANCIENT WORLD

"Previously the doings of the world had been, so to say, dispersed, as they were held together by no unity of initiative, results, or locality; but ever since this date history has been an organic whole, and the affairs of Italy and Africa have been interlinked with those of Greece and Asia, all leading up to one end" (Polybius, *Histories* 1.3). These words were written in the second century B.C. and refer to the Roman conquest of the Mediterranean world, but they are even more appropriate as the preface to an account of the world in the Year One. By then, much of the inhabited world was united politically or linked by trade and diplomacy in a way that it had never been before.

This book celebrates the Year One by bringing together works of art created by all the cultures flourishing at the beginning of the first millennium that are represented in the collections of the Metropolitan Museum. At that time five contiguous powers stretched from the Atlantic Ocean across the Mediterranean Sea and Asia to the Pacific: the Roman Empire, the Parthian Empire, the Kushan Empire, the nomadic confederation of the Xiongnu, and the Han Empire. Works from these regions and from independent kingdoms in Arabia, India, Southeast Asia, Korea, and Japan are presented here, as well as art of the city-states and kingdoms of Mesoamerica and the western coast of South America.

Although travel was arduous and knowledge of geography imperfect, numerous contacts were forged between far-flung regions during this period, as empires expanded—spreading ideas, beliefs, and customs among heterogeneous peoples—and

1. *Caravan in the Pamir Mountains, Afghanistan.*
Trade routes across Central Asia have passed through the high Pamirs for over two thousand years.

as valuable goods were moved over long distances through trade, barter, and the payment of tribute.

Tangible evidence of the links that existed two thousand years ago between the peoples of Europe, the Mediterranean, and Asia came to light recently in a region of northern Afghanistan formerly known as Bactria. Bounded to the north by the Oxus River and to the east and south by the mountains of the Hindu Kush, Bactria lay on a great plain in Central Asia almost equidistant between Rome, capital of the Roman Empire, and Chang'an, capital of the Han Empire in China. Here, at an ancient Bactrian site known as Tillya-tepe, six princely tombs dating to the early first century A.D. were excavated in 1978. Among the thousands of artifacts uncovered there were such imported objects as two bronze mirrors from China, an incised ivory comb from India, a gold coin of the Roman emperor Tiberius (r. A.D. 14–37) minted at Lugdunum in Gaul, a gold coin of the Parthian king Mithradates II (r. ca. 124–88 B.C.), an Indian coin, and two glass bottles from Mediterranean work-shops. Several fine engraved gems are Greek in subject and style. Numerous gold plaques show writhing animals worked in the vigorous style found in the art of nomadic Eurasian tribes such as the Scythians and Sarmatians. A splendid pair of gold clasps inlaid with turquoise that represent Dionysos, Greek god of wine, and his consort, Ariadne, riding a powerful pantherlike beast combine a Greek subject with this nomadic animal style. All these objects, called by the excavators the Golden Hoard of Bactria, were kept in the National Museum of Afghanistan in Kabul until their disappearance during the recent upheavals there. The treasure symbolizes the web of interconnections established at the beginning of the first millennium between peoples who often had only a tenuous knowledge of each other's very existence.

The Roman Empire ringing the Mediterranean and the Han Empire in China flourished at the same time, expanded geo-graphically to domains of about the same extent, and ruled approximately equal numbers of people. Although a vast empire had been acquired by the Romans over a period of three hundred

years (see map, pp. 24–25), it was not until the last quarter of the first century B.C. that the stable rule of Augustus, the first Roman emperor, ushered in a long period of unprecedented peace and prosperity in the Mediterranean world. Virgil's famous fourth eclogue, a poem written in 40 B.C., had foretold the advent of this extraordinary epoch with the image of a newborn child, an idea that in the Middle Ages came to be associated with the birth of Christ.

> *Ours is the crowning era foretold in prophecy:*
> *Born of Time, a great new cycle of centuries*
> *Begins. Justice returns to earth, the Golden Age*
> *Returns, and its first-born comes down from heaven above.*
> *Look kindly, chaste Lucina, upon this infant's birth,*
> *For with him shall hearts of iron cease, and hearts of gold*
> *Inherit the whole earth—yes, Apollo reigns now.*

Prophecies and portents abounded at this time of change. A comet filled the sky for seven nights after the assassination of Julius Caesar in 44 B.C.; the horoscope of his grandnephew and heir, Octavian, the future emperor Augustus, was so astounding that when he came to power he published it and issued coins stamped with his astral sign, Capricorn. The star described in the New Testament that guided the Magi from the East to Bethlehem may have been yet another of these astrological events.

After the defeat of Mark Antony in a sea battle at Actium off the northwest coast of Greece in 31 B.C. and the subsequent suicide of Antony and his consort Cleopatra, queen of Egypt, Octavian emerged as the sole and undisputed ruler of the Roman Empire. During the next forty-four years he presided over the development of an institutional and ideological framework that preserved the traditions of the Roman Republic while concentrating effective power in his own hands as *princeps*, the "first man" of the state. After his restoration of the Republic in 27 B.C. the Senate conferred on him the honorific title "Augustus." A social and cultural program that enlisted literature and all the

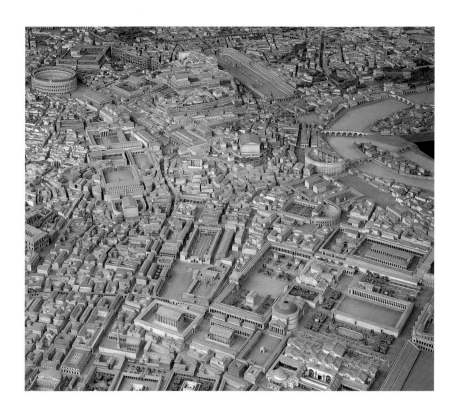

2. *Model of Ancient Rome,* detail showing the city as it appeared at the height of its expansion under the emperor Constantine in the early fourth century A.D. Museo della Civiltá Romana, Rome

arts from architecture to gem-cutting not only revived time-honored values and customs but also promoted allegiance to Augustus and his family throughout the empire. The city of Rome was transformed by hundreds of new buildings and renovated temples that glorified the imperial dynasty.

Augustus doubled the size of the provincial empire, whose different areas were assimilated in different ways. Egypt was annexed, with special status as the personal estate of the emperor, who presented himself as successor to the pharaohs. The long-established political and social structure of the country was apparently little changed. Egypt's immense agricultural wealth became essential to averting famine in overcrowded Rome, and its location made it the gateway for imperial trade with Africa and the East. Spain was finally subjugated, and the northern frontiers of the empire were established along the Rhine and Danube Rivers. In central and western Europe most of the territories were occupied by the tribal federations of the Celts, great warriors who by the first century B.C. were living a settled, agricultural life. Under Roman rule, Gaul (roughly the area of modern France and Belgium) was divided into four provinces. A network of roads, constructed to move and supply the army, led to the growth of new towns such as Lugdunum (modern

Lyons), which was located at a main crossroads of the transportation system. It became the administrative, financial, and commercial center of the entire region, housing a branch of the imperial mint and serving as a distribution center for Mediterranean products such as olive oil and wine. A federal sanctuary there with an altar to Rome and Augustus became the annual meeting place for the aristocratic delegates of the sixty Celtic tribes, many of whom became Roman citizens and adopted a Roman way of life.

The empire had no single unified culture. Instead of a one-way transmission of ideas and styles from the Romans to the various peoples they ruled, there was an interchange and a co-existence of diverse beliefs, customs, and artistic traditions. From the eighth century B.C. onward Greek language and culture had spread throughout the Mediterranean world, first through the founding of colonies by the major city-states of Greece and Asia Minor and later through the conquests of Alexander the Great and the establishment of great kingdoms by his generals. As the Romans began their expansion into the eastern Mediterranean during the third century B.C. they were deeply impressed by the wealth and beauty of the Greek cities that came under their rule, not only the ancient centers of classical culture and art such as Athens but also the newly founded capitals such as Alexandria in Egypt, where a cosmopolitan population gathered and the later Greek culture that has come to be called Hellenistic flourished. Victorious generals returned to Rome with booty that included works of art in all media, and Greek teachers and artists were brought to Rome. Roman literature and art came to draw heavily on the motifs and styles of classical Greek and Hellenistic art. In Egypt, the ancient artistic canons continued unchanged or were combined with Greco-Roman styles. Likewise, a hybrid Gallo-Roman art developed in the northern provinces.

The state religion mandated veneration of the emperor throughout the lands Rome controlled, and worship of the Roman pantheon was widespread, but numerous foreign cults

such as those of Cybele, Mithras, and Dionysos became popular. Some shared features with mystery religions, which had secret initiation rites and offered a sense of community and hope for an afterlife. During the Hellenistic period the ancient Egyptian divinity Isis had been given Greek form and made the consort of the newly created Greco-Egyptian god Serapis. Rapidly identified with almost every major female deity in the Mediterranean world, she became one of the most important divinities in the Roman Empire. Jews lived in many parts of the Roman world as well as in the province of Judaea. Several distinct sects had arisen among the Jews of Judaea during the Hellenistic period, and in the late first century B.C. many Jews believed that a Messiah—the anointed one, a king sent by God—would soon appear to sit on the throne of Israel and that a radical reorganization and judgment of the world was imminent. Ascetics, prophets, and preachers, among them John the Baptist and Jesus of Nazareth, drew large crowds. Jesus taught that the Kingdom of God was forthcoming. His followers, convinced that he was the Messiah (the Greek translation is Christos), began to spread his word throughout the eastern Mediterranean after his death, drawing both Jews and non-Jews into a new faith that would develop into a world religion, Christianity. It is of course from the presumed birthdate of Jesus that our Year One derives.[1]

The Han Empire in China, powerful at the same time as the Roman Empire, asserted sovereignty over thousands of square miles of territory (see map, pp. 128–29). Surrounded by a great

[1]The counting of years from the birthdate of Jesus was first introduced in 525 by a Scythian monk, Dionysius Exiguus, in a document prepared for Pope St. John I. However, the practice did not become widespread until the eighth century, during the reign of Charlemagne, the Frankish king and emperor of the West. A.D. is the abbreviation for *Anno Domini*, "In the year of our Lord." (Dionysius was probably wrong by a few years in calculating the year of Jesus' birth.) The use of B.C., "Before Christ," to count backward from the same date is even more recent, dating from the seventeenth century. The more secular terms C.E. and B.C.E. ("Common Era" and "Before the Common Era") were first proposed in the early twentieth century and are now frequently used.

expanse of ocean to the east, the high mountains of Tibet to the southwest, and the arid Gobi Desert and cold steppes of Mongolia to the north, the Chinese believed that they constituted the civilized world in the same way that the inhabitants of the Mediterranean world envisioned themselves as the center of civilization. The Han Empire lasted for four hundred years, the Former or Western Han dynasty ruling from 206 B.C. to A.D. 9 and, after a brief interregnum, the Later or Eastern Han dynasty from A.D. 25 to 220.

Many of the precedents and institutions that have shaped Chinese policy and thought for centuries were established by the emperor Wudi, who reigned for over fifty years, from 141 to 87 B.C. He brought the empire's recently unified territories firmly under his control, breaking up the fiefdoms of the aristocracy and putting in place an elite bureaucracy of scholar-officials who were trained in literature and a sociopolitical doctrine based partly on the rules of ritualized conduct and right hierarchical distinctions that the Chinese sage Confucius had defined in the late sixth century B.C. Schools throughout the empire sent their best students to the imperial university, where by the Later Han dynasty over ten thousand future officials were enrolled, to study the Five Classics of Confucius, which taught such moral principles as self-restraint, concern for others, and loyalty to superiors. Ancient cosmological ideas and organizing principles such as the eternal alternating flow of yin and yang were synthesized with Confucian ethics to develop a worldview in which it was the emperor's role to maintain a proper balance between heaven and earth. Magic and astrology also flourished in the Han court; the very layout of the emperor's palace in the great capital of Chang'an was said to have been aligned with certain constellations. Toward the end of the Western Han dynasty, omens and portents of coming change were widespread, and it is interesting to note that in 3 B.C. thousands of frenzied people converged on the capital city, convinced that the world was coming to an end.

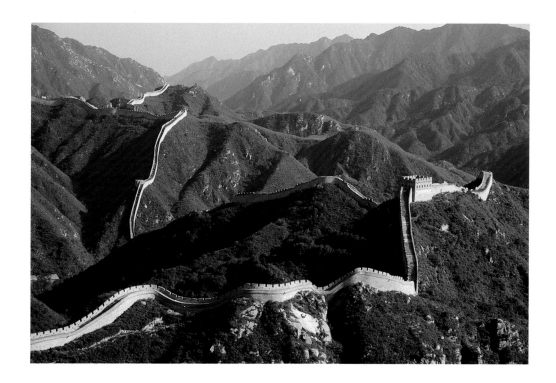

3. *Great Wall of China.*
The emperor Qin Shihuangdi
(r. 221–210 B.C.) created this defense
of China's northern border, some
1,500 miles long, by uniting several
preexisting walls. It was modified
by the emperor Wudi in the
second century B.C. and many
times subsequently.

The government, which was highly centralized, sponsored irrigation projects and canals that extended river transportation. Roads with posting stations were built throughout the empire. State monopolies controlling the production of iron, salt, and liquor and the sale of grain produced new revenues and curbed the power of wealthy merchants. However, China's most famous luxury product—silk—never became a monopoly; its production on countless private farms was actively encouraged by the imperial authorities. The painstaking cultivation of a species of the domesticated mulberry silkworm (known only in China), the unraveling of the silken filaments that compose its cocoon, and the production of silk thread and cloth had already been undertaken in China by the second millennium B.C. Although a silk was produced from the cocoons of wild moths in many parts of the ancient world, no other material could match Chinese silk in luster, texture, and lightness. Rolls of silk were a form of currency within China, and over the years the Han government gave thousands of rolls and thousands of pounds of silk floss as tributary gifts to pacify and control the tribes and states along their borders.

Nomadic tribes had long been raising livestock and horses on the grasslands of the steppes of inner Asia, but it was not

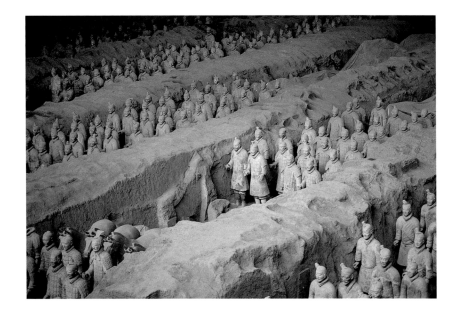

4. *Terracotta Army,*
Qin dynasty (221–206 B.C.).
When Qin Shihuangdi's tomb
was discovered in 1974 in
Xian, China, excavations revealed
thousands of lifesize terracotta
warriors guarding the grave.
They demonstrate the power of
the dynasty that laid the
foundation for the Han era.

until the late third century B.C. that one group, the Xiongnu, brought clans and tribes together in what amounted to an empire stretching from Korea across Mongolia to the Altai Mountains. The containment of these aggressive horsemen on the northern borders of China was a major concern for the emperor Wudi. He strengthened the Great Wall that had been built in the late third century B.C. to protect the frontier and sent troops far into the Xiongnu territory. Wudi developed policies that led to the expansion of Chinese power and influence some three thousand miles westward into Central Asia—cutting off a further spread of the hostile nomads and at the same time forging relationships with small principalities and city-states along what would later become one of the great trade routes of the world, the so-called Silk Road or Silk Route.

This expansion began with two of the most extraordinary recorded journeys in antiquity. In 139 B.C. the emperor sent one of his officials, Zhang Qian, with about one hundred men, in search of allies to help fight the Xiongnu. After ten years of captivity in the hands of that enemy, Zhang Qian escaped and made his way westward beyond the Pamir Mountains to the high valley of Ferghana and to Bactria, where the Yuezhi, a nomadic people who had been pushed westward by the Xiongnu, were newly settled. Although Zhang Qian failed to obtain a military

alliance with the Yuezhi, he set out again in 115 B.C. to make diplomatic overtures to some of the small states in the same Central Asian regions, taking as gifts tens of thousands of cattle and sheep and quantities of gold and silk. Traveling through the oasis towns of the Takla Makan desert and over the surrounding mountains, he reached Ferghana, Sogdiana, and Bactria, all occupied by prosperous pastoral states. Many of these sent envoys to the Han court in return. The emperor even dispatched a Chinese princess to marry the ruler of the Wusun in the Ili valley, receiving one thousand horses as a betrothal gift.

By the end of the second century B.C. the Chinese had extended their frontier westward to the edge of the Takla Makan desert, and Ferghana, almost three thousand miles from Chang'an, had been captured. Fifty years later the Xiongnu to the north were pacified through a reciprocal tribute system whereby they accepted vassal status in return for enormous annual gifts. (In 1 B.C., for example, the Xiongnu received 370 garments, 30,000 rolls of silk, and 30,099 pounds of floss silk.) Similar relationships were forged with the city-states of Central Asia, and goods began to move from China westward as far as Bactria, from there to be transported overland either to the Mediterranean coast or south to ports on the Indian Ocean.

The Chinese had little knowledge of the lands and peoples to the west of Bactria. Likewise, the Romans had but the vaguest notion of the Seres, or silk-people—those remote inhabitants of Asia who produced the extraordinarily fine silk that was reaching Mediterranean markets by the mid-first century B.C. (Julius Caesar had an awning of it; Cleopatra wore transparent silk gowns.) But just as the Chinese sphere of influence extended westward to the regions around Bactria, Mediterranean civilization had penetrated eastward, also to the regions around Bactria. In the fourth century B.C. Alexander the Great had conquered West Asia from the Mediterranean to the Indus River, and after his death in 323 B.C., most of the vast region was ruled for almost two hundred years by the Seleucids, a royal dynasty descended from one of his Macedonian generals. In Bactria

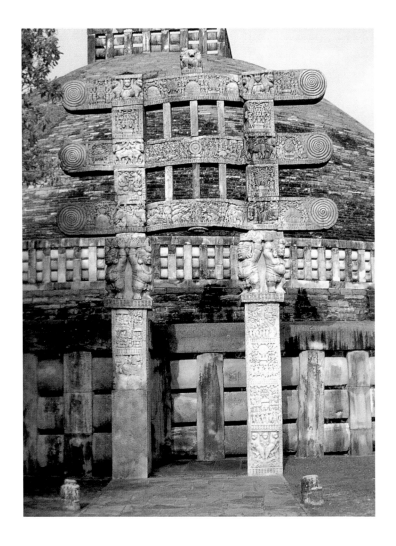

numerous Greek settlers founded small kingdoms, built cities, and introduced Greek language, customs, religious cults, and artistic traditions to the area. Their power reached its peak in the time of Eucratides I (r. ca. 170–145 B.C.), whom ancient writers called "ruler of one thousand cities." By about 130 B.C. Bactria had been overrun by the nomadic Yuezhi, and the Chinese envoy Zhang Qian encountered them soon thereafter on his mission to the west. The gold-filled tombs at Tillya-tepe described above probably belonged to aristocratic members of these tribes. The mixture of Hellenistic Greek, Chinese, Indian, and nomadic objects uncovered there attests to the wealth and cultural syncretism to be found in Bactria by the Year One.

At about this time the Yuezhi united under a powerful leader and began a series of conquests that made them masters of a

5. *Great Stupa at Sanchi,* rebuilt 2nd–1st century B.C. over an older core. Madhya Pradesh, central India. This gigantic monument, with a burial mound and carved gateways, is an early example of Buddhist art, slightly predating the era of the Kushans.

great state, which, since they had come to be called "Kushans," is known as the Kushan Empire; it included Bactria, Gandhara in the valley of the Kabul River high in the Hindu Kush, and the plains of northern India watered by the Indus and Ganges Rivers. From the mid-first century A.D. through the second century A.D. the Kushans were at the geographical center of a network of trade routes that connected the Roman world, the Red Sea, the Arabian Sea, India, Central Asia, and China. Although few written records exist, their wealth and culture can be glimpsed in the extraordinary series of gold coins minted by the Kushan kings. Struck on a weight standard based on that of Roman gold coins, they portray a succession of rulers together with a great variety of divinities of Greek, Iranian, Hindu, and Buddhist origin. Buddhism, which had originated with the teachings of the Indian prince Siddhartha Gautama in the fifth century B.C., flourished under the Kushans. The first sculptural images of the Buddha were created in Gandhara at this period, and Buddhism began to filter eastward toward China as monks traveled along the trade routes of Central Asia. The remains of many Kushan cities have been uncovered: among the most important were Bactra (modern Balkh) in Bactria, Purushapura (Peshawar) near the Khyber Pass in the Hindu Kush, Taxila in Gandhara, Kapisa (Begram), and Mathura on the northern plains of India. Fortified with walls and towers, these urban centers bustled with Buddhist establishments, administrative buildings, and trade entrepôts.

By the Year One all the conditions were in place for a great expansion of international trade. Quantities of Chinese silk circulated as a medium of gift exchange, tribute payment, or commodity for trade among the nomadic tribes and city-states of Central Asia. Traders from Sogdiana, to the north of Bactria, were especially active middlemen in the transport of silk through Kushan territory, taking it over passes in the Karakoram Range and the Hindu Kush down to Barbarikon, a port at the mouth of the Indus River, or Barygaza (Broach) farther down

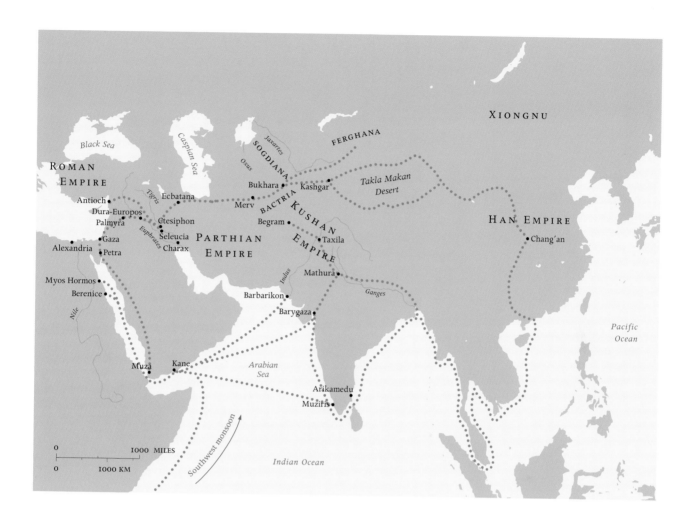

the Indian coast, from which it could be carried westward
to Mediterranean ports.

An overland route from Bactria to the west passed through
Parthia, ruled by the Arsacids, an Iranian dynasty that had
gradually conquered lands in the Seleucid Empire (see map,
pp. 102–3). Its expansion owed much to the rule of two great
kings, Mithradates I and Mithradates II, whose reigns together
occupied most of the years between 171 and 88 B.C. and who
made the Parthian Empire one of the major powers of the ancient
world, controlling the greatest part of Mesopotamia, Iran, and
western Central Asia. Like the Roman Empire it was ethnically,
politically, and culturally diverse, with strong Greek traditions.
The kings ruled from the capital at Ctesiphon on the Tigris River,
with many ceremonies and titles adopted from the Achaemenid

6. *Trade Routes.*
Map of the eastern Mediterranean
and Asia, showing the trade routes
discussed in this essay

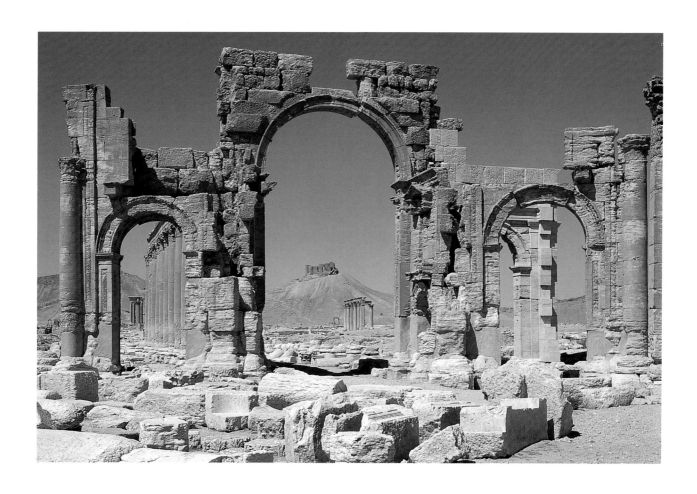

7. *Monumental Arch on the Main Colonnaded Street, Palmyra*, 2nd century A.D. Palmyra, Syria. Public buildings, a great marketplace, and covered walkways lined the central colonnaded street of this famous desert city.

Persians, who had dominated the area until the advent of Alexander the Great. Their power was sometimes challenged, however, by nobles with vast estates and their own standing armies.

Numerous trade routes carried goods between East and West. A Parthian Greek called Isodorus of Charax described them in a book entitled *Parthian Stations*, written around the Year One. From Antioch on the Mediterranean coast, routes crossed the Syrian desert via Palmyra to Ctesiphon and Seleucia on the Tigris River. From there the road led east across the Zagros Mountains to the cities of Ecbatana and Merv, where one branch turned north via Bukhara and Ferghana into Mongolia and the other led into Bactria. Spasinu Charax (home of Isodorus), a port on the Persian Gulf, was a great center of seaborne trade. Goods unloaded there were sent along a network of routes throughout the empire—up the Tigris to the capital, Ctesiphon; up the Euphrates to Dura-Europos; and on through the caravan cities of the Arabian and Syrian desert.

Many of these overland routes ended at ports on the eastern Mediterranean, from which the merchandise was distributed to cities throughout the Roman Empire.

Enormous fortunes had been amassed by members of the ruling elite as Rome gained power in the Mediterranean during the second and first centuries B.C., and general prosperity increased with the advent of peace during the reign of Augustus. The demand for luxury items from the East, such as fine silk and spices, influenced imperial policy in the eastern Mediterranean and led to the establishment of new trade routes, across the Indian Ocean.

In 63 B.C. Syria had become a Roman province, while other areas such as Judaea and Nabataea were made into client kingdoms. Further eastward, expansion was blocked by the Parthians, who inflicted an ignominious defeat on the invading Romans in 53 B.C., overwhelming an army of seven legions and killing its commander, Marcus Licinius Crassus. Some ten thousand Roman prisoners were settled in Parthia. After several attempts to avenge this disaster failed, Augustus managed to recover the lost legionary standards and some of the prisoners through a negotiated peace, but relations with Parthia were never good. Moreover, the tariffs charged for moving merchandise through Parthia were always high.

With the annexation of Egypt in 30 B.C., Rome gained control of ports on the Red Sea that gave access eastward into the Indian Ocean. In 26/5 B.C. an expedition led by Aelius Gallus, prefect of Egypt, sought in vain to conquer the small kingdoms of southwest Arabia in present-day North and South Yemen. The trees that produce frankincense and myrrh, fragrant gum resins widely used as incense offerings to the gods throughout the ancient world as well as in medicine and cosmetics, grow only in southern Arabia and northern Somalia. Their monopoly over the production and distribution of incense brought enormous wealth to the South Arabian states. Pliny the Elder, writing toward the middle of the first century A.D., described them as the wealthiest kingdoms in the world (Pliny, *Natural*

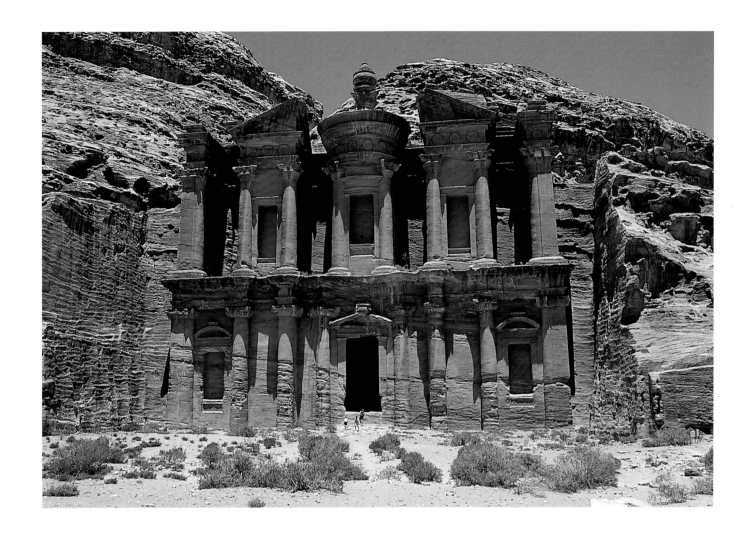

8. *El-Deir, Petra,*
1st century A.D.
Petra, Jordan. Carved into one of the
sandstone cliffs that surround the
ruins of the Nabataean capital of
Petra, this facade with an interior
room may have been a cult
monument to a deified king.

History VI.32.162) and estimated that of the hundred million
sesterces expended by the Roman Empire on goods from
Arabia, India, and China, approximately one half was spent
for Arabian merchandise alone. Numerous trade routes went
overland through the Arabian desert. Some ended at Petra, the
rockbound city of the Nabataeans in what is now southern
Jordan, where new caravans could travel on to Gaza and other
ports on the Mediterranean or north to Damascus or east to
Parthia. A complex of sea routes linked the incense ports of
South Arabia and Somalia with ports in the Persian Gulf and
India in the east, and also with ports on the Red Sea, from
which merchandise was transported overland to the Nile and
then to Alexandria.

Arab and Indian seamen had been plying the waters of the western Indian Ocean for centuries, but it was not until about 116 B.C., during the reign of Ptolemy VIII, ruler of Egypt, that a Greek named Eudoxus managed to sail to India. Thereafter some twenty ships made the journey from Egypt to India every year. Under Augustus this traffic suddenly increased to well over one hundred ships per year, and for the first time in history significant commerce on the Indian Ocean was directly linked with that of the Mediterranean region. Thanks to a brief handbook, the *Periplus Maris Erythraei* (Sailing Guide for the Erythraean Sea), probably written in the mid-first century A.D., we have more detailed information about this exotic commerce than any other trade activity in the Roman Empire. The *Periplus* supplied sea captains and merchants with information about winds, distances, and harbors in the Red Sea, the Gulf of Aden, and the western Indian Ocean, as well as listing what could be bought or sold in the various ports. Loaded with merchandise that had been shipped from the Mediterranean up the Nile to Coptos and carried overland to the Red Sea ports of Myos Hormos or Berenice, vessels sailed down the Red Sea. One route followed the western coast of Africa to approximately where Dar es Salaam stands today. At ports along the way traders obtained ivory, tortoiseshell, frankincense, and myrrh in exchange for staples such as tools, iron, tin, and tableware. Another route led to the Arabian ports of Muza and Kane, where frankincense and myrrh were traded for clothing, copper, tin, and various drugs and cosmetics. From Kane ships took off across some two thousand miles of open sea for India, heading northeast for either Barbarikon, at the mouth of the Indus River, or Barygaza, on the Gulf of Cambry—or southeast to ports such as Muziris on the Malabar Coast.

The timing of these voyages was determined by the prevailing winds of the Indian Ocean—the monsoons—which blow from the southwest during the summer months and from the northeast in the fall. While the latter is a gentle wind in balmy

weather, the former is so strong and stormy that even today marine insurance is suspended during its height. The Romans could take advantage of the powerful southwest monsoon for a fast journey to India because their merchant ships were large and heavy, constructed with exceptionally strong hulls and special rigging.

Cargoes worth a fortune were carried in these huge vessels. Western traders sold raw materials such as lead, tin, and copper as well as slaves, drugs and cosmetics, wine, coral, silverware, and glass. At Barbarikon and Barygaza they could buy nard, spikenard, and bdellium, three valuable ingredients for cosmetics and medicine, from the Himalayas; lapis lazuli from what is now Afghanistan; silk cloth and yarn from China; and skins, probably from the steppes of Central Asia. The southwestern port of Muziris offered gems such as Indian diamonds and emeralds, cottons, and Chinese silk as well as ivory and tortoiseshell. Spices, however, were the most eagerly sought commodity. Cassia, cloves, ginger, nutmeg, and mace, imported from China, mainland Southeast Asia, and Indonesia, could be purchased in India, but Indian pepper and cinnamon, available in large quantities at the ports of the Malabar Coast, were most in demand. Indeed, in A.D. 92 the emperor Domitian constructed special warehouses in the spice quarter of Rome for the storage of pepper.

As many as three Indian embassies to Augustus are recorded, one of which featured the first public viewing of a tiger. The influx of luxury products to Rome increased during the reign of Tiberius (r. A.D. 14–37), who inveighed in vain against the wearing of silk, especially by men (Tacitus, *Annales* 2.33). A generation later the satirist Petronius described how the nouveau-riche Trimalchio has specially ordered the seed of a rare and costly mushroom from India (Petronius, *Satyricon* 38.4). The carved ivory handle of an Indian mirror found at Pompeii indicates that some traders brought back works of art. Despite this plethora of imported goods, the East remained a fabled, distant land to most people living in the Roman Empire and must have carried associations of exotic romanticism much like those that still

cling to it. In the second century A.D. the writer Xenophon of Ephesus could compose a story worthy of the best romantic novel in which the heroine, purchased as a slave by a rich Indian visiting Alexandria, only escapes to rejoin her lover when brigands attack the caravan taking her to a port on the Red Sea (Xenophon of Ephesus 3.11 ff.).

Although there are references to the "Yavanas," or westerners, in some poetry written in southern India, and inscriptions refer to permanent settlements on the west coast of the subcontinent, most evidence for the presence in India of traders from the Mediterranean during the first and second centuries A.D. comes from archaeological excavations. Enormous numbers of gold and silver coins, most dating to the reigns of Augustus and his successor, Tiberius, have been discovered in central and southern India, indicating that the balance of trade must have been in India's favor. A cache of Roman bronzes, including a statuette of Poseidon, vessels, and mirrors, was found at an ancient inland site. Indian ships carried the merchandise along the eastern coast of India, although the Romans were apparently familiar with ports up to the mouth of the Ganges. Storage warehouses, trade quarters, and fragments of Roman pottery and glass vessels have been uncovered at Arikamedu, on the eastern coast near the modern town of Pondicherry, making it likely that Mediterranean traders were settled there. Raw glass, waste glass, and hundreds of beads have also been excavated there; local craftsmen may have supplied glass beads throughout the Indo-Pacific area.

Although little is known about sea trade between India, Southeast Asia, and China during the first and second centuries A.D., isolated incidents are recorded in both Roman and Chinese literature. The easternmost port known to the author of the *Periplus* was Chryse, probably on the coast of Burma. Pliny the Elder recounts that during the reign of Claudius (A.D. 41–54), the freedman of a certain Annius Plocamus was blown, perhaps from Arabia, across the Indian Ocean to Taprobane (modern Sri Lanka) and returned with an embassy from the island, who

provided much information about its geography and customs; this included assertions that their island faced the country of the Seres, to which they had traveled, and that there they had traded with blond, blue-eyed people on the beach (Pliny, *Natural History* VI.24.84–89). In the mid-second century A.D., Ptolemy, the Greek geographer, was able to describe places that can be identified with Malay, Sumatra, or even Java, and mentions a city named Kattigara that has been thought to be as far east as Singapore, Hanoi, or Guangzhou (Canton).

Despite all this trade and travel, it appears that direct contacts between Rome and China were never actually established in the period around the Year One. According to the Chinese document *Hou Han Shu* (History of the Later Han), in A.D. 97 the Chinese general Ban Chao sent an ambassador named Gan Ying as envoy to the West. He arrived at the coast of a great sea but turned back when the Parthians told him that "there was something in the sea that made a man long for home, and many men lost their lives on it." Scholars cannot be sure which sea is meant, but Gan Ying may have reached the Persian Gulf. As far as we know, the first Romans arrived in China in A.D. 166. Chinese sources describe this visit as an official delegation from the emperor Antun (Marcus Aurelius), although it may have been a private enterprise pretending to be official. The gifts the visitors brought—ivory, rhinoceros horns, and tortoiseshell—could all have been bought in India or in China itself.

Works of art offer the best evidence for the remarkable web of interconnections among the disparate cultures that thrived two thousand years ago. Just as the rich variety of objects in the tombs of the nomadic Yuezhi at Tillya-tepe in Bactria demonstrates that there was contact between China, India, Parthia, and the Mediterranean world around the Year One, another treasure found nearby at Begram, sixty miles north of Kabul, shows how this contact continued and increased during the following century and a half. Begram has been identified as ancient Kapisa, the summer residence of the Kushan kings. During excavations in the 1930s a spectacular cache of objects was unearthed in two

sealed adjoining rooms of what is usually described as a palace. Indian ivories, fragments of Chinese lacquer boxes, Roman bronzes, vessels of porphyry and alabaster, and over 150 glass objects from Mediterranean workshops littered the storeroom floors. In addition there was an extraordinary collection of plaster casts, including forty roundels obviously cast from the relief medallions in the centers of Greek or Roman silver bowls. These must have served as models for artists working at the Kushan court. The material, which can all be dated to before the mid-second century A.D., testifies once again to the variety of the cultures that came together in a high plain of Central Asia, midway between Rome and China, at the center of all the trade routes that connected the ancient world. We are fortunate that the diverse cultures flourishing in the Year One can also be elucidated through their art as it is represented in the collections of the Metropolitan Museum.

—*Elizabeth J. Milleker*

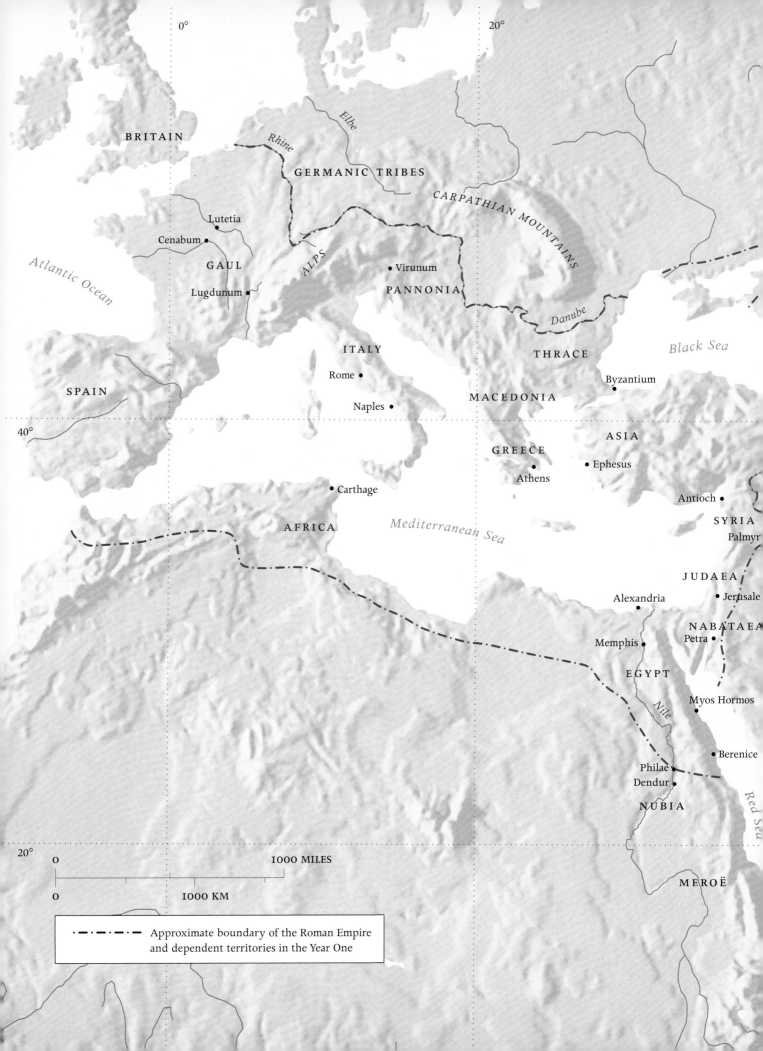

BRITAIN

GERMANIC TRIBES

Elbe

Rhine

CARPATHIAN MOUNTAINS

Lutetia

Cenabum

Atlantic Ocean

GAUL

ALPS

Virunum

PANNONIA

Danube

Black Sea

Lugdunum

ITALY

THRACE

SPAIN

Rome

Byzantium

Naples

MACEDONIA

40°

ASIA

GREECE

Ephesus

Athens

Carthage

Antioch

Mediterranean Sea

SYRIA

AFRICA

Palmyr

JUDAEA

Alexandria

Jerusale

NABATAEA

Memphis

Petra

EGYPT

Myos Hormos

Nile

Berenice

Philae

Dendur

Red Sea

NUBIA

20°

0 1000 MILES

0 1000 KM

MEROË

— · — · — · Approximate boundary of the Roman Empire
and dependent territories in the Year One

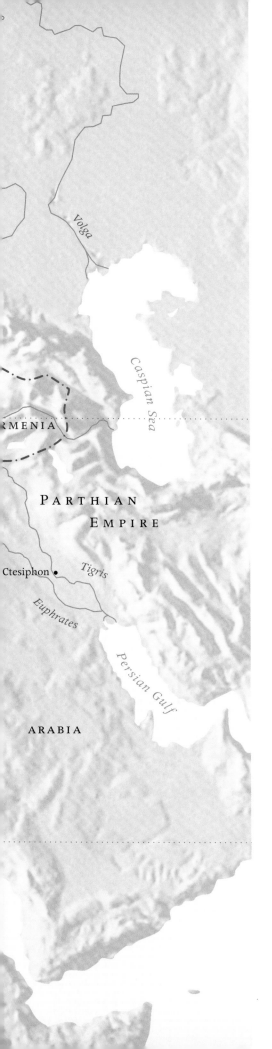

Volga

Caspian Sea

RMENIA

PARTHIAN
EMPIRE

Ctesiphon •

Tigris

Euphrates

Persian Gulf

ARABIA

THE MEDITERRANEAN WORLD: THE ROMAN EMPIRE

ROME

Traditionally founded in 753 B.C., Rome began as a small cluster of primitive huts dating back at least to the tenth century B.C. From such insignificant and unpromising beginnings it developed into a city-state, first ruled by kings but from 509 B.C. onward organized in a new form of government, the Republic. This unique power-sharing partnership between the patricians, the ruling class, and the plebs, or ordinary citizens, continued until the late first century B.C. During the last three centuries B.C. Rome also became a metropolis, the capital city of a vast expanse of territory acquired piecemeal by conquest and by diplomacy. The strains of governing an ever-expanding empire, combined with the fact that relatively few citizens profited from Rome's new wealth, led to the collapse of the Republic. The city experienced a long and bloody series of civil wars, political crises, and civil disturbances, culminating in the dictatorship of Julius Caesar and his assassination on the Ides of March, 44 B.C.

After Caesar's death the task of reforming the Roman state and restoring it to a condition of peace and stability fell to his grandnephew and heir, Octavian, then only eighteen years old. Although he was dismissed by Mark Antony, the leading general among Caesar's followers, as "a mere boy who owes everything to his name," Octavian emerged some thirteen years later "like a Colossus" bestriding the Roman world. By war or by proscription he had eliminated all opposition to his rule. In 27 B.C. Octavian sought to legitimize his position by restoring

the Republic while effectively establishing himself as *princeps*, the "first man" of the state. Awarded the honorific title of Augustus by a decree of the Senate, he continued to rule Rome and its empire by various direct and indirect means until his death in A.D. 14 at the age of seventy-six.

Rome was already the largest, richest, most powerful, and possibly most populous city in the Mediterranean world, but during his reign Augustus transformed it into a truly imperial city. He imposed a new political and administrative system that facilitated more efficient rule of the empire. He encouraged writers to compose works that proclaimed Rome's imperial destiny. The *Histories* of Livy, no less than the *Aeneid* of Virgil, were intended to demonstrate that the gods had ordained Rome "mistress of the world"—and thus to justify and legitimize its dominion over other cities and peoples.

The empire over which Augustus presided was made up of numerous disparate parts; one of his first tasks was to consolidate Roman holdings and define their borders. In the 20s B.C. the emperor himself campaigned in Spain in order finally to pacify the barbarian tribes that had resisted Roman rule there for two hundred years. Meanwhile his generals took the offensive in Gaul, the Alps, the Balkans, Africa, upper Egypt, and Arabia. On the eastern frontier, where the Parthians had proved formidable adversaries, Augustus scored a major diplomatic success, securing the return in 20 B.C. of the Roman standards they had captured in the humiliating defeats of Crassus (in 53 B.C.) and Mark Antony (in 36 B.C.). The event was celebrated by the issue of special coins bearing the legend *Signis Receptis* (The standards have been recovered) and was represented in relief on the cuirass worn by Augustus in the famous statue of him found at Prima Porta, now in the Vatican Museums. Further campaigns carried out in the last two decades of the first century B.C. against various barbarian tribes pushed the northern frontiers of Rome up to the Danube and the Rhine. Tiberius, Augustus's stepson and eventual successor, played a major role in the conquest of Pannonia (principally in present-day

Hungary), just as he had done earlier in the negotiated settlement with Parthia. Thereafter efforts focused on the annexation of Germany, with Roman armies advancing against the Germanic tribes as far as the river Elbe. However, the annihilation of the general Varus and his three legions in the Teutoburg Forest in A.D. 9 effectively thwarted Roman ambitions in Germany. At his death Augustus left an empire "surrounded by the ocean and by far-off rivers," but not quite "the empire without end" that Virgil had Jupiter promise Rome as its destiny in the *Aeneid*.

Acutely aware that empire is a matter of culture as well as conquest, Augustus embarked on a massive building program aimed at turning Rome into a metropolis of gleaming marble with public buildings and amenities befitting its position as the imperial capital (fig. 2). He completely transformed the city's appearance. The high artistic quality of monuments such as the Ara Pacis Augustae (Altar of Augustan Peace) was matched by an innovative use of space and materials: the earliest hemispherical concrete dome was probably erected during Augustus's reign, a period of great advances in architecture and civil engineering. Conditions in Rome under Augustus also attracted craftsmen from all around the Mediterranean world. Spurred on by imperial and private patronage, they established workshops that were soon producing a range of objects—sculpture, silverware, gems, glass—of the highest quality and originality.

Thus at the beginning of the first century A.D. Rome stood at the head of an empire that dwarfed all its neighbors, with the possible exception of the Parthian Empire. Romans themselves perceived their position of "masters of the world" as divinely ordained and destined to last forever. The success of the new order established by Augustus can be measured by the actual longevity of Roman imperial rule: the last western emperor, appropriately named Romulus Augustulus, was deposed in A.D. 476, and the eastern half of the empire only came to an end when Constantinople—the "New Rome"—fell to the Ottoman Turks in A.D. 1453.

The stern, uncompromising expression on the three faces seen here embodies the austere traditional values of the Roman Republic, which lasted from the fifth century until the late first century B.C. Patrician clans had long preserved images of their ancestors in their homes, but it was probably not until the second century B.C. that marble portraits of victorious generals and governing magistrates began to proliferate in public spaces. As the Romans came into sustained contact with the Greek-speaking cities and kingdoms of the eastern Mediterranean, they adopted the custom of setting up honorific statues and employed Greek artists to carve them. Instead of the charismatic, youthful images favored by the Hellenistic kings, who wished to be associated with Alexander the Great, the Roman ruling class chose a sober, objective style. The traditional Roman concept of virtue called for old-fashioned morality, a serious, responsible public bearing, and courageous endurance in the field of battle. Prestige came as the result of age, experience, and competition among equals within the established political system. These are values expressed in the portraits of grim-faced middle-aged men seen here. The individual bony structure of each face is carefully modeled and the hard surface of the flesh is deeply etched with wrinkles. All three men have furrowed brows, piercing eyes, and thin, tightly sealed lips. Their hair is close cropped in a military style.

Although we do not know the names of these individuals, the portraits offer a few clues about them. The head seen here (fig. 9), with its broad forehead, narrow chin, and long, scrawny neck, is so similar in structure to images of Julius Caesar as he appears on coins and in sculpture that formerly it was identified as that famous general and politician. Perhaps the man who is the actual subject of the portrait wished to accentuate this resemblance because he sympathized with the dictatorship of Caesar and with the cause of Caesar's grandnephew and heir, who would become Augustus.

9. *Portrait of a Man.*
Roman, early Augustan period, late 1st century A.D.
Marble, H. 12⅜ in. (31.5 cm)

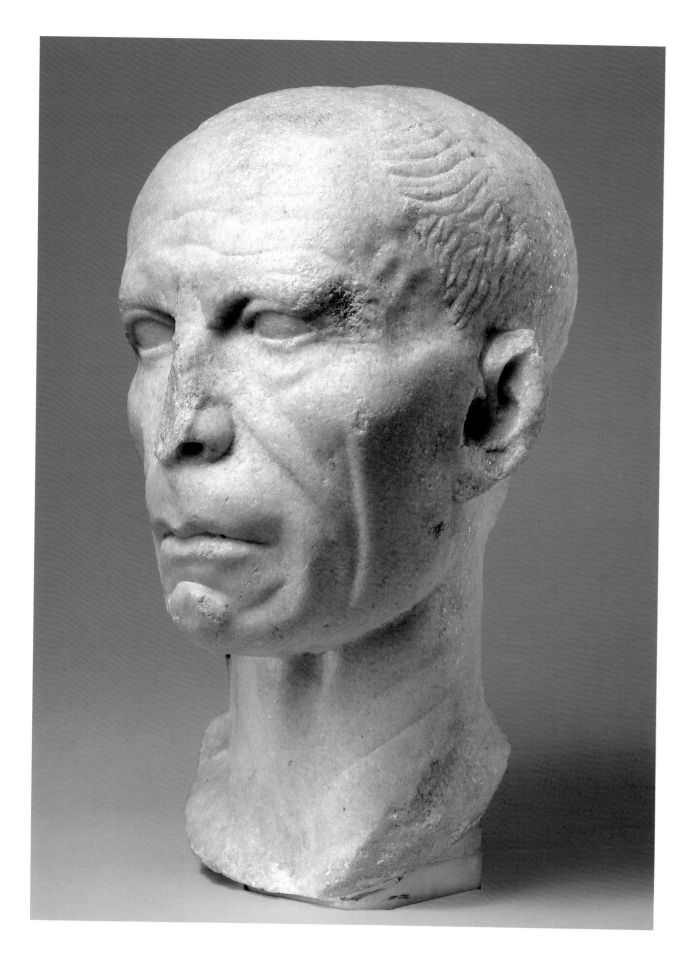

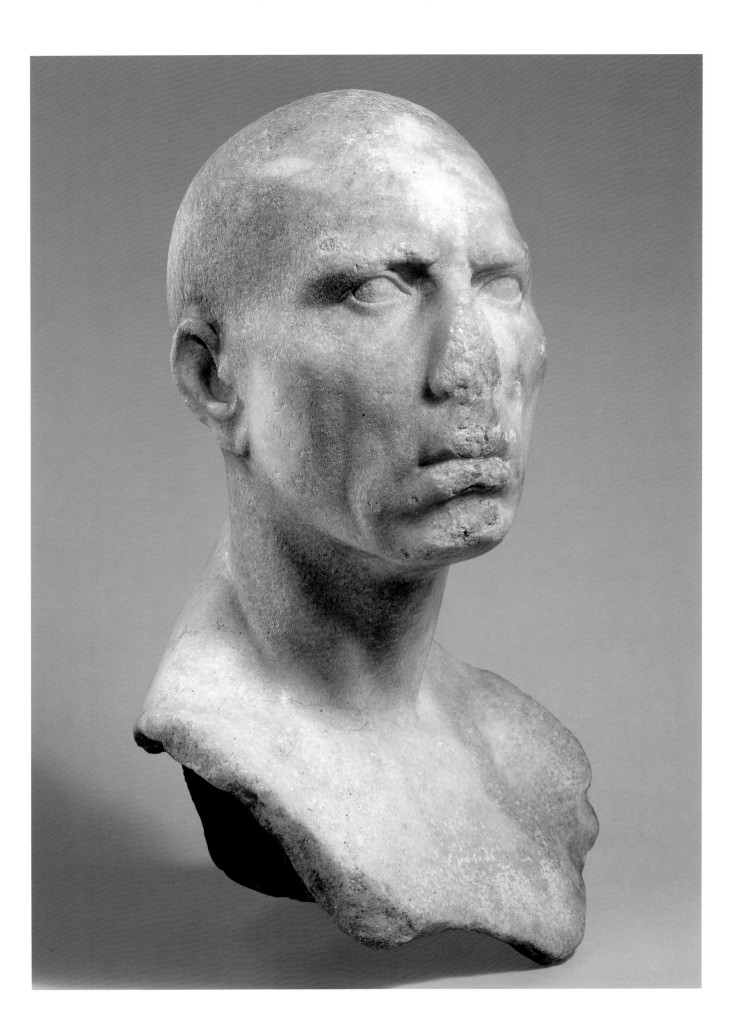

The head on the right (fig. 11) is from a funerary relief and probably represents a freedman, or former slave, who had achieved prosperity after obtaining his freedom. Such reliefs showing busts of family members within a windowlike frame were often set into the outer wall of a family's funerary building.

The portrait bust on the left (fig. 10) incorporates a large expanse of chest, which indicates that it was carved toward the middle of the first century A.D. Most surviving portraits carved in the hard, realistic manner seen in these three works date to the first century B.C., but the style continued in fashion until the mid-first century A.D. and was revived intermittently thereafter.

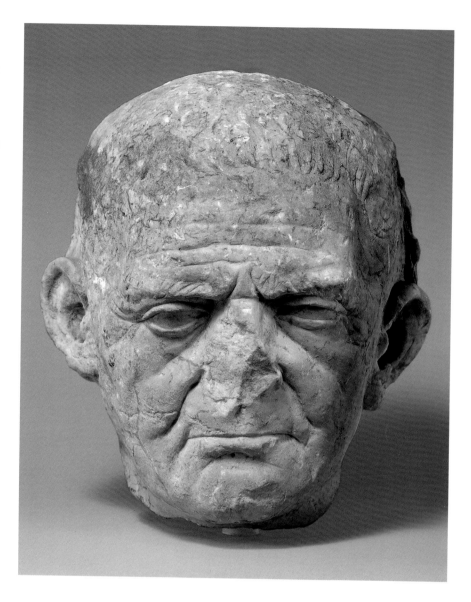

11. *Head of a Man from a Funerary Relief.*
Roman, early Augustan period, late 1st century B.C.
Marble, H. 9⅝ in. (24.5 cm)

FACING PAGE
10. *Portrait Bust of a Man.*
Roman, Julio-Claudian period,
mid-1st century A.D.
Marble, H. 17½ in. (44.3 cm)

In 30 B.C. Gaius Julius Caesar
Octavianus, grandnephew and heir
to Julius Caesar, became master of
the empire that Rome had amassed
over the previous three centuries. A
long, chaotic period of civil wars
and military dictatorships came to
an end as the young Octavian began
to shape a new form of government
that would ensure peace and stabil-
ity. Over the next forty-four years he
introduced institutions and an ideol-
ogy that combined the traditions of
Republican Rome with the reality of
kingship. A new type of leadership
evolved in which Octavian officially
relinquished command of the state
to the Senate and the people while
actually retaining effective power
through a network of offices, privi-
leges, and control over the army.
In 27 B.C., after this restoration of
the Republic, the Senate conferred
on Octavian the honorific title of
Augustus—an adjective with con-
notations of dignity, stateliness,
even holiness.

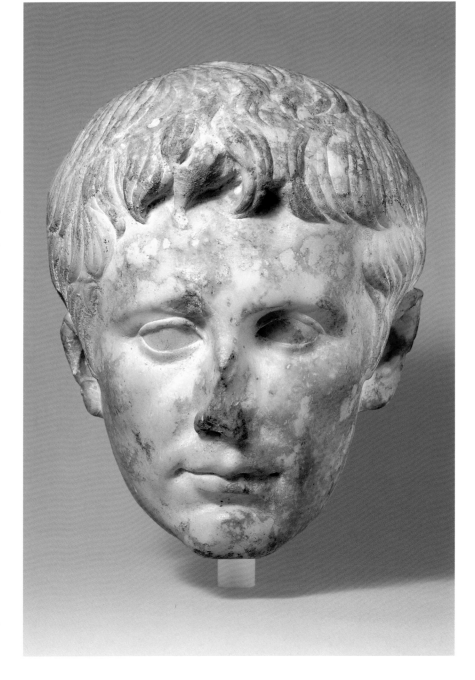

12. *The Emperor Augustus.*
Roman, Tiberian period, A.D. 14–37.
Marble, H. 11 in. (27.8 cm)

At about the same time, an official portrait was created that embodied the qualities Caesar Augustus wished to project, and hundreds of versions of it were disseminated throughout the empire—on coins, gems, busts of all sizes, and full-scale statues. Over 150 of these works are still known today, and among them are the two portraits seen here (figs. 12, 13). This image of Augustus drew neither from the dramatic, semidivine imagery of Alexander and other Hellenistic rulers nor from the relentlessly realistic style of late Republican portraits. It was a new conception of a ruler portrait, in which the features are individualized but the overall effect is of calm, elevated dignity and brings to mind classical Greek art of the fifth century B.C. With this studied understatement Augustus could evoke the values of the glorious past of Athens and at the same time present himself simply as *primus inter pares*, "first among equals."

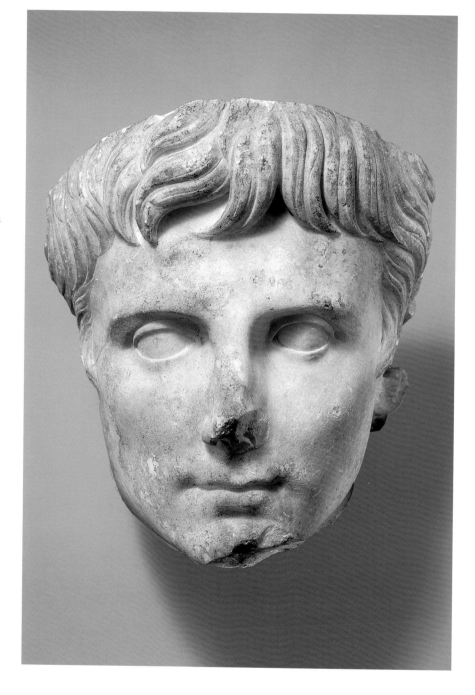

13. *The Emperor Augustus.*
Roman, Tiberian period, A.D. 14–37.
Marble, H. 12 in. (30.5 cm)

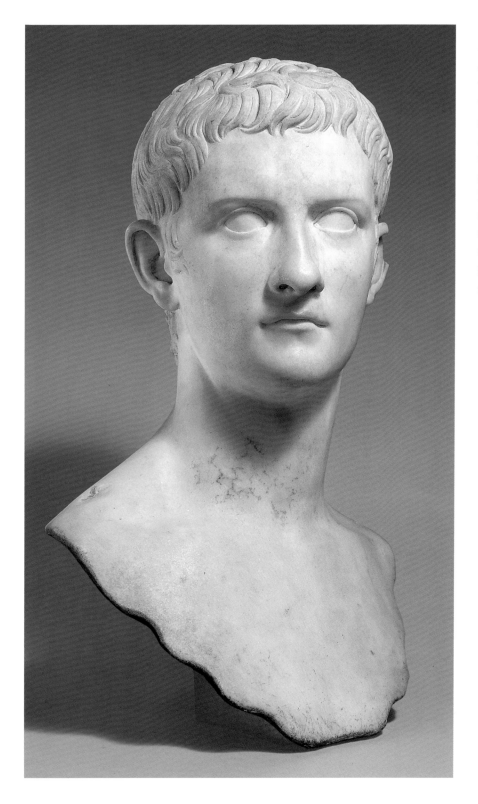

The portrait style created for Augustus was adopted by his family and immediate successors in order to stress the unity and continuity of the Julio-Claudian dynasty. This fine marble bust of the emperor Gaius Julius Caesar Germanicus, known as Caligula (r. A.D. 37–41), has regular features and carefully designed locks of hair similar to those in portraits of Augustus; here, however, the artist has also conveyed something of Caligula's vanity and cruelty in the proud turn of the head and the thin, pursed lips (fig. 14).

14. *The Emperor Gaius Julius Caesar Germanicus, Known as Caligula.* Roman, Julio-Claudian period, A.D. 37–41. Marble, H. 20 in. (50.8 cm)

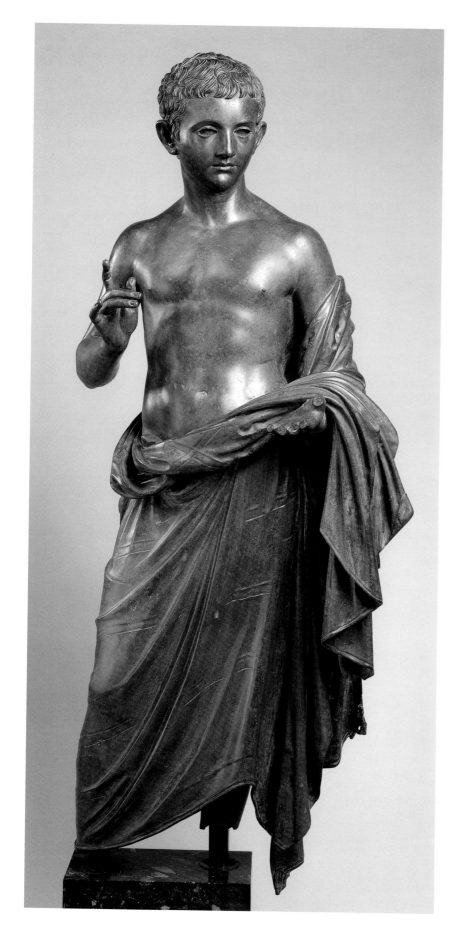

The appearance of rulers and their wives in official portraits set the fashion for men and women throughout the empire. This lifesize bronze statue of a boy with short hair, a broad face, and prominent ears (fig. 15) resembles images of young princes of the imperial house. The portrait was found on the eastern Mediterranean island of Rhodes, whose ancient Greek cities were wealthy, flourishing centers of commerce and culture during the Roman period. Although he wears a Greek himation (cloak) rather than the Roman toga, the boy may well have been the son of an important Roman official stationed on the island.

15. *Portrait Statue of a Boy.*
Roman, Augustan period, late 1st century B.C.–early 1st century A.D.
Bronze, H. 48½ in. (123.2 cm)

This powerful bronze head of a mature man also has short locks carefully arranged over the forehead (fig. 16). It bears some resemblance to known portraits of Marcus Vipsanius Agrippa, lifelong friend and supporter of Augustus. The head was found at Susa, near Turin, together with fragments of a military statue and an inscription bearing Agrippa's name.

As soon as he took power, Augustus set in motion a program aimed at restoring the time-honored values of virtue, honor, and piety. Religious cults were revived, temples were rebuilt, public ceremonies and sacrifices filled the calendar. The emperor was the chief state priest, and many statues show him in the act of prayer or sacrifice, with a fold of his toga pulled up to cover his head in a gesture of piety. The marble head seen here (fig. 17) is veiled in this manner. However, the features are so youthful and idealized and the curls so stylized that this work may represent the Genius, or protective spirit, of the living emperor rather than the emperor

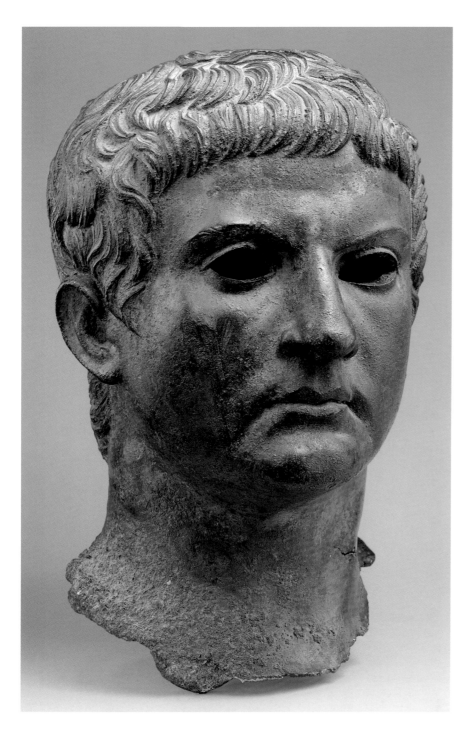

16. *Portrait of a Man.*
Roman, Julio-Claudian period, early 1st century A.D. Bronze, H. 12¼ in. (31 cm)

17. *Veiled Head of a Man.*
Roman, Julio-Claudian period, first half of the 1st century A.D. Marble, H. 10 in. (25.4 cm)

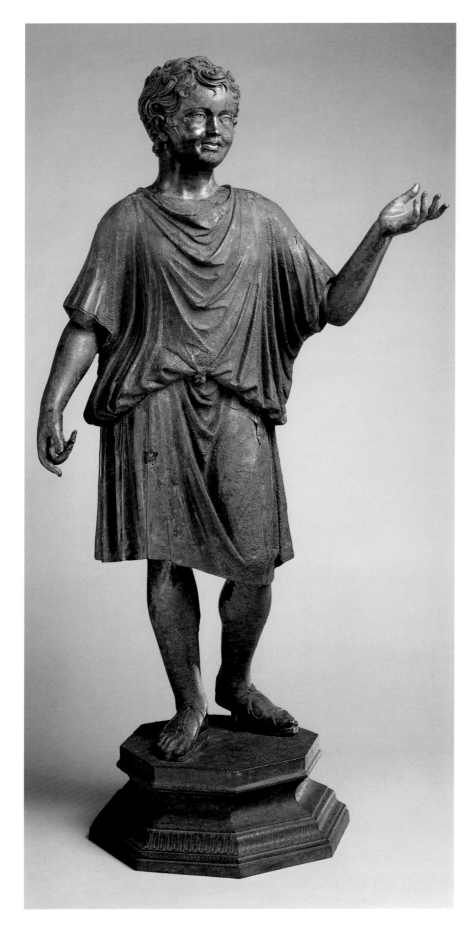

himself. Traditionally, the protective spirit of the head of every Roman household was worshiped at the family shrine. It was represented by a statuette with a veiled head, holding implements of sacrifice. Similar veneration of the Genius Augusti, introduced by the paternalistic Augustus, was widespread at public shrines and altars.

Through the promotion of old and new cults, many of them associated in some way with the ruler, bonds were created between the emperor and members of all the social classes. Throughout the Julio-Claudian period men of every rank chose to be portrayed in the act of pious sacrifice, and a popular type of sculpture represented young boys who served as acolytes at religious ceremonies. This bronze statue (fig. 18) shows such a boy, standing at ease with his left arm outstretched.

18. *Camillus (Acolyte)*. Roman, Claudian period, ca. A.D. 41–54. Bronze, H. 46⅛ in. (117.1 cm)

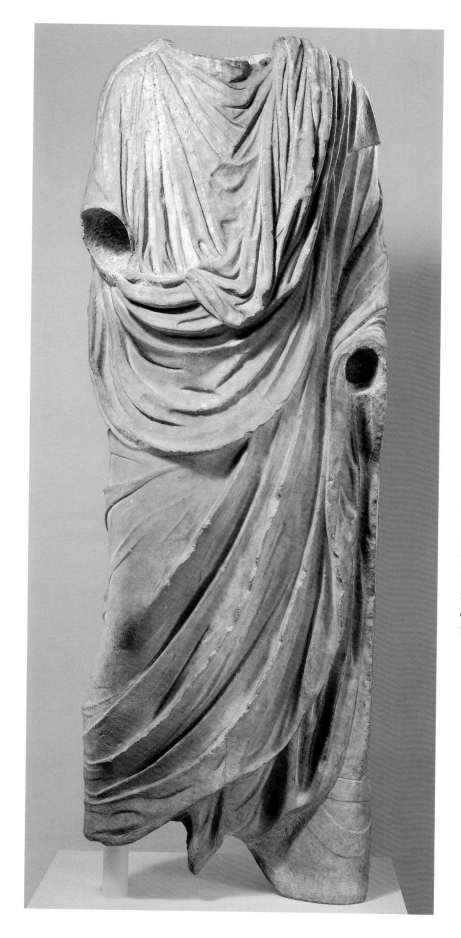

A cylindrical leather box for scrolls that stands at the feet of this figure identifies him as a man engaged in public business. He wears a tunic and over it a toga, the most characteristic Roman dress. The toga, a length of woolen cloth with rounded ends, had been the traditional garment of the Romans for centuries, but by the late first century B.C. it was declining in popularity. As part of his effort to revive ancient values and customs, Augustus made the toga a sort of unofficial state dress that all citizens were required to wear in the forum. By the late first century A.D. the toga could be worn only by Roman citizens, and Quintilian, an authority on public speaking, warned orators that improper draping of the garment might be detrimental to a budding political career. The toga seen here is draped in the same way as those worn by officials in reliefs decorating the Ara Pacis Augustae, or Altar of Augustan Peace, erected in Rome between 14 and 9 B.C.

19. *Statue of a Togatus.*
Roman, Augustan period,
ca. 14–9 B.C. Marble,
H. 6 ft. 5⅝ in. (1.97 m)

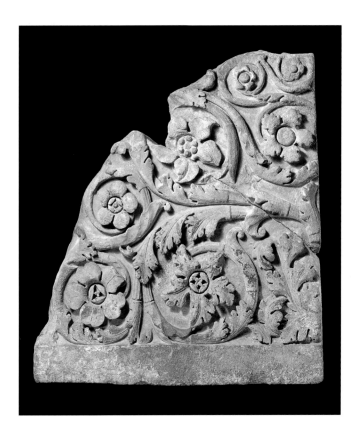

20. *Corner Acroterion*
with Acanthus Scrolls.
Roman, Julio-Claudian period, first
half of the 1st century A.D.
Marble, H. 35⅜ in. (89.8 cm)

The Ara Pacis was only one of the buildings that transformed the city of Rome during the principate of Augustus. It was customary for a general to devote part of his victory spoils to the construction of temples or public buildings, and Augustus, together with his close friend Agrippa, lavished huge sums on the improvement and embellishment of Rome. While Agrippa concentrated on practical matters that included the water system, or on amenities for the population such as free public baths, almost all the projects undertaken by the emperor served to glorify his family or enhance his reputation for piety. Imposing monuments, including his gigantic mausoleum, the temple of Apollo next to his house high on the Palatine Hill, and the lavish new Forum of Augustus with its temple to Mars Ultor (the Avenger), were highly visible additions to the city. In one generation Rome was transformed from a city of modest brick and local stone into a metropolis of gleaming marble. Quarries had recently been opened at Carrara, and for the first time in Rome's history quantities of excellent white marble were readily available.

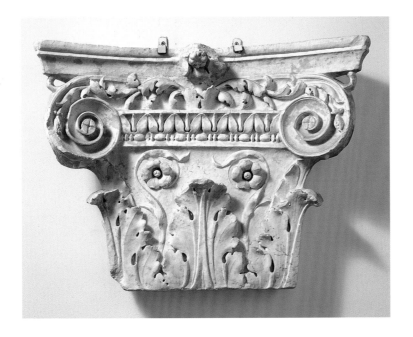

The new buildings were richly decorated on every possible surface. Even cornices, doorframes, and column bases were overspread by leafy sculpted vines loaded with fruit, flowers, and grain. The lush vegetation was inspired by Greek art of the Hellenistic period, but Augustan artists reached new heights of invention with their combinations of different plants and the intricate patterns they devised. These images of luxuriant growth became symbols of the prosperity and abundance that the programs of Augustus promised. The pair of reliefs seen on the facing page (fig. 20) once decorated the corner of a roof or high balustrade. They were set at right angles to each other, and at the corner joint a thick stalk would have emerged from a bed of floppy acanthus leaves to spread out in vines encircling huge flowers. Another acanthus plant climbs up a tall pilaster in a succession of spirals, half concealing little birds that peck at the fruit (fig. 22), while still more acanthus leaves and flowers spring from the base of a finely carved pilaster capital (fig. 21).

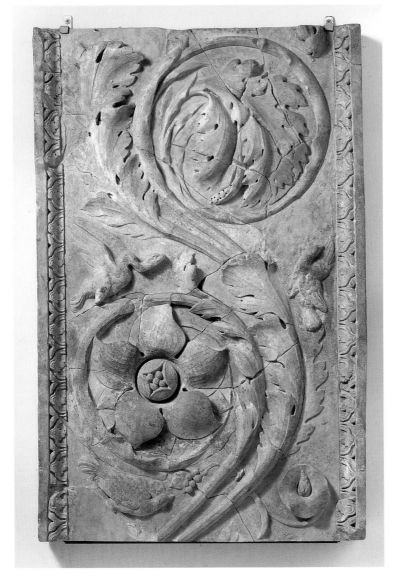

TOP

21. *Pilaster Capital.*
Roman, Julio-Claudian period,
first half of the 1st century A.D.
Marble, H. 21 in. (53.3 cm)

BOTTOM

22. *Section of a Pilaster with Acanthus Scrolls.*
Roman, Julio-Claudian period,
first half of the 1st century A.D.
Marble, H. 43¹/₂ in. (110.5 cm)

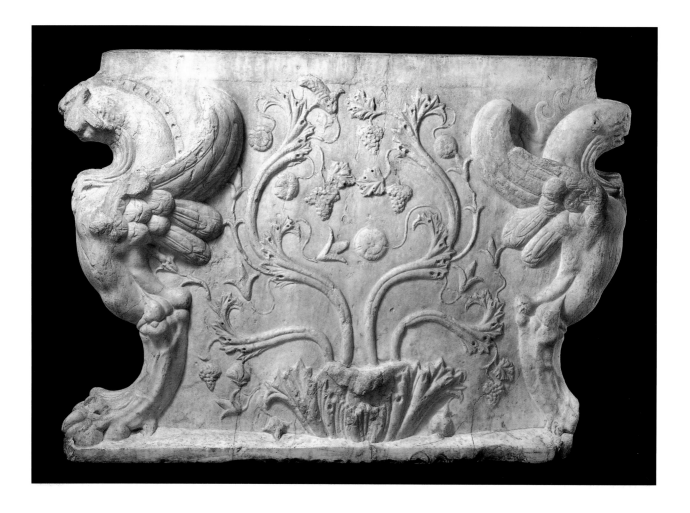

23. *Trapezophoros (Table Support).*
Roman, early Augustan period,
ca. 30–13 B.C. Marble,
H. 34⅝ in. (88 cm)

24. *Funerary Altar.*
Roman, Julio-Claudian period,
A.D. 14–68.
Marble, H. 31¾ in. (80.7 cm)

The vines and garlands that symbolized Augustan prosperity on public monuments also decorate works made for private enjoyment. This great marble *trapezophoros* (fig. 23), one of two that supported a large tabletop, probably stood in the atrium of a wealthy family's house. Its symmetrically arranged vines springing from a cluster of acanthus leaves give rise to delicate flowers and bunches of grapes, while at either end griffins stand guard. Other imagery, connected with the religious revival promulgated by Augustus, was used in the private sphere to decorate monuments such as this funerary altar (fig. 24). The inscription commemorates a certain Q. Fabius Diogenes and Fabia Primigenia, with whom he had lived for forty-seven years; the altar was dedicated by his family and freed slaves. Libations were poured over altars such as this during commemorative rituals. The heavy garland suspended from ram's heads derives from the kind of decoration found on the walls of public sanctuaries and altars. Birds of three types surround the garland, all familiar from Augustan monuments: at the center an eagle—bird of Jupiter, the ruler of the gods; at the corners swans—birds of Apollo, patron god of the emperor; and below the garland, quarreling over a piece of fruit, two songbirds—charming denizens of bountiful nature. By the time this altar was carved, some decades after the death of Augustus, these images had lost much of their public significance and become part of a common vocabulary of decorative motifs.

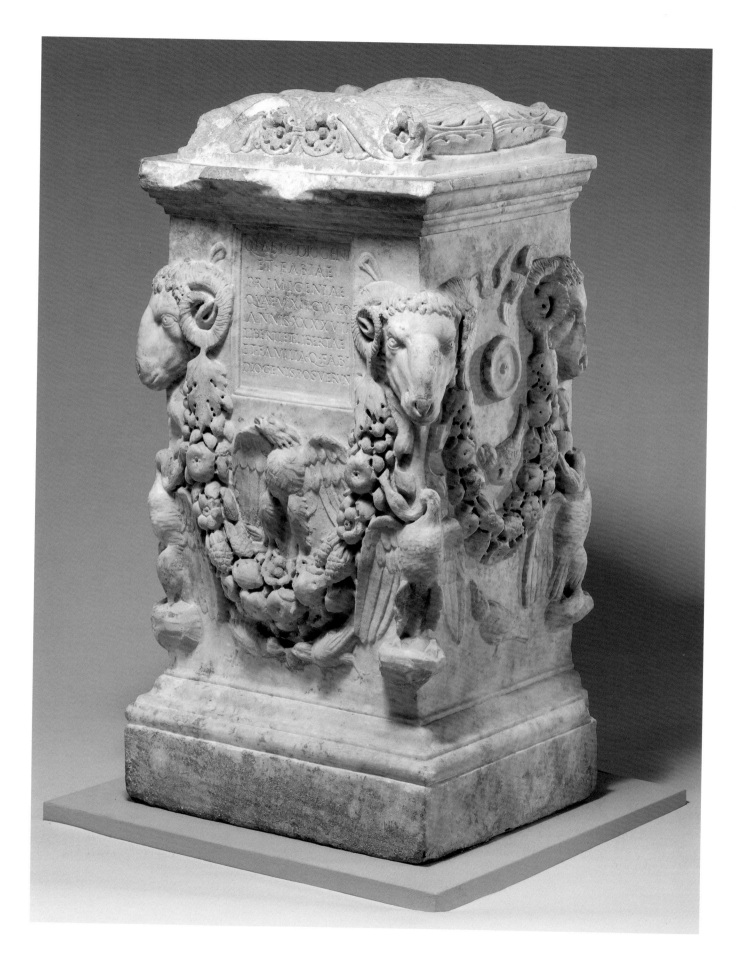

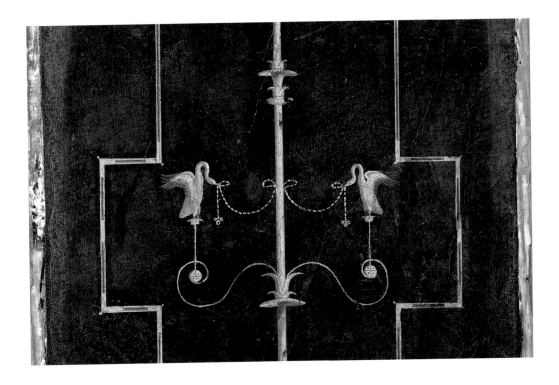

In the late fourth century B.C. the Romans started on a path of territorial expansion that within three hundred years made them masters of the Mediterranean world. Victorious generals, impressed by the wealth, culture, and beauty of the great Greek cities and by the lavish palaces of the Hellenistic kings, returned to Rome with booty that included artworks of all types. Greek teachers and artists were also brought to Rome, as privileged slaves. Soon wealthy Romans wanted to surround themselves in their homes with an atmosphere that evoked the idea of Greece and its civilization. By the late second century B.C. new objects and images were being produced in Greece and Italy that could impart the flavor of a classical gymnasium or library to a Roman gentleman's villa. There he might entertain his friends by discussing literature and art, perhaps even dressed in the Greek manner. Since these values ran counter to the austere, traditional Roman concept of virtue, a divide opened between private and public behavior. For the first time a domestic environment was specifically created for a cultural life that was intrinsically at odds with the outer world of business and politics.

Many such villas were located along the coast near Naples. One of the most sumptuous must have been the villa built by Agrippa, friend of the emperor Augustus and husband of his daughter, Julia. It stood overlooking the Bay of Naples from a spot near the modern town of Boscotrecase. The villa was partially excavated between 1903 and 1905 after its accidental discovery during work on a railway. Wall decorations that still survived in four bedrooms were removed; the Metropolitan Museum acquired sections from three rooms and the Archaeological Museum at Naples received the rest. Agrippa died in 12 B.C. and his son, Agrippa Postumus, became the villa's proprietor in 11 B.C., as inscriptions found there indicate; the frescoes must have been painted during renovations begun at that time. Painted by artists working for the imperial household, they are among the finest existing examples of Roman wall painting.

FACING PAGE, TOP
25. *Panel from the Black Room at Boscotrecase, North Wall,* detail (see fig. 27)

FACING PAGE, BOTTOM
26. *Panel from the Black Room at Boscotrecase, North Wall,* detail (see fig. 27)

The three panels illustrated here (fig. 27) come from the back wall of a rectangular bedroom, where they faced a wide doorway giving onto a terrace that overlooked the sea. As is true of much Roman wall painting, the theme is a playful rendition of architectural motifs. A low, dark red dado ran around the entire room. A narrow green band above it simulated a ledge, from which a skeleton of thin white columns appears to rise against a black background. In the center of the wall the most substantial pair support a pavilion roof, while on each side panel a candelabrum shoots up, terminating in a rectangular yellow panel with an Egyptianizing scene (fig. 25). Tiny, realistically painted swans perch improbably on threadlike spirals that emerge from the candelabra (fig. 26). Almost weightless supports set slightly behind the columns on the ledge hold up a cornice that passes behind the pavilion and the candelabra. Shallow "niches" appear to recede slightly into the surrounding space, but the architectural scheme creates almost no sense of depth or volume. The black walls behind appear at once to be flat and to dissolve into limitless space. A tiny landscape vignette floats like an island in the middle of this blackness.

This ambiguous and sophisticated decoration is a masterpiece of the so-called third style of Roman wall painting, which flourished during the reign of Augustus. While previously artists strove to create a true illusion of architectural depth, here the idea is treated whimsically with attenuated, highly refined forms. The landscape vignette derives from Hellenistic paintings, the Egyptianizing panels refer to the recent conquest of Egypt, and the swans, birds of Apollo, were popular contemporary motifs.

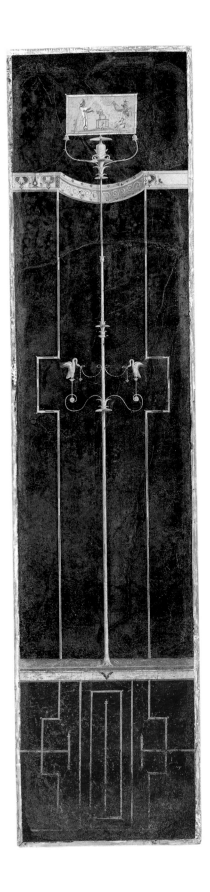

27. *Three Panels from the Black Room at Boscotrecase, North Wall.*
Roman, Augustan period, last decade of the 1st century B.C.
Fresco, H. 7 ft. 8 in. (2.33 m)

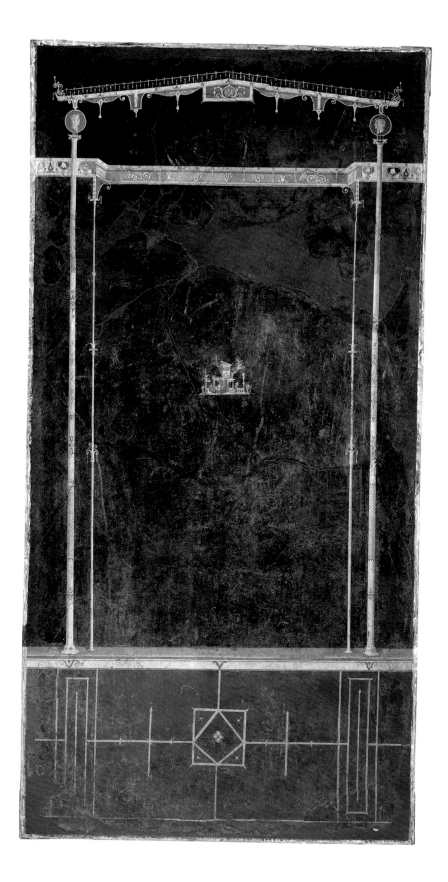
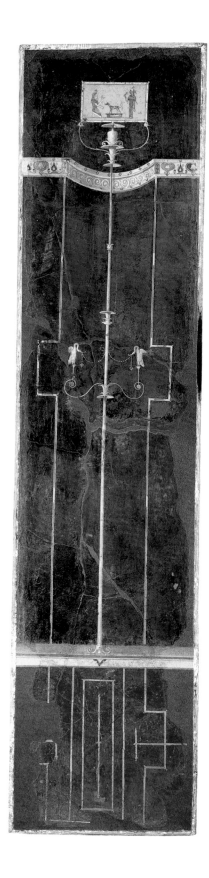

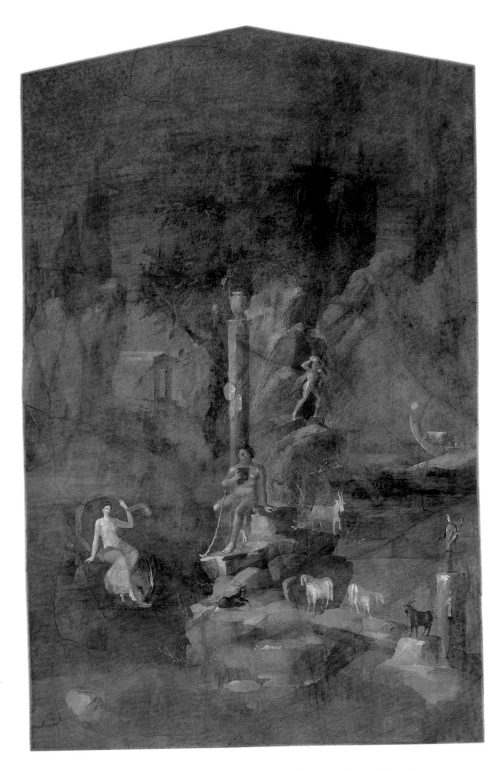

28. *Landscape with Polyphemus and Galatea from the Villa at Boscotrecase.*
Roman, Augustan period, last decade of the 1st century B.C. Fresco,
H. 6 ft. 2 in. (1.88 m)

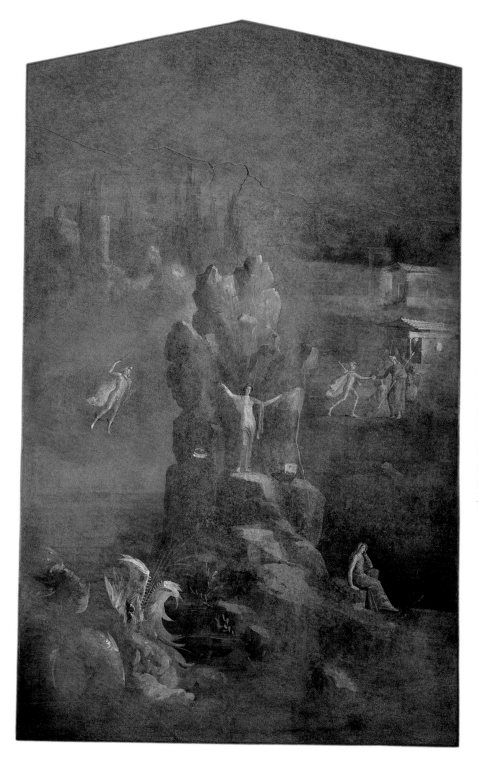

The fortunes of love and the ever-present sea are the themes linking two large wall decorations based on Greek mythology that come from another bedroom of the villa at Boscotrecase. One painting (fig. 28) presents several incidents in the story of the one-eyed giant Polyphemus. Polyphemus fell hopelessly in love with the sea nymph Galatea and was later blinded by the hero Odysseus, whose ship is seen sailing away at the far right. The other fresco (fig. 29) depicts Perseus about to rescue Andromeda (who had been chained to a rock and left to the mercy of a sea monster) and his subsequent welcome by her grateful parents. The translucent blue-green background tone of the panels unifies the disparate episodes combined in each painting and must have brought a sense of coolness to the room.

29. *Landscape with Perseus and Andromeda from the Villa at Boscotrecase.* Roman, Augustan period, last decade of the 1st century B.C. Fresco, restored H. 6 ft. 2 in. (1.88 m)

30. *Handle Attachment in the Form of a Mask.*
Roman, Julio-Claudian period, first half of the
1st century A.D. Bronze, H. 10 in. (25.4 cm)

31. *Handle Attachment in the Form of a Mask.*
Roman, Julio-Claudian period, first half of the
1st century A.D. Bronze, H. 8½ in. (21.7 cm)

Images related to Dionysos, Greek god of intoxication and ecstasy, were well suited to the luxurious and hedonistic life that wealthy Romans led in their villas. The two bronze bearded faces seen at the left (figs. 30, 31) were handle attachments for wine buckets. The wreath of ivy leaves and the fillet crossing the forehead are associated exclusively with the god of wine and his followers. The masks bring to mind archaic images of Dionysos, who until the fifth century B.C. was always shown with long hair and a beard; but their pointed, equine ears mark them as representations of satyrs or sileni, the quasi-human woodland creatures that made up the rowdy, drunken entourage of the god.

Villa gardens and peristyles (courtyards) were filled with images of Dionysos and his band of satyrs and maenads, or female revelers. This marble figure of Pan, the goat god (fig. 32), is a Roman copy or adaptation of a Hellenistic work and was probably part of a fountain complex, with water pouring from the wineskin carried on Pan's left shoulder.

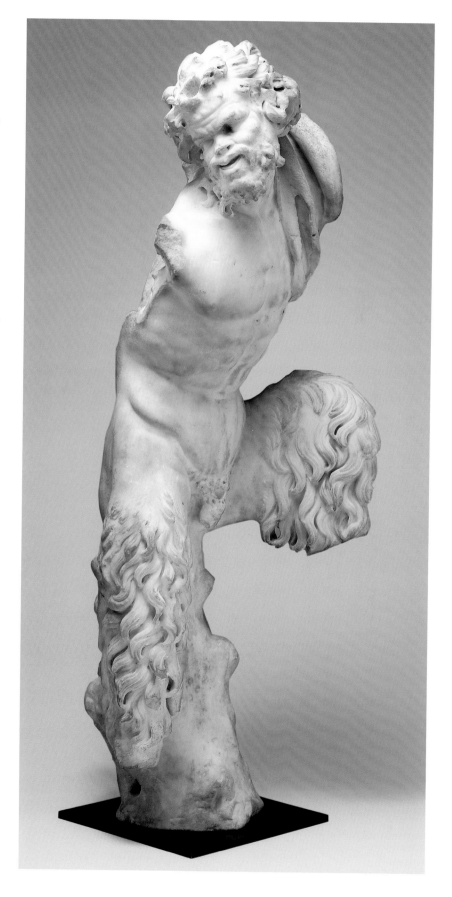

32. *Statue of Pan*.
Roman, 1st century A.D.
Marble, H. 26⅝ in. (67.6 cm)

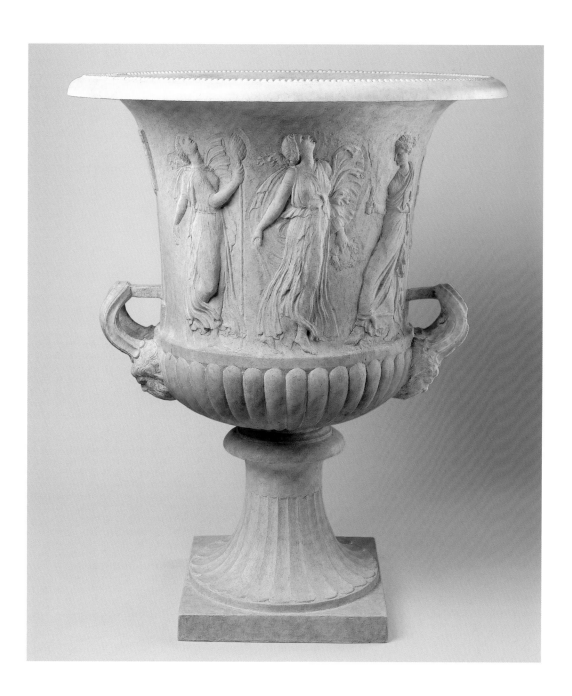

33. *Calyx Krater with Relief
of Maidens and Dancing Maenads.*
Roman, 1st century A.D.
Marble, H. 31¾ in. (80.6 cm)

Large marble vases decorated with reliefs were produced especially for such gardens. Figures drawn from a wide repertoire of classical types appear, singing and dancing, on these monumental ornaments. On one side of this vase two modestly wrapped maidens approach a girl playing a double flute, while on the other side three maenads dance in abandon to the music of wooden clappers (figs. 33, 34). Two of the maenads appear to be in a trance-like state, with their heads thrown back and their cloaks fanned out like wings. The freshness and spontaneity of these figures are partly due to the fact that the carving of the vase was never completed. The background has not been cut away to its full depth, and chisel marks on the faces and drapery remain unsmoothed.

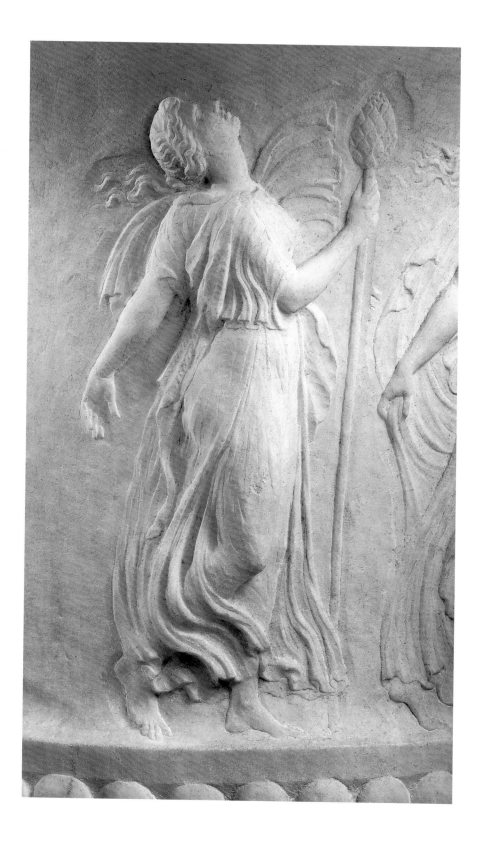

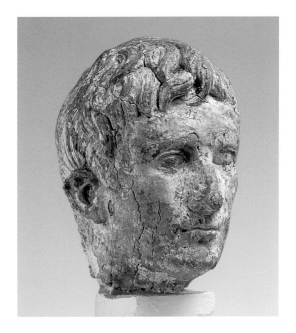

35. *Portrait Head of the Emperor Augustus.*
Roman, Augustan period, late 1st century B.C.–early 1st century A.D.
Ivory, H. 1⅝ in. (4 cm)

RIGHT

36. *Statuette of a Man Wearing a Toga.*
Roman, Julio-Claudian or Flavian period, 1st century A.D.
Jasper, H. 7⅜ in. (18.7 cm)

Augustus not only initiated a new political system but also—with his close friends, men such as the highly cultivated Maecenas—created a new cultural and artistic tradition in Rome that was intimately tied to the workings of the imperial government. While patronizing the arts, this ruling circle manipulated the talents of writers, sculptors, architects, and craftsmen to ensure that their works would promote and glorify the new regime.

Temples set up in honor of Rome and Augustus established the imperial cult as an important focus of loyalty even in distant and disparate provincial communities. But in addition to the full-scale statues of the *princeps* in bronze and marble that became ubiquitous throughout the empire, Augustus's portrait appeared on coins, gems, glass, and statuettes. The ivory head shown here (fig. 35) comes from a figure carved during the emperor's lifetime. It follows closely the official image of Augustus: neither a traditional, realistic Republican-style portrait, nor a dramatic, semidivine presentation like that of Alexander and the Hellenistic kings, but a newly synthesized portrait type that recalled the ideal of classical Greece.

The spread of "Romanitas" and of loyalty to the imperial family, key factors in the success of Roman rule, is in a way symbolized by the two other works illustrated here. The opulent jasper torso (the head and arms were probably added in another material) is from a small statue of a *togatus,* or man wearing the toga, the garment that identified him as a Roman citizen (fig. 36). Only in A.D. 212 were all freeborn men throughout the empire given the status of citizens; at the time of Augustus, citizenship was generally restricted to the inhabitants of Italy and some selected cities elsewhere and

to a few privileged individuals. It was therefore a prize eagerly sought by provincials and was granted as a reward for loyal service to Rome in either the civic or the military sphere.

The bronze portrait bust (fig. 37) has often been taken to represent one of Augustus's descendants, Agrippina the Younger, wife of the emperor Claudius (r. A.D. 41–54) and mother of Nero (r. A.D. 54–68), the last of the Julio-Claudian emperors. It is more likely, however, that the bust depicts a private individual who wished to have herself portrayed so that she resembled Agrippina—for instance, by wearing her hair in the same style. The work is one of many examples in which Roman private portraits were strongly influenced by official images of the emperor and his family, a phenomenon that points to the widely shared acceptance of and identification with the regime established by Augustus.

37. *Portrait Bust of a Roman Matron.* Roman, late Julio-Claudian period, mid-1st century A.D. Bronze, H. 9½ in. (24.1 cm)

38. *Set of Silverware*
(the Tivoli Hoard).
Roman, late Republican period,
mid-1st century B.C. Silver,
L. of ladle 6⅞ in. (17.5 cm),
H. of drinking cup 3¾ in. (9.5 cm)

Personal luxury was both condemned and eagerly pursued in late Republican Rome. After he came to power Augustus tried to curb the ever-growing desire for extravagant consumption and excessive display of wealth, but with little success; his sumptuary laws were largely ignored. Huge fortunes were expended on luxurious villas filled with furnishings and decorations of the finest quality, on lavish entertainments both public and private, and on ostentatious items of personal adornment.

Silver was avidly collected, so much so that Roman generals even took entire services of tableware with them on campaign. Sets of vessels and utensils, such as the examples shown here from the Tivoli Hoard of the late Republican period (fig. 38), were used at dinner and drinking parties. The ladle (*kyathos*) and the pair of two-handled drinking cups (*skyphoi*) bear

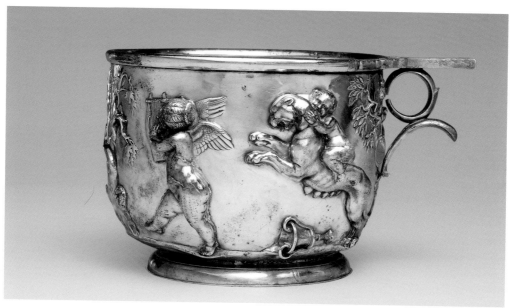

inscriptions giving the owner's name and the weight of each piece—
presumably so that a tally could be kept, and perhaps also to discourage
unscrupulous guests.

Some silverware, such as this pair of drinking cups decorated in high
relief with repoussé figures of cupids (figs. 39–41), was extremely ornate and
was clearly intended as much for display as for use. The cupids, several of
whom are shown dancing and playing instruments, may be associated with
the rites of the god Dionysos and are thus eminently appropriate on vessels
meant for a drinking party. However, figures bearing down-turned torches,
as two of the cupids do, appear on Roman funerary reliefs. This mixing
of images suggests that the figures were modeled on those in a pattern
book and have no thematic purpose beyond decoration.

TOP

39. *One of a Pair of Drinking Cups.*
Roman, Augustan period, late 1st
century B.C.–early 1st century A.D.
Silver with gilding, H. 3⅞ in. (9.9 cm)

BOTTOM

40. *One of a Pair of Drinking Cups.*
Roman, Augustan period, late 1st
century B.C.–early 1st century A.D.
Silver with gilding, H. 3¾ in. (9.5 cm)

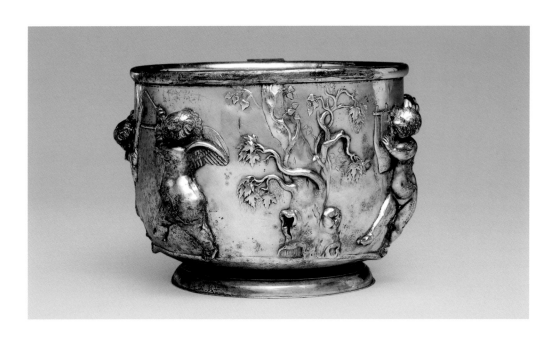

41. *Drinking Cup* (fig. 40),
side view

The two gilded cups probably belong to the time of Augustus. They find their closest parallels in two silver drinking cups from the Boscoreale Treasure—a complete set of silver tableware, 109 pieces in all, discovered in a villa outside Pompeii that had been buried by the eruption of Vesuvius in A.D. 79.

That such luxury items had a role in publicizing the social status and the material wealth of their owners is further evidenced by the frequent depiction of silver in wall paintings and floor mosaics. The cultural or political aspirations of wealthy Romans also found expression in some of the subjects chosen to decorate drinking cups, which include scenes from Greek tragedies and officially sanctioned images of imperial figures. Silver vessels thus formed an integral part of the sophisticated social milieu of Augustan Rome.

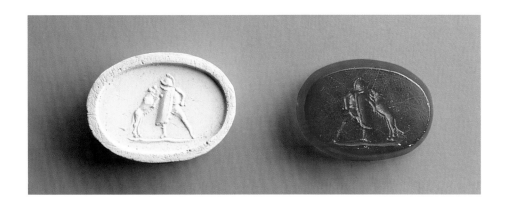

42. *Intaglio of a Gladiator Fighting a Lion.*
Roman, late Augustan to Flavian period, 1st century A.D. Carnelian,
H. 5/8 in. (1.5 cm). Shown with modern impression at left

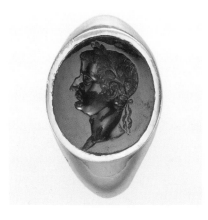

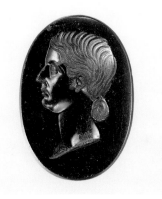

43. *Ring with Intaglio Portrait of*
the Emperor Tiberius.
Roman, Tiberian period,
A.D. 14–37. Gold and carnelian,
H. 7/8 in. (2.1 cm)

44. *Intaglio Portrait of a*
Roman Lady.
Roman, Julio-Claudian period,
1st century A.D. Jasper,
H. 1 3/8 in. (3.5 cm)

Like silverware, carved gems, often set into finger rings, were important sta-
tus symbols in Roman society. Both semiprecious stones and glass made to
look like such stones were used. Those carved in relief, often so as to display
two or more layers of color, are cameos (figs. 45–48); those engraved in nega-
tive are intaglios (figs. 42–44). Intaglios set in rings were also used as seals,
since they leave an impression in relief on the sealing.

Gems often carried portraits, but there were other popular motifs, such
as the gladiator pitted against a rearing lion seen above in an intaglio (shown
with its impression; fig. 42). Gladiatorial games, fought between opponents
or against wild animals, were held by officials to win popularity, to honor the

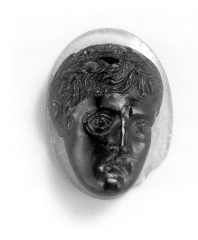

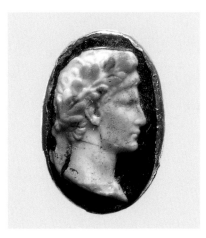

dead, or to mark a victory. In 46 B.C. Julius Caesar celebrated his triumph over the last of his rivals with lavish games that included wild beast hunts and a gladiatorial battle, staged in the Circus Maximus, between two sides each comprising five hundred infantry, thirty cavalry, and twenty elephants. Although such public entertainments were regarded with contempt by educated Romans, they were enormously popular throughout the empire. Gladiatorial combats were represented on stone reliefs, mosaics, glass (see fig. 54), and terracotta lamps as well as on gems.

Frequently gems recalled family traditions or political allegiances. According to the Roman author Suetonius, who wrote biographical sketches of Julius Caesar, Augustus, and the Julio-Claudian emperors, Julius Caesar himself was a passionate collector of gems. Under his successor, Augustus, the art of gem cutting reached its peak; the emperor's own signet ring was made by the Greek engraver Dioskourides, the finest gem artist of his time. Imperial patronage of the craft went beyond commissions for personal use, since many fine gems were presented to friends and supporters as gifts. They often bore overtly propagandistic subjects, portraying Augustus or other members of the Julio-Claudian dynasty with the attributes of semidivine beings. Such imagery could not be openly expressed in large-scale portraits, since it might offend traditional Roman values and alienate those who still hoped for the true restoration of the Republic.

The sardonyx cameo portrait (fig. 47) exemplifies this imagery: it shows Augustus as a triumphant deified being, wearing a laurel wreath and aegis and armed with a baldric and spear. The aegis, a cape usually associated with the Olympian gods Zeus (the Roman Jupiter) and Athena (Minerva), is here decorated with the head of a wind god—perhaps intended as a personification of the summer winds that brought the corn fleet from Egypt, and thus an oblique reference to Augustus's annexation of Egypt after the defeat of Mark Antony and Cleopatra at Actium in 31 B.C. The precedents for this imagery lie not in the Republican tradition of gem carving but rather in the art of the Hellenistic kingdoms, where rulers, following the example of Alexander the Great, assumed the attributes of various gods and heroes. By decree of the Roman Senate, Augustus was similarly deified after his death in A.D. 14.

Alexandria, the capital of the Ptolemaic kingdom of Egypt, became a major center for the production of cameos. The superb artistry and skill of the craftsmen who worked there under the patronage of the royal court is exemplified by the sardonyx cameo bowl known as the Tazza Farnese, now in the Archaeological Museum in Naples. After 30 B.C. some of these Egyptian gem carvers may have moved to Rome to serve new masters, taking with them not only their skills but also their allegorical styles.

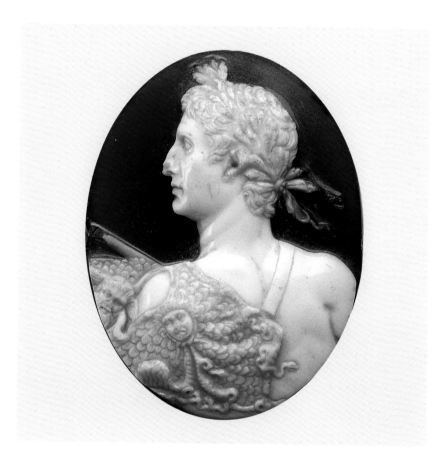

The other sardonyx cameo of Augustus (fig. 48) is said to be from Egypt. Here the emperor's portrait is in a medallion supported by a double-headed Capricorn. Suetonius records how Augustus adopted this astrological sign as his own: "He had such confidence in his destiny that he made his star public and had a silver coin struck bearing as a device the constellation Capricorn, under which he was born."

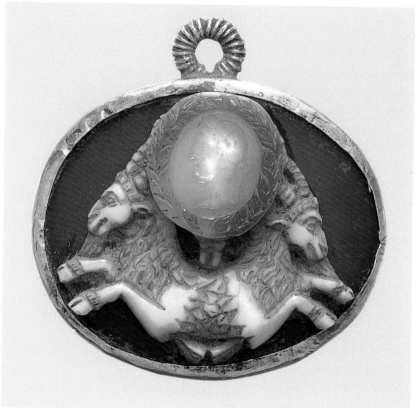

TOP
47. *Cameo Portrait of the Emperor Augustus.* Roman, Claudian period, A.D. 41–54. Sardonyx, H. 1½ in. (3.7 cm)

BOTTOM
48. *Cameo of a Double Capricorn with a Portrait of the Emperor Augustus.* Roman, Augustan period, 27 B.C.–A.D. 14. Gold and sardonyx, H. 1⅛ in. (2.9 cm)

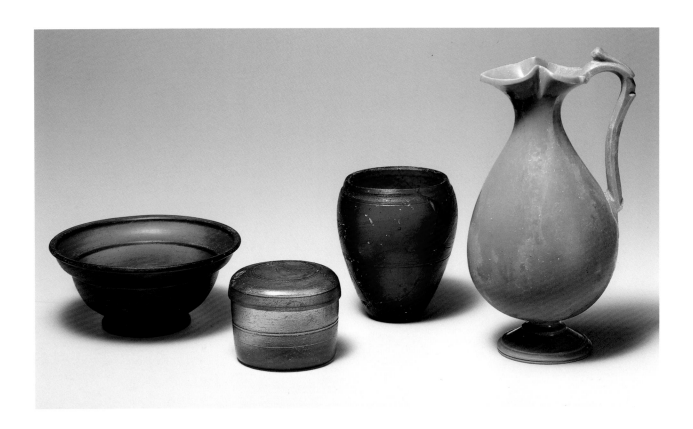

49. *Four Cast Glass Vessels.*
Roman, Augustan to Julio-Claudian
period, ca. 10 B.C.–A.D. 50.
Monochrome glass, H. of pitcher
7⅛ in. (18.1 cm)

The Romans remained relatively uninterested in and unfamiliar with glass-ware until late Republican times. The common Latin word for glass, *vitrum*, does not appear in surviving Latin texts before the mid-first century B.C., and actual finds of glass on Roman sites are extremely rare before the time of Augustus. In the latter part of the first century B.C., after the annexation of Syria and Egypt—the two main glass-producing centers of the Hellenistic world—glassworkers (*vitrarii*) flocked to Italy and set up workshops, principally in Rome itself. Suddenly glass became fashionable and much admired by the Roman aristocracy. When the Augustan poet Horace published his *Odes* in 23 B.C., he praised a spring near his country villa by describing it as *splendidior vitro* (more sparkling than glass).

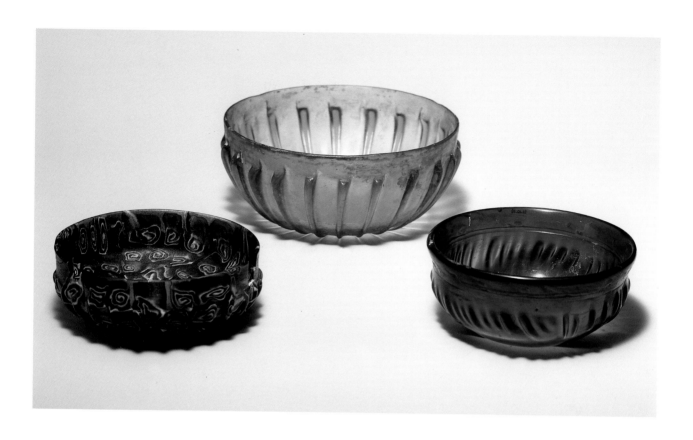

Early examples of Roman glass were made by some kind of casting technique and were then further worked and polished. Catering at first purely to the rich upper class, the newly established industry produced an array of luxury cast wares based on the forms, decorative patterns, and techniques that had been popular since late Hellenistic times. But as the manufacture of glass developed, subtle stylistic differences emerged that reflect the changing tastes and preferences of the Roman clientele. For instance, hemispherical and ribbed bowls, both monochrome and with polychrome designs, had been manufactured in the eastern Mediterranean region from about the middle of the second century B.C.; but at Rome the colors of the monochrome vessels became more vivid and translucent (figs. 49, 50), while the patterns of polychrome mosaic

50. *Three Cast Glass Ribbed Bowls.* Roman, late Augustan through Julio-Claudian period, ca. A.D. 1–68. Glass, greatest Diam. 6⅝ in. (16.8 cm)

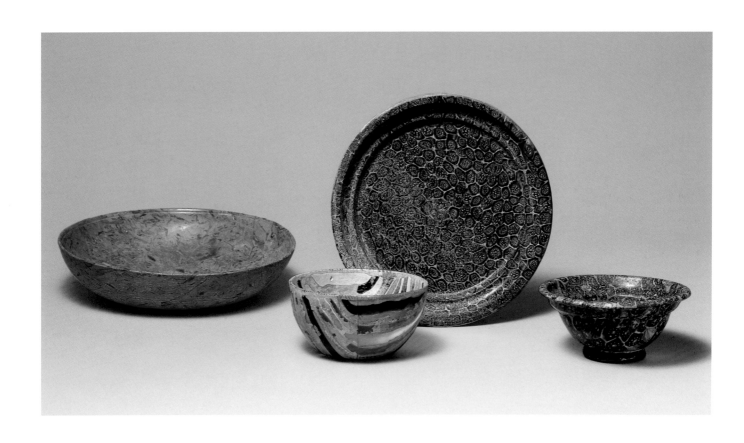

51. *Four Cast Polychrome
Glass Vessels.*
Roman, late Augustan through
Julio-Claudian period,
ca. A.D. 1–68. Glass, greatest
Diam. 6⅞ in. (17.3 cm)

glass (figs. 50, 51) became ever more varied and inventive. (Mosaic glass was produced by an elaborate process in which molten glass was drawn out into long "canes" of different colors that were bundled together. These were sliced crosswise, the slices arranged in a mold, and the whole heated until the pieces fused.) Similarly, while ribbed bowls remained popular well into the first century A.D., the Roman glass industry produced a much wider range of shapes than its Hellenistic predecessors, with many of the new forms modeled on metal or ceramic vessels. This is well illustrated by one particularly opulent type of ware, gold-band glass, for which gold leaf was sandwiched between sheets of colorless glass and combined with other canes of colored glass. In late Hellenistic times only tall, cylindrical perfume bottles (*alabastra*) were made by this process. When the Italian industry adopted the technique it found a ready market among the Roman elite for a much wider variety of small gold-band vessels—including bottles, bowls, lidded boxes (*pyxides*), and some more unusual shapes—which it produced in considerable quantities (fig. 52).

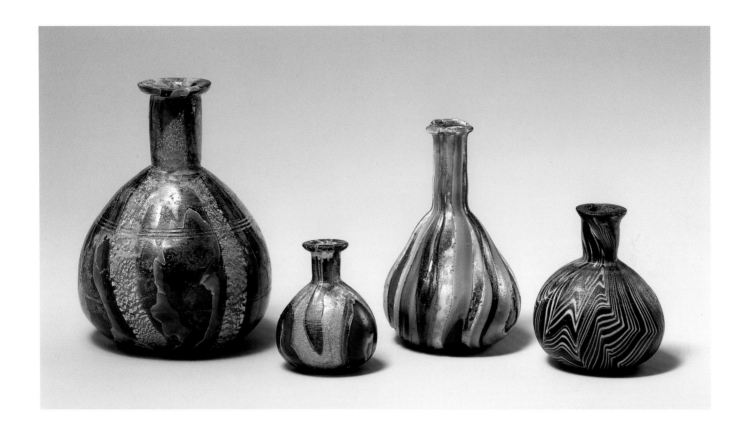

Ingenuity and experimentation characterized the early Roman glass industry, which flourished in the prosperous, secure conditions provided by the Augustan regime. Also of enormous importance was the revolutionary invention of glassblowing. This had occurred in about 70 B.C. somewhere in West Asia, probably in one of the Syrian cities, although the earliest evidence for glassblowing activity comes from excavations in the Jewish Quarter of Jerusalem's Old City. The invention was rapidly passed on to Rome by immigrant glassmakers and during the course of the first century A.D. came to dominate glass production there. A much simpler and faster process than casting, glassblowing sparked an enormous expansion in the glass industry. Even in the earliest stages Roman glassworkers created objects of outstanding technical skill and artistic merit, of which the best-known example is the Portland Vase in the British Museum, London. Of cameo glass finely carved with allegorical figures, the vessel is a masterpiece of glassblowing that was probably made in Rome in about 30–20 B.C.

52. *Gold- and Color-Band Mosaic Glass Bottles.*
Roman, late Augustan to Julio-Claudian period, ca. A.D. 1–40.
Glass, greatest H. 4⅛ in. (10.5 cm)

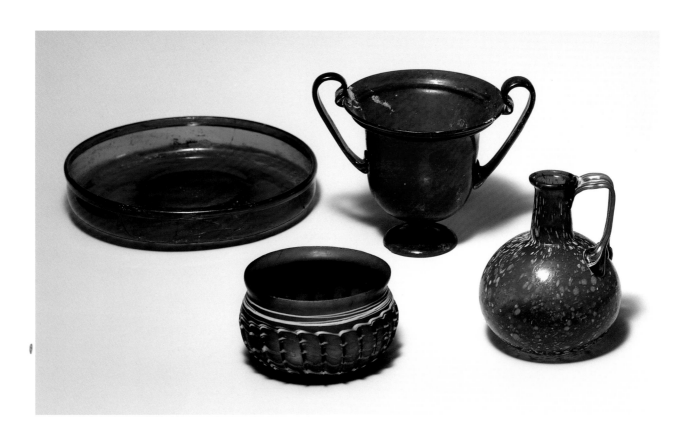

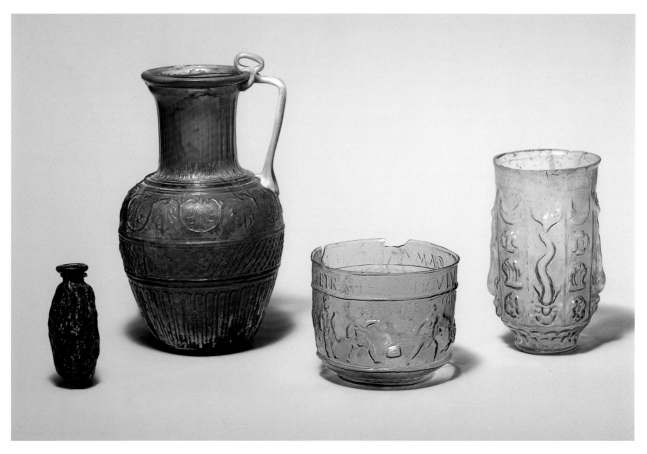

Glassblowing quickly developed in two different directions—toward the mass production of plain, inexpensive containers, such as perfume bottles, and toward the development of a wide range of decorative tablewares and luxury glass vessels for well-to-do Romans (figs. 52, 53). Soon after the invention of free-blowing, some craftsmen experimented with the new technology, combining it with techniques of glass casting and pottery molding to create a method in which glass was blown into a mold. The earliest makers of mold-blown glass probably lived in Syria or Judaea, but some of them may have moved to Italy and established workshops there. A few craftsmen put their names on the molds; the most famous and gifted of them, Ennion, was active during the early decades of the first century A.D. (see fig. 54). In some cases a form already established in cast glass, such as the ribbed bowl, became the model for free-blown and mold-blown imitations. One class of mold-blown vessels, which includes the gladiator cup illustrated here, was decorated with scenes of action in the circus or the arena, reflecting the preoccupation with public games in all levels of Roman society.

A popular type of vessel, produced in some quantity from the second quarter of the first century A.D. through the early second century A.D., was the date flask (fig. 54), made to resemble a ripe date. Several surviving examples were clearly blown using the same mold, which may have been shaped directly from an actual fruit. Date flasks were used to hold scented oils or medicines, possibly made from date extract, and may also have served as symbolic gifts. The Augustan poet Ovid refers to dates being commonly given as gifts at the New Year, and an ambassador from King Herod of Judaea is recorded as having presented Augustus with fresh dates on an embassy to Rome in 12 B.C.

Thus in the first century A.D. glass became a common household item throughout the Roman world, serving both functional and decorative purposes and appealing to a wide cross section of Roman society. Largely as a result of the invention of glassblowing, glass was cheap and plentiful for the first time. This led to the rapid development of new applications, of which glass mirrors and windowpanes—both Roman inventions—are just two examples. That glass is ubiquitous today is in many ways the direct result of the emergence of the Roman glass industry two thousand years ago.

FACING PAGE, TOP
53. *Four Free-Blown Glass Vessels.* Roman, Tiberian through early Flavian period, ca. A.D. 20–80. Glass, greatest Diam. 7⅛ in. (18 cm)

FACING PAGE, BOTTOM
54. *Four Mold-Blown Glass Vessels.* Roman, Julio-Claudian to Hadrianic period, ca. A.D. 25–125. Glass, greatest H. 7¼ in. (18.4 cm). The tall jug is signed by Ennion.

GAUL, BRITAIN, AND PANNONIA

The Roman historian Livy, writing at the end of the first century B.C., offers an account of the Celts' first encounter with the city of Rome and its citizenry, which took place in 390 B.C. The Celts approach to storm the city (an attack that Livy views as not entirely unjustified), but as these wrathful and impetuous warriors pass through Rome's open gates they are struck dumb by the magnificence of its temples and the dignity of its noble citizens. An unintended slight on the part of a Celt provokes an angry blow from a Roman, which in turn spurs a merciless attack. The Celts plunder Rome and burn its temples and homes to the ground. The attacking Celts are ultimately slaughtered by a Roman rescue force, but only after a six-month siege of the Roman citadel that leaves both captives and captors devastated by hunger and pestilence (Livy, *Histories* 5.34–50).

Livy's account was intended both as a cautionary tale and as a justification to his Roman audience of the Roman right, even obligation, to command a great empire. Its narrative force depends upon the starkly drawn contrast between the hot-headed savage and the civilized Roman. Livy's characterization of the Celts drew upon a long literary tradition: the writers of classical antiquity, who provide virtually all the contemporary descriptions of the Celts, emphasized their long hair and large size, their violent tempers, their love of gold, and most especially their military prowess. These military skills in fact made them both feared and revered, and they were much sought after as mercenaries throughout the Mediterranean world.

Archaeological finds and mentions in literature reveal that the Celts were a diverse array of autonomous regional tribes who spoke related languages and shared a similar material culture and

social structure. Between the beginning of the first millennium B.C. and the first century A.D., the Celts conquered and settled much of Europe. At their height in the third century B.C. they controlled an area that extended from the Atlantic Ocean to the Carpathian Mountains. Some of the earliest archaeological evidence for Celtic cultures dates from the sixth and fifth centuries B.C. and has been found in eastern France and western Germany along what were most likely the major trade routes connecting the Rhine, Seine, Loire, and Danube Rivers with the Rhone. Graves excavated in these areas are rich in bronze weapons and vessels, wooden chariots, gold jewelry and ornaments, and imported luxury goods that indicate trade with the Mediterranean.

By the time Livy was writing, the raids and conquests for which the Celts were infamous had radically diminished as they developed an economy based on production and exchange rather than war booty. Celtic society was primarily rural and agricultural, but as Celtic territories expanded and contact with Mediterranean cultures increased, urban sites more like those of the Roman world began to develop. By the first century B.C., Celtic territories were dotted with fortified settlements, known in Roman sources as *oppida*. These sprawling hilltop sites were conglomerations of residential, political, and administrative buildings and had streets and elaborate walled defenses. They appear to have been hubs of industrial activity, centers for storage and processing of raw materials obtained in the countryside, and important trading posts. In them coins were produced, metalwork and other handicrafts were manufactured for export, and imported goods such as wine and oil were consumed. With the rise of *oppida* the Celts moved from the barter economy of a

culture circumscribed by its regional boundaries to a monetary economy that engaged in trade with distant Celtic tribes and with increasingly influential Rome.

The first centuries B.C. and A.D. are the period in which Rome transformed itself from a republic to an empire. Much of this transformation took place at the expense of its Celtic neighbors to the north. Indeed, Rome had become the great conquering power that the Celts had been a few centuries earlier. Julius Caesar was one of a number of Roman leaders who legitimized their claims to power by conquering Celtic lands, gathering manpower, plunder, and prestige while expanding Rome's borders. In *The Gallic Wars,* Caesar famously recounted his march into the Celtic lands north of the Alps, through Gaul, and up into Britain. It was a harsh campaign that lasted from 58 to 50 B.C. The Celts of Gaul and Britain were formidable opponents who, at least according to Roman accounts, often outnumbered Caesar's forces, but ultimately they were defeated by the Roman war machine. While distant Britain would not be decisively conquered and annexed for another hundred years, Caesar thoroughly subdued neighboring Gaul, seizing its wealth and imposing heavy taxes on its inhabitants.

The general devastation inflicted by Roman occupation, along with the cultural, diplomatic, and economic ties Gaul had already developed with Rome, made it ripe for a relatively quick assimilation to Roman ways. Roman authorities encouraged the Gallic nobility to take on Roman citizenship, to assume Roman administrative and military roles, and to adopt Roman dress. The emperor Claudius even managed to convince a reluctant Roman Senate to admit Gallic noblemen into that illustrious body in 48 A.D., although the experiment was short-lived. While an *oppidum* lacked the infrastructure and tight organization of a classical city,

after Roman conquest many of these centers were able to adapt their administrative structures to fit the Roman model. Prosperous Roman cities such as Tolosa (Toulouse), Cenabum (Orléans), and Lutetia (Paris) grew directly out of Celtic *oppida*.

Celtic traditions did continue to manifest themselves in local religious practices. Native gods were worshiped alongside the Roman pantheon, which itself was often fused with foreign deities that the Romans had imported from the eastern provinces. The hybrid nature of Romano-Celtic religion resulted in new kinds of temple structures unique to this period. Even so, the many architectural and sculptural monuments in a distinctively Roman style that still stand in modern-day France make for powerful testimony to the thoroughgoing imposition of Roman culture on first-century Gaul.

Under Caesar's grandnephew and heir, Augustus, Roman armies also advanced into central Europe, ultimately making the Danube River the imperial frontier. Pannonia, a Celtic-Illyrian land wedged into the crook of the Danube as it veers to the south, was defeated by the Roman army after decades of relentless engagement that began with Augustus's capture of the strategically crucial *oppidum* of Siscia in 35 B.C. Roman conquest of the area was completed by Tiberius in 12 B.C., although in A.D. 6 the Pannonians rebelled against Roman rule. After the revolt was put down Pannonia was organized as a separate province. In a pattern typical of Roman territorial expansion, Roman soldiers and bureaucrats rapidly occupied the new province and established a Roman civil administration, while local men were drafted to serve as auxiliary detachments for the Roman army. Pannonia, like Gaul and Britain, thus came to serve as an important military province, critical for defense against the "barbarians" who lived beyond the empire's expanding borders.

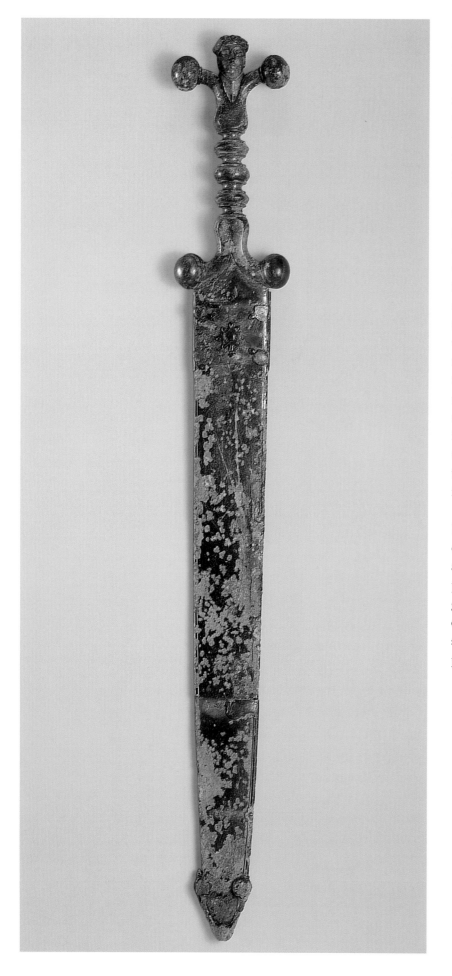

When describing the Celts, Caesar emphasized the particular esteem accorded to their warriors. This double-edged sword (fig. 55) offers its own eloquent testimony to the value the Celts placed on war and weaponry. Celtic artists often ingeniously integrated animal and human forms into the decoration of precious objects, and here the sword's hilt takes the dramatic shape of a warrior (fig. 56). The figure's head, with its carefully defined features and finely drawn curls, contrasts with the strikingly abstract limbs and body. Paired arms and legs have become V-shaped forms that terminate in round knobs, while the torso consists of three ring moldings. The scabbard, which is now amalgamated to the iron blade, still displays much of its original ornamentation, including three small incised hemispheres on the front upper end, a trilobed appliqué at the tip, and an elaborate loop at the back for attaching the scabbard to a belt.

Weapons of this type may have been thought to enhance the power of the owner, or perhaps they served a talismanic as well as practical purpose in battle. Their inclusion in graves richly outfitted with banquet equipment and parts of chariots suggests that they were the valued property of aristocratic warriors.

55. *Sword.*
Celtic, France (?), 1st century B.C.
Iron (blade) and copper alloy
(hilt and scabbard),
L. 19¾ in. (50.2 cm)

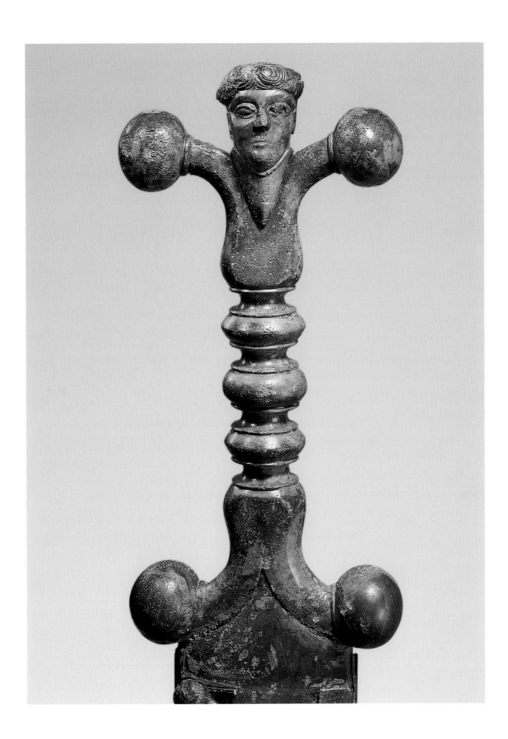

Swords with an anthropoid hilt are characteristic artifacts from Celtic Europe of the first century B.C., and some fifty examples from the period have been found in widely dispersed sites. They provide evidence of the close social and economic ties that existed at this time across broad areas of Europe among members of a battle-waging elite.

56. *Sword,* detail showing hilt

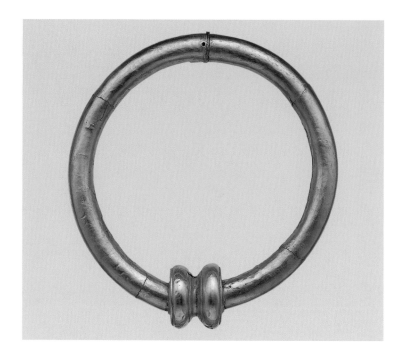

57. *Coins.*
Celtic, Belgium, 1st century B.C.
Gold

58. *Torque.*
Celtic, Belgium, 1st century B.C.
Gold, Diam. 5⅜ in. (13.6 cm)

These two torques (neck rings) and nine coins were part of an assemblage of gold objects placed in a pot and buried near a spring at what is now Frasnes-les-Buissenal in southwest Belgium, probably in the middle of the first century B.C. The simple lines and slender proportions of the small torque (fig. 58) contrast with the impressive heft and rich ornamentation of its companion. The large torque (fig. 59) is formed of sheet gold that would have been affixed to an iron core by means of beeswax and resin, and its wearer would have had to pull the two halves apart in order to place it around his neck. Elaborate repoussé decorations adorn the joins at the front of the torque; on either side of the massive terminals, a stylized ram's head is embedded in a surround of spirals, scrolls, and sinuous creatures. A simpler scroll-and-circle motif in repoussé appears on the less conspicuous join at the back.

The coins (fig. 57) are those of the Nervii and the Mornini, Celtic tribes who inhabited the locale in which they were found. Their probable date suggests that the hoard was buried in about 50 B.C., right at the time that Caesar's army was invading the area. While it is possible that the hoard was hidden to safeguard the valued objects, it seems more likely that the burial was intended as a ritual offering at a sanctuary where members of a tribe or tribes met. Hoards of gold rings and gold coins gathered and left by first-century Celts have been found at a number of sites in western Europe, usually at conspicuous locations such as near a river or spring. A torque from one hoard found in the Champagne region of France bears an inscription clearly indicating that it was part of a dedicatory offering.

On the evidence of the sculpted figures and tomb finds, it seems likely that torques were generally reserved for chiefs and warriors as indications of their social status, although aristocratic women wore them as well. It is possible that these particularly sumptuous torques, placed at a sacred site, were intended to adorn a cult statue rather than a human being.

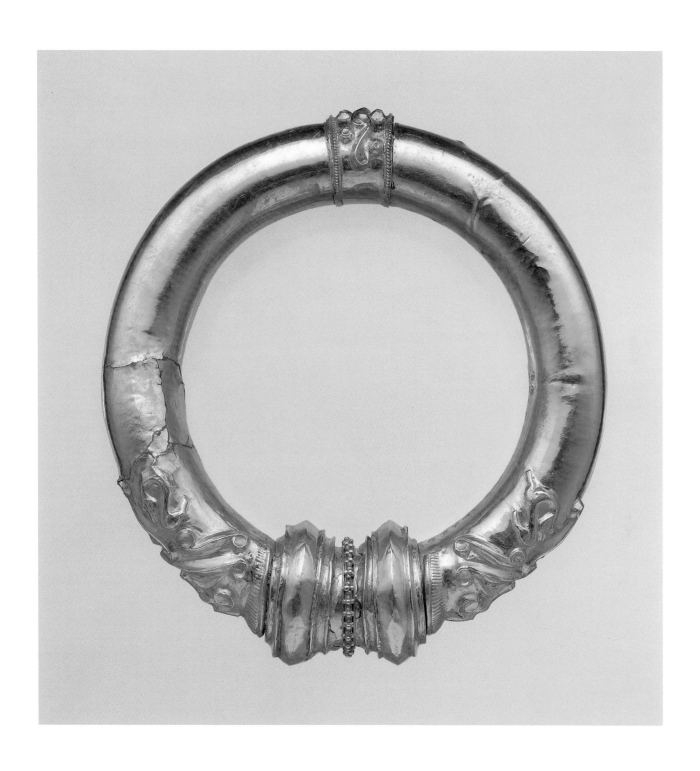

59. *Torque.*
Celtic, Belgium, 1st century B.C. Gold,
Diam. 8¼ in. (21 cm)

60. *Terret (Rein Guide)*.
Celtic, Britain, 1st century A.D.
Bronze with champlevé enamel,
H. 2¼ in. (5.7 cm)

The Celts' use of chariots in warfare was legendary in the ancient world. Classical writers including Polybius, Livy, and Julius Caesar describe the terror and turmoil wreaked upon the Roman infantry as Celtic chariots entered battle by the hundreds, all bearing spear-throwing warriors. The Celts of Britain particularly favored chariots, employing them in battle long after their counterparts in Gaul had switched to the use of cavalry. Chariots played a major role in the defense of Celtic Britain during Roman invasions in the first centuries B.C. and A.D. Archaeological evidence obtained in the excavation of numerous metalsmiths' shops of this period demonstrates that even in small communities considerable resources were devoted to the outfitting and ornamentation of these valued military vehicles.

This terret (fig. 60), made sometime around the Roman conquest of Britain in A.D. 43, comes from one of the numerous workshops then specializing in the production of richly decorated, high-quality bronze and champlevé enamel fittings for horses and chariots. To make this kind of enamel embellishment, cavities for the design were either cast into the object from the beginning or scooped out of the metal ground, then filled with powdered glass which was fused by heat. Harness mounts, horse bits, and terret rings from several regions of Britain display exuberant patterns of incised lines and brightly colored circles, fan-shapes, and commas of the same type of ornament that so enlivens the surface of this terret. The decorative effect is enhanced by the terret's distinctive silhouette, which is created by the regular placement of projecting "lips." The lips too serve as fields for ornamentation in enamel and carry reflecting patterns of dots and fans. This terret would originally have been attached to a chariot yoke, where it probably served to guide the reins of a double harness.

The wing fibula, a kind of decorative safety pin, attests to the taste for
elaborate jewelry among women in the Roman provinces during the first
centuries A.D. Used to secure a garment at both shoulders, pairs of fibulae
were an essential part of a Pannonian woman's dress, along with one or more
necklaces and a simple headdress.

The type of fastener known as a wing fibula has a wide, trapezoidal
catchplate that provides a field for elegant decoration. It derives its name from
the C-shaped wing extensions that project from the knob at the bend of the
bow. This wing fibula (fig. 61) is a particularly fine example, rare for both the
quality of its material and the sophistication of its metalwork. Wrought in sil-
ver, largely covered with gold foil, and adorned with carnelians, it displays a
variety of surface patterns. The knob is punchmarked with a zigzag design,
and a simple line of punchworked dots runs the length of the bow. Twisted
gold wire applied in straight and wavy lines accentuates the outside edges of
the catchplate, which is decorated with filigree scroll and heart motifs at its
narrow end. It broadens at the other end to include openwork patterns in sil-
ver of linked circles and linked hearts. The fibula would have been worn with
the point of the pin directed upward, allowing the delicate perforated pattern
of the catchplate to extend beyond the shoulder and catch the light.

61. *Wing Fibula.*
Provincial Roman, Pannonia
(present-day Hungary),
2nd century A.D. Silver, gold, and
carnelians, L. 7¾ in. (19.6 cm)

ROMAN EGYPT

Pharaonic culture had lasted three thousand years by the time of the Roman conquest of Egypt in 30 B.C. So stable and cohesive were the ancient Egyptian religious and artistic forms that the several waves of foreign incursion and rule experienced over the preceding millennium had largely been absorbed without producing marked changes.

With its conquest by Alexander the Great and the Macedonian Greeks in 332 B.C., however, Egypt's level of involvement in the wider Mediterranean world was raised significantly, and a strong Greek influence began to be exerted on certain aspects of the culture. After the death of Alexander, his general Ptolemy ruled, at first unofficially and from 305 B.C. officially, as Alexander's heir and the first king of the Ptolemaic dynasty. Alexander had built a new capital city, Alexandria, which turned outward toward the Mediterranean and the Hellenistic world; the Ptolemaic court itself was emphatically Greek in atmosphere and practice; Greeks and people from the eastern Mediterranean settled in Egypt in greatly increased numbers; and Greek became the principal language of administration.

Still, Egypt remained in many respects unchanged. For nearly three hundred years the Ptolemies ruled from a capital inside the country (albeit at the northernmost boundary), maintaining the traditional Egyptian order in which the king stood at the nexus of religion and culture and conscientiously continuing the observance of age-old ceremonies at the original capital of Memphis. They sought to create a powerful fusion between Egyptian cult and Greek convention by adopting the Egyptian god of fertility and rebirth Osiris Apis (Serapis) as the main deity of Alexandria and representing him as a Hellenistic father god; they were prolific builders in the traditional Egyptian style at temples such as Edfu, Dendera, and many other places.

By the mid-second century B.C., however, the Ptolemies had begun to rely increasingly on support and intervention from Rome to settle destructive family disputes. By the time Cleopatra VII, who would be the last of the Ptolemies, came to the throne in 51 B.C., Egypt was the only one of the great Hellenistic kingdoms that had not yet officially come under Roman hegemony. Cleopatra, who is reported to have been the first Ptolemy to actually learn to speak Egyptian and who paid personal attention to the rites of traditional gods, may have offered some hope of awakening Egypt's latent energies. Through her liaison with Julius Caesar and her later liaison with and marriage to Mark Antony she brought Egypt to the center of the world stage, but the drama played out to a disastrous ending in the naval battle of Actium off northwestern Greece in 31 B.C., when Antony and Cleopatra's forces were defeated by those of Octavian, who beginning in 27 B.C. would be known as Augustus.

Rome's rule over Egypt officially began with the arrival of Augustus in August 30 B.C. Egypt had a special status: it was designated the personal estate of the emperor, to be ruled by a prefect he appointed for a limited term. This effectively depoliticized the country, neutralizing rivalries for its control among powerful Romans and at the same time undermining any possible focus for local sentiments. After perhaps a decade during which a significant Roman military presence was necessary, stable conditions resulted and endured more or less for a century, encouraging economic growth.

The value of Egypt to the Romans was considerable. Revenues from the country were almost equal to those from Gaul and more than twelve times those from Judaea. Egypt's wealth was largely agricultural: its rich surplus of grain was transported across the Mediterranean in great grain ships, like

the one whose foundering during a storm is described by Paul in Acts 27.6 ff. The arrival of these ships at the Italian port of Puteoli, eagerly awaited every year, was the cause of great celebration in Rome. Egypt also produced papyrus for writing on, glass, and other luxury goods famed in the Roman era. Its deserts yielded a variety of minerals, ores, and fine stones, such as porphyry and gray granite from the edge of the Red Sea, which were brought to Rome to be used for statuary and architectural elements. Along the Nile, the desert routes, and the sea routes from the Red Sea port of Berenice, trade flourished with central Africa, the Arabian Peninsula, and India.

Soon after they had occupied Egypt the Romans followed the Nile south, attempting to solidify their influence in the rather barren region of lower Nubia, especially over its trade and gold routes. Lower Nubia was at this time controlled by the kingdom of Meroë farther south on the Nile and was particularly valued by Meroë for the access it gave to the important temple of Isis at Philae, just south of Egypt's southern border at Aswan. Seizing the opportunity provided by a military foray of the Meroites to Aswan in 24 B.C., the Augustan prefect Petronius marched far into Nubia. There he defeated the Meroitic *kandake* (ruling queen mother), perhaps Kandake Amanireinas or Kandake Amanishaketo (whose famous treasure of gold jewelry was found in 1834, still in her pyramid at Meroë), and destroyed the northern Meroitic city of Napata. In 23 B.C. a peace was declared establishing Roman authority over a restricted strip of land south of Aswan and along the Nile but leaving Meroë in control up to that point. During the reign of Augustus many Egyptian temples were enlarged or built in the occupied territory, projects partly intended to reinforce the Roman presence in the area by using the influence of the cult of Isis of Philae.

Equally significant was the impact of Egyptian arts and religion in Rome and throughout the empire. The conquest of Egypt and its incorporation into the empire inaugurated a new phase of fascination with its extraordinary ancient culture. Augustus himself had two Egyptian obelisks transported to Rome, the first of many brought there by the Romans. "Egyptian-style" architecture, statuary, and grottoes were installed in Roman pleasure parks. The cult of Isis, the Egyptian mother goddess of great magical power personally accessible through mysterious rites, had an immense impact throughout the empire. Although Isis had been worshiped in Rome since at least the mid-first century B.C., the city's first major temple for the cult of Isis and Serapis, the Iseum Campese, was probably built by Caligula (r. A.D. 34–71). Later, Domitian (r. A.D. 81–96) replaced it with a new, more magnificent one and built temples for the goddess elsewhere in Italy.

Trade goods and cultural influences flowed from Egypt to Rome through the great metropolis of Alexandria, which Diodorus of Sicily described as "the first city of the civilized world" in the first century B.C. (before Augustus's architectural enrichment of Rome). With a population derived from all around the Mediterranean, Alexandria was vibrant and dazzling, a city of synthesis and cross-fertilization but also of volatile factional tensions. Its architectural magnificence begins to reemerge in some measure through recent excavations, including underwater excavations in the harbor—where stone blocks from the lighthouse of Pharos and huge statues, apparently thrown down by earthquakes or perhaps moved there to strengthen the breakwater, have been rediscovered. Alexandria's great libraries and its community of writers, philosophers, and scientists, the most famous at this time perhaps being the hellenized Jewish philosopher Philo, were renowned throughout the ancient world.

Outside Alexandria, the change to Roman rule was probably very little felt by Egypt's population. Augustus and the first-century Roman emperors represented themselves as the successors to the pharaohs and continued to build temples in Egyptian style with no conspicuous break from the Ptolemaic era, although the relative austerity of architectural models from early in that period was favored over the exuberant forms of late Ptolemaic temples. Most of the surviving temples and chapels of the Roman era in Egypt's Nile Valley are south of the Fayum (the agriculturally rich oasis that joined the Nile Valley below the delta). Others were built in outer regions like the western oases or lower Nubia, where the demonstration of a continued presence was strategically important. The ancient, powerfully compelling Egyptian funerary religion was little changed: the dead were still mummified, attended in the passage to the next world by the canine-headed Anubis, and identified with Osiris. The age-old agricultural character of the economy was a constant. Nor did the composition of the elite alter substantially; it remained a group of mixed background, both "Greek" (descendants of Ptolemaic soldiers from Greece and the eastern Mediterranean area who had been settled mostly in the Fayum) and Egyptian.

Still, changes had been instituted intentionally and unintentionally by the Romans, and, perhaps as a result, transformations of traditional artistic and religious forms seem to have

accelerated. The many written records on papyrus that survive from Roman Egypt provide evidence that temple revenues and priesthoods were brought under stronger state control; that new structures of government formalized the privileges (and duties) associated with "Greek" background; and that there was a new emphasis on private property, accompanied by new incentives for private gain. In the visual arts, the long-standing practice of placing stone statues of officials in temples virtually evaporated, and Egyptian gods (except possibly for funerary gods) were increasingly presented in Hellenistic style. Most remarkably, the funerary arts evolved in a new and creative direction. The traditional Egyptian idealized and timeless images of the deceased that were made for attachment to mummies gave way to images incorporating contemporary Greco-Roman styles of hair and dress as influenced by fashions of the imperial court at Rome. Particularly arresting are the panel portraits painted in the illusionistic Greco-Roman style and in the Greek encaustic technique (pigment mixed with beeswax).

Egypt of the first century A.D., then, functioned in the Mediterranean world as an active and prosperous Roman province. The culture remained distinctly individual, with its ancient traditions still serving as the basis of religious belief and artistic creativity, but it was also capable of producing new amalgams that incorporated influences from Greco-Roman culture with fresh intensity.

The great goddess Isis was especially venerated by the Nubians at her temple at Philae, on Egypt's southern border. Several traditional Egyptian temples to the goddess and to associated gods were constructed under the Romans in the part of lower Nubia that they controlled, along the Nile south of Philae. The temple of Dendur, built by the Augustan prefect Petronius about 15 B.C., is one of these (fig. 62). It was dedicated to Isis, Osiris, and two locally deified figures, Pedise and Pahor.

Originally the tiny temple was built against a cliff and facing the Nile. A chamber cut into the rock behind it may have been the tomb of Pedise and Pahor. The large gateway at the front was connected to a now-missing brick surrounding wall; then came a courtyard, and then the temple itself (fig. 62). The structure is made up of a modified pronaos (porch) fronted by two columns partially connected to the sides by screen walls, an offering hall, and a sanctuary. A crypt, probably meant for the storage of sacred images, is built into the rear wall.

Before the temple enclosure was a broad, flat cult terrace, a frequent feature in the Ptolemaic and Roman periods. The divine images could emerge onto the cult terrace to view their territory or to greet a visiting deity. It may be that in addition to the temple priests, members of certain religious societies had the right to gather there.

The wall decoration of the offering hall and sanctuary is unfinished, although a small relief scene carved on the back wall of the sanctuary shows Pahor and Pedise worshiping Isis and Osiris. Holes along either side indicate that the scene may have been covered by wooden doors, which would have been opened for cult observances. The pronaos, the temple's exterior, and the gateway are decorated with reliefs depicting Augustus, as pharaoh, making many kinds of offerings to the gods of the temple and to associated gods, including Meroitic deities such as Arsenuphis and Mandulis. The reliefs are sculpted in a somewhat subdued version of the late Ptolemaic style, with plastic modeling of the figures and dense columns of inscription.

The temple, which would have been permanently covered by water when the Nile was dammed to form Lake Nasser, was removed from its original position by Egypt's Department of Antiquities in 1963.

FACING PAGE
62. *Temple of Dendur*.
Egypt, lower Nubia, ca. 15 B.C.
Sandstone, H. 21 ft. (6.4 m)

ABOVE
63. *Temple of Dendur* in situ,
ca. 1865–85. Photograph by
Antonio Beato

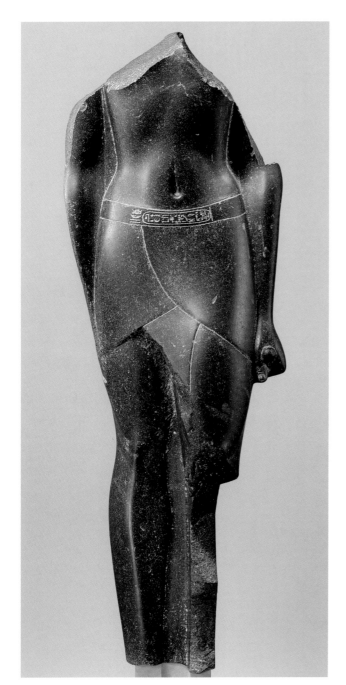 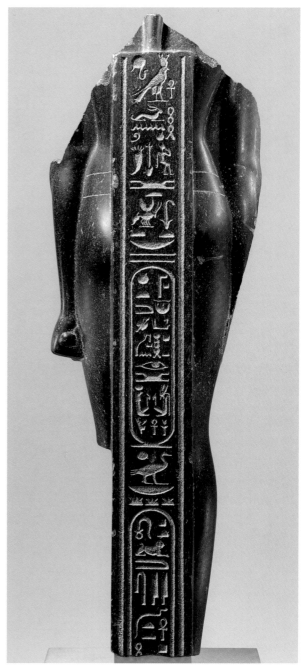

64, 65. *Torso of a Ptolemaic King
Inscribed with the Cartouches
of a Late Ptolemy,*
front and back views. Egypt,
80–30 B.C. Dark basalt, H. 36⅝ in.
(93 cm)

The two statues seen here share a general way of rendering the structure of
the human torso that has its origins in the fourth century B.C. Beneath the
full breast the rib cage slopes back to a flat abdomen from which rises a
round, fleshy stomach with a teardrop-shaped navel. The hips are delineated
by a long curve that extends from waist to knee. Sculptural traces indicate
that each work showed a king wearing the pharaonic *nemes* headdress. The
emphatic energy conveyed by the inscribed statue in particular (figs. 64, 65),
with its very high buttocks, long thighs, clear modeling, and taut, low-slung
belt, suggests freshness and youthfulness.

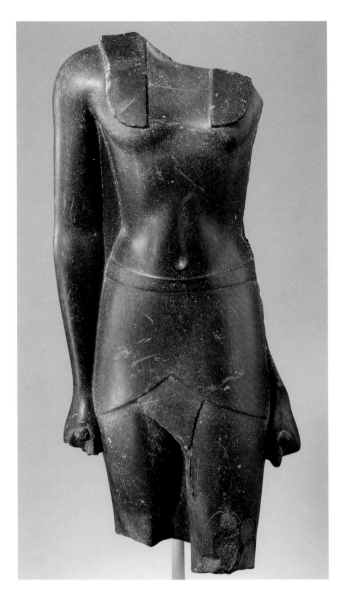
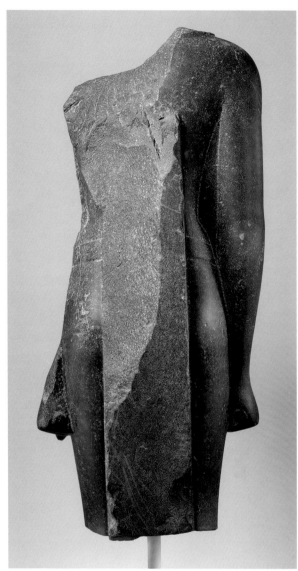

66, 67. *Torso of a Ptolemaic King*,
front and back views. Egypt,
332–30 B.C. Dark basalt, H. 31⅛ in.
(79 cm)

While the uninscribed statue (figs. 66, 67) probably dates to the Ptolemaic period, when for unknown reasons inscriptions were often omitted from statues, the other statue actually bears in the cartouches names known for both Ptolemy XII and XV. (Ptolemy XIII and XIV, whose formal names are poorly known, are other kings possibly represented by the statue.) Ptolemy XII, called Auletes, was the father of Cleopatra and of Ptolemy XIII and XIV, two very young brothers with whom she successively shared the throne before sharing it with her son Ptolemy XV (Caesarion) from the time he was three. Either Auletes, who built extensively in Egypt, or Caesarion, whose status was promoted by his mother, is most likely to be depicted here.

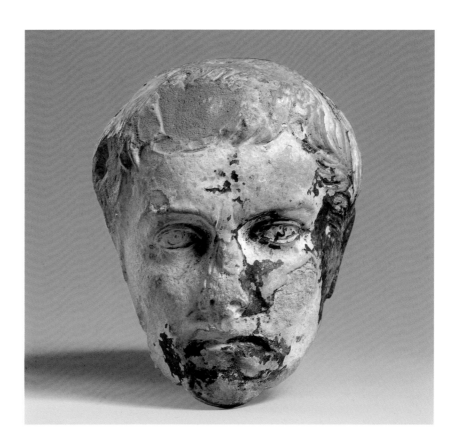

68. *Head of Augustus.*
Egypt, said to be from Memphis,
30 B.C.–A.D. 14. Faience,
H. 2⅝ in. (6.8 cm)

Octavian (soon to be known as Augustus) was only thirty-three when he defeated Antony and Cleopatra at Actium on the coast of Greece in 31 B.C. Ten months later he was in Egypt for the first and last time when he led his troops against the couple, who had withdrawn to Alexandria. He stayed only a few weeks, long enough to be there for the suicides of Antony and Cleopatra and to do away with Caesarion (Ptolemy XV), Cleopatra's seventeen-year-old son by Caesar. The victor was dismissive of Egyptian religious traditions, refusing to visit the sacred Apis bull at Memphis, the ancient religious capital, with the caustic comment that he was accustomed to worshiping gods, not animals.

For political reasons, however, Augustus was soon reconciled to Egypt's religion and had himself represented repeatedly in temple reliefs in the role of pharaoh, as at Dendur, with his Roman name and imperial titles written in hieroglyphs inside the royal Egyptian cartouche.

This small head (fig. 68), said to be from Memphis, may have been a dedication connected with the cult of Augustus known to have existed in that city. The portrait considerably postdates his conquest of Egypt, since it shows him as an older man: the slightly loose flesh of his face is drawn into furrows between the brows, and lines stretch from the corners of his nose toward the mouth. Memphis, an important port for Upper and Middle Egypt and the Fayum, was also a crafts center. Remains of late Ptolemaic and early Roman faience workshops were excavated there between 1908 and 1913 by Flinders Petrie.

Philae, an island in the Nile at Egypt's southern border, was a major cult site of the goddess Isis and also included temples to associated gods. Probably during the reign of Claudius, a temple was built to Harendotes, or Horus the Avenger (of his father Osiris). The original temple was square with a pronaos containing one row of four columns, between which were screen walls. The walls were carved on the outside with relief scenes; above them was a cavetto cornice and above that a uraeus (royal cobra) frieze. On the inside of the walls were other relief scenes. The temple was dismantled in Byzantine times and the stones were reused as building blocks in a nearby church.

This block from a screen wall (fig. 69) was located at the level of the cavetto cornice, which may be seen on its outer side. The side illustrated here faced the interior of the temple. The lower part of an inscription, including the king's cartouche, and part of a ritual scene are preserved: the ibis-headed god Thoth pours a libation over the head of the pharaoh, seen at the right wearing the cap crown. A stream of ankh and *was* signs flows forth, symbolizing life and dominion.

Raised relief that projects markedly from the back surface is characteristic of works of the late Ptolemaic and Roman periods. Here the tumid relief surface is relatively unmodeled, although attention is given to fine details like the corner of the king's mouth and the soft flesh surrounding it.

69. *Relief Showing the God Thoth and Pharaoh.*
Egypt, Philae, probably Claudian period, A.D. 41–54. Sandstone, W. 24 in. (61 cm)

70. *Crocodile.*
Egypt or Rome, 1st century B.C.–
1st century A.D. Red granite,
L. 42½ in. (108 cm)

Associated with the lush banks of the Nile and the rich swamp environment, crocodiles seemed to the Egyptians to incorporate the dual powers of creation and destruction. In the fertile, agricultural Fayum basin, which was heavily populated in the Ptolemaic and Roman periods, the animals were widely revered as a manifestation of the creator god Sobek. In their role as representations of creative forces, crocodiles also accompanied great deities like Isis.

Already during Hellenistic times and particularly during the Roman period, the cults of Serapis and Isis spread throughout the Mediterranean, along with a general interest in Egypt. Sanctuaries to those gods and other buildings in Italy were adorned with appropriately evocative reliefs and statuary. These could be brought from Egypt, carved on the spot by Egyptian sculptors in stone shipped from Egypt, or purely local work but rendered in an "Egyptianizing" style. The crocodile seen here (fig. 70) is of Egyptian granite, and the apt characterization of the animal almost certainly indicates that it was carved by an Egyptian sculptor. However, a very similar crocodile sculpture was found on the premises of the main Isis sanctuary in Rome, the Iseum Campese, and it is possible that this crocodile too adorned a Roman Isis sanctuary.

This palm (joining piece) of a ceremonial fan depicts a royal baldachin on top of a papyrus umbel (fig. 71). Sockets for three ostrich plumes are on the back. The lower end of the palm fitted onto a long staff.

The baldachin consists of two slender lotus-bundle columns, perhaps copied from New Kingdom paintings, which support a cavetto cornice topped by a uraeus frieze. The cavetto is decorated with a winged sun disk. In openwork below, a pharaoh is enthroned on a small platform flanked by crouching lions. Goddesses with human and lion heads hold feathered fans on either side of him.

Royal cartouches appear just below the cornice, at the right. Although the names do not make sense, the signs in one cartouche could be a poor copy of one of the names of Amenemhat III of the Twelfth Dynasty (ca. 1844–1797 B.C.). This king was revered as the first to reclaim arable land from the Fayum swamps. He was buried in the Fayum area, at Hawara, in a pyramid accompanied by a huge temple, whose ruins were admiringly known by Greeks and Romans as the Labyrinth. In the Roman period the surrounding area became a popular burial site. This fan might have been used in a temple at nearby Arsinoë, capital of the Fayum.

71. *Palm of a Ceremonial Fan.*
Egypt, 1st–2nd century A.D. Bronze with gold and glass inlay,
H. 4¾ in. (12 cm)

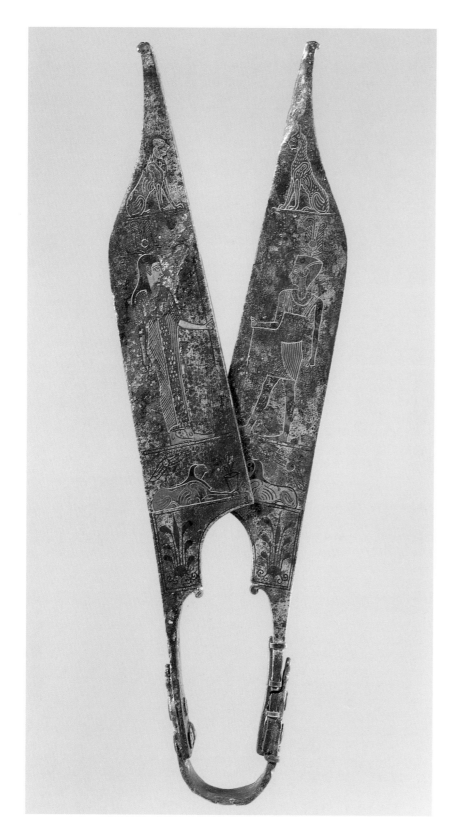

On each side the decoration of these shears (fig. 72) is divided into three registers. The top register contains a cat and dog (a cat and lion on the side not shown); the center fields display a god and a goddess in plumed crowns; and at the bottom two falcon-headed sphinxes recline (human-headed on the side not shown). All the paired figures face each other. A delicate vegetal motif decorates the blade just above the join to the handle.

A combination of vague iconography, attenuated drawing, and dour expressions marks this very elaborate piece as being in an "Egyptianizing" rather than actual Egyptian style. The reputed provenance of the object is on the southeastern shore of the Black Sea—an area under Roman control—where perhaps it served a ritual function at some richly endowed Isis sanctuary. Traces of Isis worship have been noted at hundreds of sites throughout the vast reach of the Roman Empire, as far north as Britain and even as far east as Afghanistan.

72. *Shears.*
Said to be from Trabzon, northeastern Turkey (ancient Trapezus), perhaps 1st century A.D. Bronze inlaid with silver and probably black copper, H. 9⅜ in. (23.7 cm)

Identifications between Egyptian and Greek gods were often made by the mixed population of Ptolemaic and Roman Egypt. This tall, sensuously modeled, and delicately painted figurine (fig. 73) represents Isis-Aphrodite, a form of the great goddess Isis emphasizing the fertility aspects associated with Aphrodite. Although otherwise nude, she wears elaborate accessories, including an exaggerated *calathos* (the crown of Egyptian Greco-Roman divinities) emblazoned with the sun disk and horns of Isis.

Figures of similarly bedecked goddesses are found throughout the Greco-Roman world and are associated with generally female concerns such as marriage, conception, and birth. The Egyptian version is distinguished by its compressed, upright, frontal pose and by its having sometimes been placed in burials. These facts suggest a direct relation to anonymous female figurines of dynastic times, whose efficacy extended to rebirth after death and applied to men and women alike.

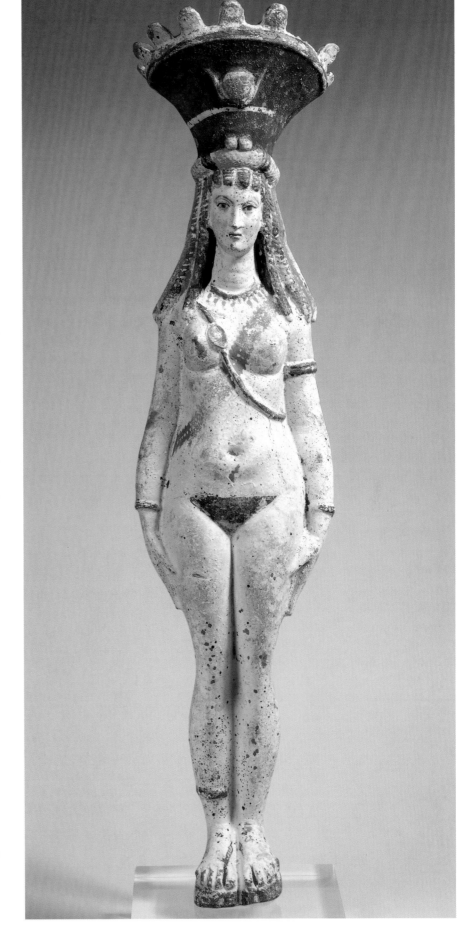

73. *Isis-Aphrodite.*
Egypt, 2nd century A.D. Terracotta, white engobe, and paint, H. 19½ in.
(49.5 cm)

Harpokrates, or "Horus the child," the son of Isis and Osiris/Serapis, is here represented as a chubby toddler with a plump, crooked forefinger reaching toward his small mouth (fig. 74). He holds the knobby club of Herakles and on his head wears a vestigial double crown detailed with striations and dots. The crown is obscured in the front by a very large sun disk bearing a uraeus. A rarely noted deep blue corrosion gives the piece a rich tone.

Harpokrates, the quintessential divine son, was extremely popular and had already been assimilated to other gods during pharaonic times. During the Hellenistic and Roman eras the syncretisms multiplied. The association of Harpokrates with Herakles in these eras seems to be based on warrior characteristics that Harpokrates had acquired in earlier conflations with other deities. Once Roman rule came to Egypt the worship of Harpokrates spread throughout the empire, so it is possible that the unusual details of the god's crown and disk denote a non-Egyptian origin.

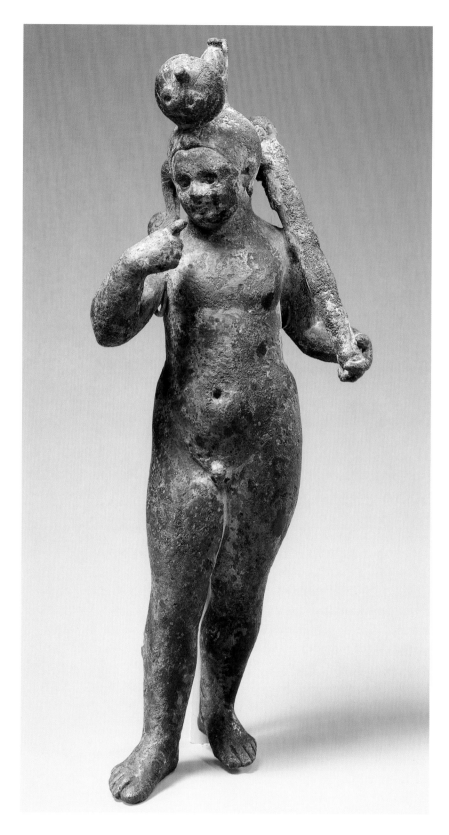

74. *Harpokrates.*
Egypt, perhaps 1st century A.D. Bronze, H. 7¼ in. (18.5 cm)

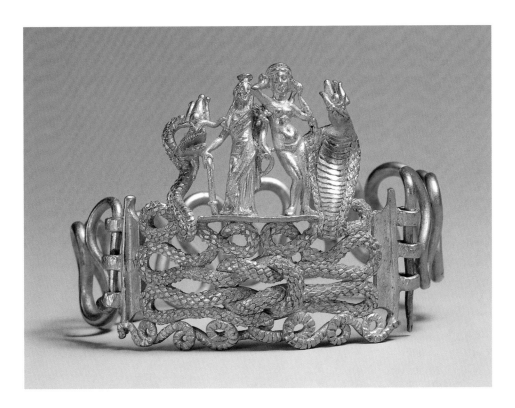

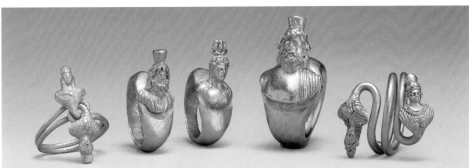

The centerpiece of this bracelet (fig. 75) consists of the bodies of two snakes intertwined to form a Herakles knot. The snake on the left wears the *atef* crown and represents Agathodaimon, while the cobra on the right wears the double feathers, disk, and horns of Isis and represents Terenouthis. The two are agrarian/fertility deities associated with Serapis and Isis. On a small platform between them stand two goddesses. One is Isis-Tyche (or Isis-Fortuna), a deity closely associated with the city of Alexandria; she is identifiable by her crown, the cornucopia frequently carried by Hellenistic Egyptian goddesses, and the rudder she grasps, symbolic of Alexandria's maritime prominence. The nude figure is Aphrodite. Talismanic powers of fertility and favorable destiny are evoked by this group. The body of the bracelet is hinged to the centerpiece at one end, and the other end acts as a pin to close the bracelet. Hinged bracelets with figural imagery like this one are very rare.

In the group of rings (fig. 76), three thick, cast examples carry a bust of Serapis or Isis mounted on the bezel. Busts of Isis and Horus or possibly Serapis form the terminals of the coiled wire rings.

TOP

75. *Bracelet.*
Egypt, probably 1st century B.C.–
1st century A.D. Gold, H. 1½ in.
(3.9 cm)

BOTTOM

76. *Group of Rings.*
Egypt, probably 1st century B.C.–
1st century A.D. Gold,
greatest H. 1¼ in. (3.2 cm)

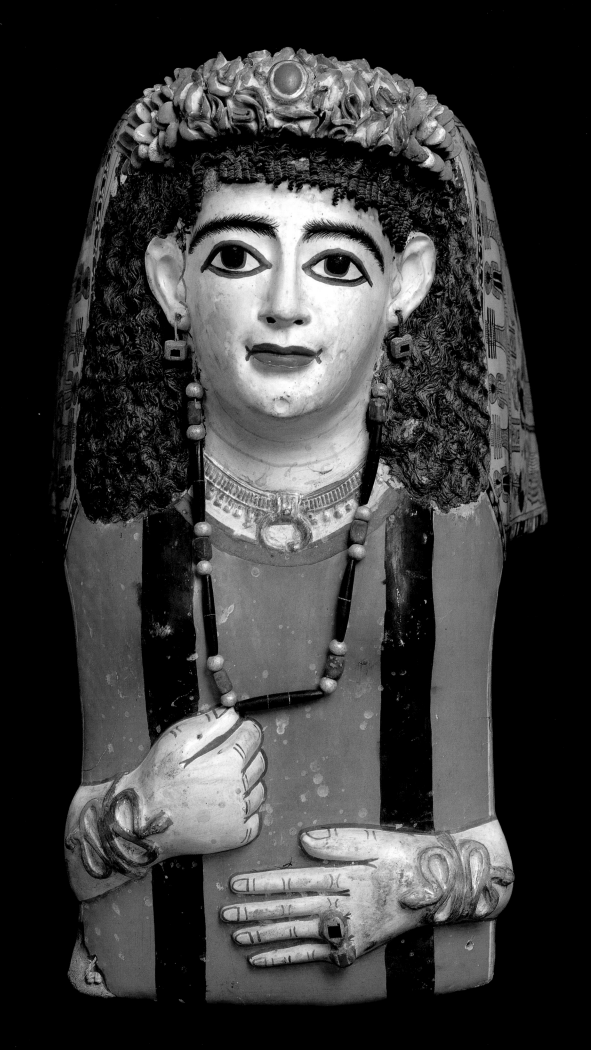

Coverings and coffins made for mummies in Roman Egypt took a variety of forms that were to some degree expressive of regional preferences, although virtually all showed the influence of Roman fashion and dress. Mummy masks like this one (figs. 77–79) derive from pharaonic prototypes and in Roman times were particularly popular in Middle Egypt.

The woman is represented as if lying flat upon her bier. She wears a long Egyptian-style wig made of flax, papyrus, and other plant fibers. Attached to the wig is a thick garland of white plaster rose petals tipped in pink. She is dressed in a deep red tunic with black vertical bands known as *clavi*. One of her necklaces includes a crescent pendant, an ornament often worn by women of Roman Egypt in the first century A.D. Her elaborate snake bracelets probably represent the benevolent serpent of the Greek healing god Asklepios rather than the Egyptian uraeus cobra, which signifies royalty. At the lower edge of the tunic are two small holes that were used for attaching the mask to the mummy.

The back of the woman's head appears to be resting on a support, whose sides are elaborately and colorfully decorated with traditional Egyptian subjects and extremely intricate patterns. On either side (fig. 78) a procession of

77. *Mummy Mask of a Woman with a Jeweled Garland.*
Egypt, probably Meir, ca. A.D. 60–70. Painted plaster, cartonnage (linen and gesso), and plant fibers, H. 20⅞ in. (53 cm)

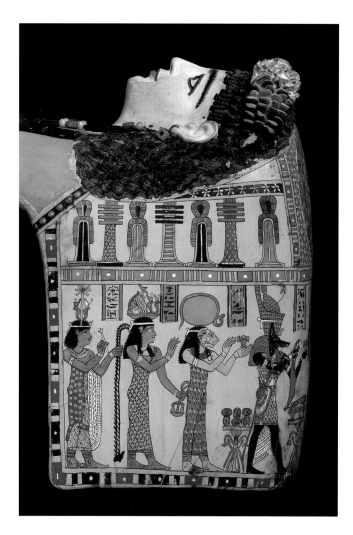

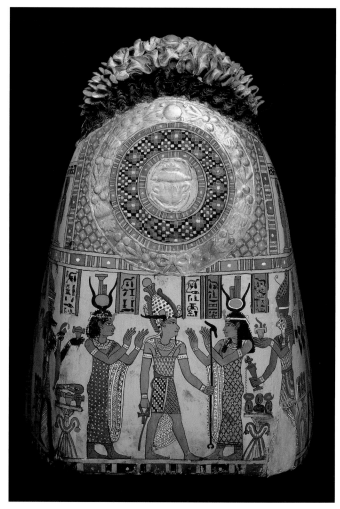

78. *Mummy Mask,* side view

79. *Mummy Mask,* top end view

deities approaches Osiris, who is in the center of the top end of the support (fig. 79). Above Osiris, placed so that it would be over the head of the deceased, a gilded scarab beetle representing the reborn sun is encircled by a checkered-pattern ring and a wreath of leaves and berries.

This remarkable mask is very much like two others in the Cairo Museum that were excavated at Meir in Upper Egypt.

From a flurry of energetic brush-strokes emerges the bright face of a calm and beautiful young woman (fig. 80). Her large eyes are accentuated by long lashes. A mass of loose curls covers her head, and some strands fall along the back of her neck on her left side. She wears a deep red tunic of a type popular in the Roman Empire in the first and early second centuries.

The background of the painting retains traces of gilding that would have emphasized the young woman's status as one of the divine deceased. The lower edge is unfinished where it was covered by the wrappings of the mummy.

This portrait is painted in the Greek style: the head is seen in a three-quarter view with indications of volume and depth, and with highlights and shading that suggest a single light source. From about the mid-first century A.D., panel portraits in this style were sometimes inserted over the faces of mummies. The custom was particularly prevalent in the Fayum area of Egypt, where the population had a strong "Greek" admixture, but such portrait mummies are found throughout Egypt. The panels are among the few surviving examples of Greek panel painting, which was lavishly praised by ancient authors.

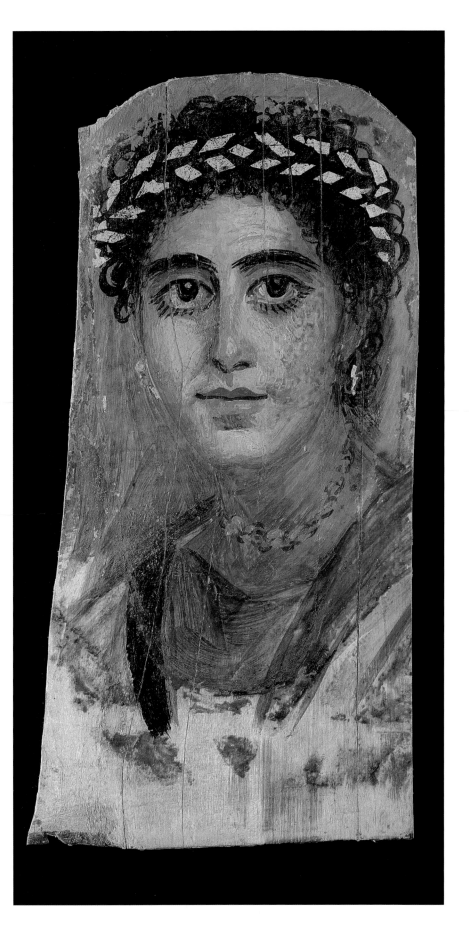

80. *Young Woman with a Gold Wreath.*
Egypt, ca. A.D. 90–120. Encaustic on limewood, H. 16¼ in. (41.3 cm)

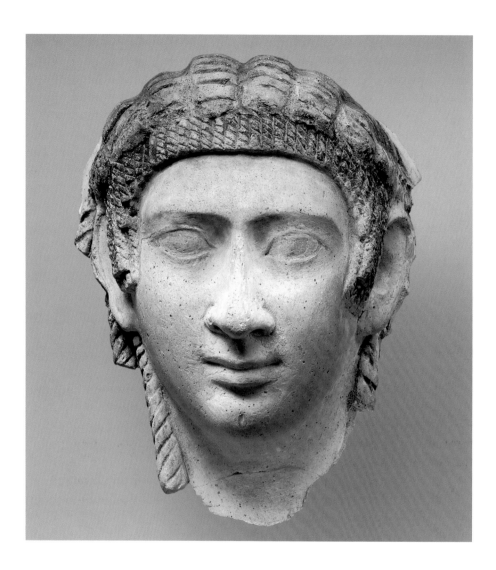

81. *Mummy Mask.*
Egypt, 1st century A.D. Gypsum
plaster with traces of paint,
H. 6⅞ in. (17.5 cm)

This woman's waved hairstyle is based on Roman court fashion, but three hanging corkscrew curls behind the ears and a short fringe of curls over the forehead and in front of the ears seem to reflect a local style (fig. 81). Toward the back of her head, above her ears, are traces of a smooth area that once represented a pillow. In general, earlier Roman-period masks such as this one show the deceased as if reclining on a bier with the head on a pillow, while later masks have the head raised as if the deceased is rising from the bier. The underneath edge of this example is flat where it is meant to be attached to a body covering of wood or other materials.

Most masks of this Roman-period type were made in a mold and could be further modeled by hand to produce a more individual appearance, if desired.

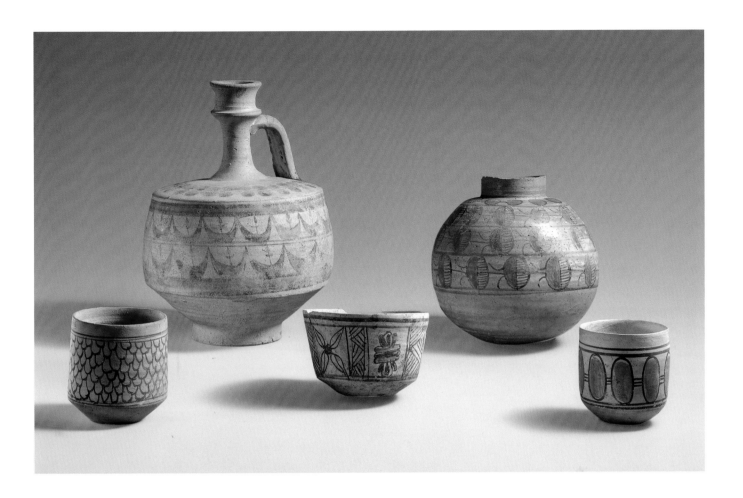

After a stable border had been established between Roman Egypt and areas controlled by Meroë, settlement in the Meroitic regions of lower Nubia intensified and economic prosperity grew. Several cemeteries of the first to third centuries A.D. have been found in this area. Inlaid woodwork, glass, metalwork, jewelry of faience, shell, metal, semiprecious stones, and polished quartz, and a rich repertoire of pottery are characteristic objects in lower Nubian burials.

Ceramics produced in Meroë are known mainly through the lower Nubian finds. Most of the pottery is painted, but stamped and barbotine (a type of applied clay decoration) wares are also represented. Among the examples of painted pottery the hands of different artists can be identified, and archaeologists have found vessels by the same painter at widely separated sites, testifying to a thriving ceramics industry and active trade, or possibly to the movement of painters. Here (fig. 82) the handled jug shows the typically Meroitic ankh-and-crescent motif in registers around the side, while the upper surface displays a Hellenistic vine decoration. The beakers and spherical jar carry abstract and semiabstract patterns. The feather pattern (left front) is shared with Egypt, and the bundle forms (center front) are perhaps derived from the protective Egyptian *sa* amulet. All but one of the ceramic vessels depicted are from Faras, a site north of the second cataract of the Nile.

82. *Group of Meroitic Vessels.*
Most from Faras, lower Nubia,
1st–3rd century A.D.
Fired and painted clay,
greatest H. 9¾ in. (24.7 cm)

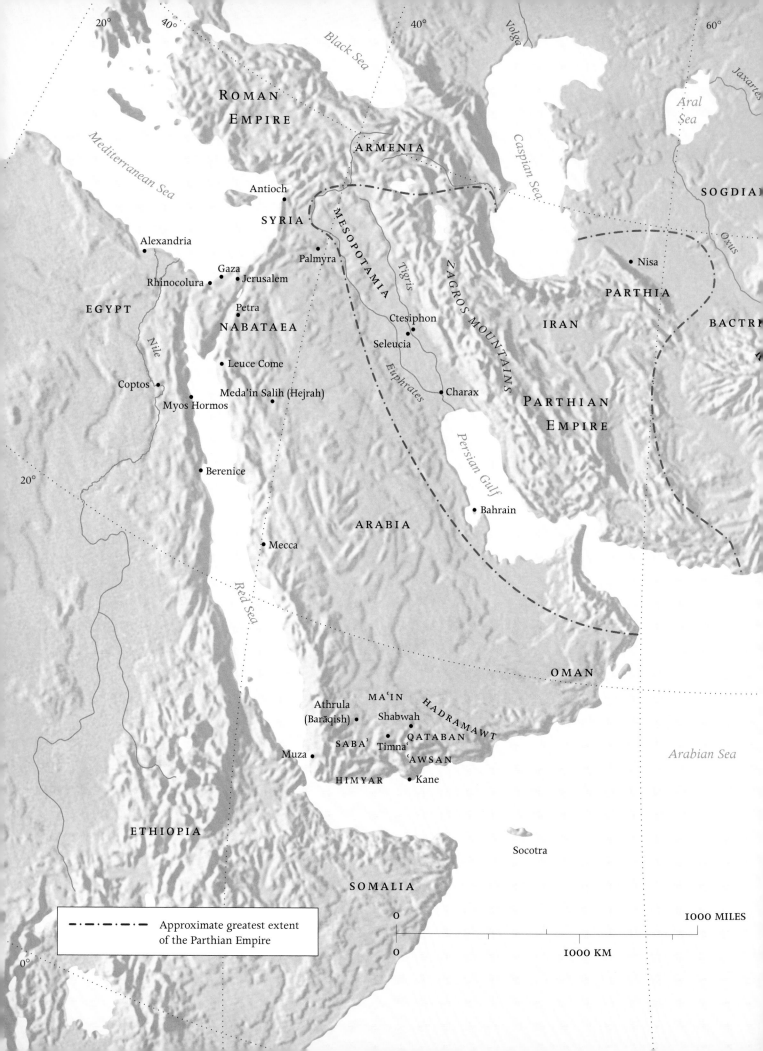

ROMAN
EMPIRE

Black Sea

Volga

ARMENIA

Mediterranean Sea

Antioch

SYRIA

SOGDIA

Aral Sea

Caspian Sea

Oxus

Jaxartes

Alexandria

Palmyra

Gaza

Rhinocolura

Jerusalem

PARTHIA

Nisa

Tigris

MESOPOTAMIA

ZAGROS MOUNTAINS

EGYPT

Petra

NABATAEA

Ctesiphon

IRAN

BACTRI

Seleucia

Nile

Euphrates

Leuce Come

Coptos

Meda'in Salih (Hejrah)

Charax

PARTHIAN

Myos Hormos

EMPIRE

Persian Gulf

Berenice

ARABIA

Bahrain

20°

Red Sea

Mecca

Arabian Sea

OMAN

MA'IN

HADRAMAWT

Athrula
(Barāqish)

Shabwah

Socotra

SABA'

QATABAN

Muza

Timna'

'AWSAN

HIMYAR

Kane

ETHIOPIA

SOMALIA

0

0

1000 MILES

Approximate greatest extent
of the Parthian Empire

1000 KM

0°

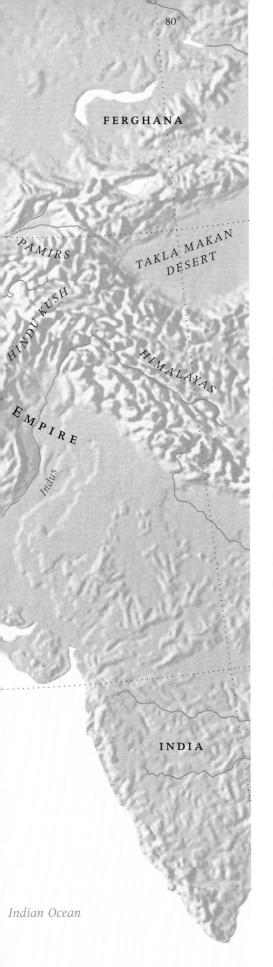

WEST AND CENTRAL ASIA

The lands east of the Mediterranean Sea, extending through Mesopotamia and into Iran and Central Asia, were home to a variety of peoples speaking different languages. Their inhabitants had witnessed the ebb and flow of many empires. Invasions from the east, of migrating Iranian peoples, and from the west, most notably that of Alexander the Great, brought new populations and new cultural influences.

At the time around the Year One, much of West Asia had been conquered by Rome or come within the Roman sphere of influence. Syria was the principal Roman province at the eastern end of the Mediterranean, while many of the neighboring lands were client kingdoms or vassals of Rome. Other areas maintained varying degrees of independence, or, as in the case of the Parthian Empire, complete independence.

Since the trade routes that joined Europe and China crossed these West and Central Asian territories, many of their inhabitants were engaged in trade and transport. Those kingdoms strategically located at crossroads exercised power and a cautious cooperation with regard to one another, while their linkage along the far-reaching routes made them both donors and recipients in a fluid cultural interchange.

SOUTH ARABIA

South Arabia had long captured the curiosity and imagination of the Greco-Roman world. This inaccessible land of frankincense and myrrh was known as Fortunate Arabia (in Greek, Arabia Eudaemon; in Latin, Arabia Felix), and in mythology the region was the birthplace of Dionysos and the burial place of Isis and Osiris, according to the Roman historian Diodorus Siculus. By the first century B.C. the Greco-Roman world also had factual knowledge of South Arabia and could accurately describe its coastline, incense harvest, and trade routes. Nevertheless, this remote land remained unconquerable. Aelius Gallus, prefect of Egypt, led an expedition there about 25 B.C. under the order of Augustus, who knew of its legendary wealth. Aided by guides from the Arab kingdom of Nabataea, his troops ventured into what is now northern Yemen, where a bilingual inscription in Latin and Greek from Barāqish (ancient Athrula) attests to a brief Roman presence.

While frankincense and myrrh, which are gum resins, could also be obtained from trees growing in Ethiopia and Somalia, it was the South Arabians who distributed these fragrant substances throughout the world along the Incense Route. The Incense Route was traditionally described as commencing at Shabwah in Hadramawt, the easternmost kingdom of South Arabia, and ending at Gaza, a port north of the Sinai Peninsula on the Mediterranean Sea. Geography benefited the South

Arabians in their role as merchant-traders. The Arabian Peninsula is connected by land to the Sinai, Syria, and Mesopotamia and is surrounded by the navigable waters of the Red Sea, the Indian Ocean, and the Persian Gulf, which together were known in antiquity as the Erythraean (Red) Sea. By the Year One both the camel caravan routes across the deserts of Arabia and the ports along the coast of South Arabia were part of a vast trade network covering most of the world then known to Greco-Roman geographers.

The South Arabians transported not only frankincense and myrrh but also spices, gold, ivory, pearls, precious stones, and textiles—all of which arrived at their ports from Africa, India, and the Far East. The geographer Strabo, writing around the Year One, compared the immense traffic along the desert routes to that of an army. For centuries South Arabian sailors also exploited the seasonal monsoon winds for shipping across the Indian Ocean. When knowledge of the monsoons spread to the Greco-Roman world at about the beginning of our era, sea trade was still being regulated by the South Arabian kingdoms, which had imposed a system of taxation on commerce by both land and sea. Already agriculturally self-subsistent, these kingdoms—Sabaʾ, Hadramawt, ʿAwsan, Qataban, Maʿin, and Himyar—grew tremendously wealthy through the transport of goods destined for lands beyond the Arabian Peninsula.

Frankincense was exported for use as incense at religious and funerary ceremonies, while myrrh was sought for cosmetics and perfumes. Both substances were also thought to have medicinal value; Greco-Roman authors recommended them for curing ailments ranging from poisoning to paralysis. In South Arabia too, incense was used for religious offerings, and altar-shaped censers were often placed in tombs. This bronze incense burner from southwestern Arabia (fig. 83) is a cylindrical container set on a conical base. Seven spikes extend upward from the high front panel, which resembles an architectural facade and bears a depiction in relief of two snakes flanking a round disk set within a crescent. The motif of disk and crescent appears often on South Arabian votive plaques and censers. An ibex, separately cast and identifiable by its ridged horns, stands on a plinth that projects from the censer's front. The ibex serves as a handle for the censer and perhaps had cultic significance; both the ibex and the snake are frequently associated with deities of the South Arabians. The serpent, which had apotropaic powers, has been identified with the national god of Maʿin, while the ibex may represent the god of the Sabaeans.

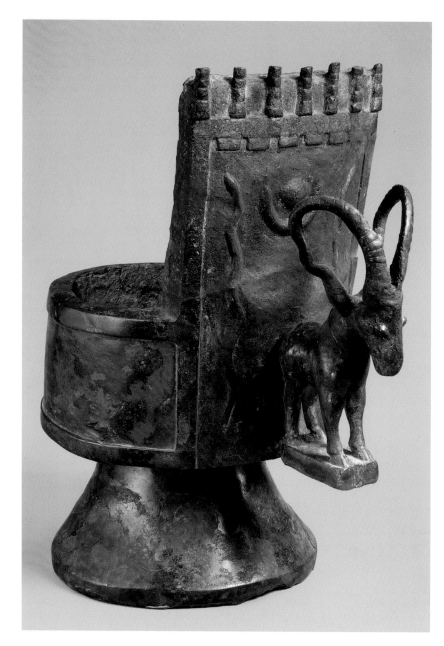

83. *Incense Burner.*
South Arabia, 1st century B.C. Bronze, H. 10⅞ in. (27.6 cm)

84. *Female Head.*
South Arabia, 1st century B.C.–1st century A.D.
Alabaster, H. 12¼ in. (31.1 cm)

South Arabian sculpture associated with palaces and domestic settings often reflects a strong Greco-Roman influence. In contrast, ancestral images, funerary portraits, and votive dedications exhibit a distinct style that is characteristically local. Finely carved from alabaster, which is a raw material of the region, the female head illustrated here (fig. 84) most likely was a funerary or votive object intended for a tomb or temple. The undersurface of the base and the flat top and back of the head are roughly cut. Similar heads were often set into niches, and the surfaces that would not be visible were frequently left unfinished. The three-stepped base, which is carved in one piece together with the woman's head and long neck, bears a Sabaean inscription that names the individual represented and her clan—*gubbâ° Mašâmân*.

The symmetry, frontality, geometric, angular features, and inlaid eyes of this head are characteristic of South Arabian sculpture. As on other female heads, the locks of hair extend in triangular projections below the ears. The nose is narrow and high ridged, meeting the face at a sharp angle. As can be seen from the side, the forehead slopes into the ridge of the nose, leaving the eyes and cheeks in a recessed plane. The mouth is small and resembles a raised circle with a horizontal groove to indicate lips. The ears, set high and carved flat, are the head's most naturalistic feature. Although the forms are geometrically conceived, the face is softened and given volume by the full cheeks, which appear flushed because the sculptor carved the woman's face on the side of the alabaster block that has a rosy hue.

THE NABATAEANS

Nabataea, an important destination of travelers on the caravan
route from South Arabia, emerged as a great merchant-trader
kingdom during the first centuries B.C. and A.D. Originally a
nomadic tribe in northern Arabia, the Nabataeans had settled in
neighboring southern Jordan by 312 B.C., when they captured
the interest of Antigonus I "the One-Eyed," a former general of
Alexander the Great, who unsuccessfully attempted to conquer
their territory. By that time the city of Petra was the center of
the Nabataean kingdom, which, although it came increasingly
within the Roman sphere, remained essentially independent
until it was incorporated into the Roman province of Arabia
under the emperor Trajan in A.D. 106. Petra was strategically sit-
uated at the crossroads of several caravan routes that linked the
lands of China, India, and South Arabia with the Mediterranean
world. The renown of the Nabataeans spread as far as Han-
dynasty China, where their capital was known as Rekem. The
city of Petra is as famous now as it was in antiquity for its
remarkable rock-cut tombs and temples, which combine ele-
ments derived from the architectures of Egypt, Mesopotamia,
and the hellenized West (fig. 8).

During the reign of King Aretas III (r. 85–62 B.C.) the
Nabataeans extended their territory northward and briefly
occupied Damascus. Their expansion was halted by the arrival
of Roman legions under Pompey in 64 B.C. and the subsequent
creation of the Roman province of Syria. But Nabataea continued
to flourish and remained one of the most successful and prosperous

client kingdoms on the periphery of the Roman Empire. At various times it included the lands of modern Jordan and Syria, northern Arabia, and the Sinai and Negev deserts. At its height under King Aretas IV (r. 9 B.C.–A.D. 40), Petra was a cosmopolitan trading center with a population of at least twenty-five thousand, and the caravan route that linked it to the Mediterranean was important to the entire system of trade passing through the Near East. In particular, the South Arabians depended upon the Nabataeans to convey goods overland to Mediterranean harbors, and much of the shipping traffic along the Red Sea passed through Nabataean ports.

In the first century A.D. Pliny the Elder described Gaza as the northern terminus of the Incense Route and stated that the overland journey from Timnaʿ in South Arabia to Gaza consisted of sixty-five stages divided by halts for the camels. The route ran along the western edge of Arabia's central desert about one hundred miles inland from the Red Sea coast. The trade routes through the Arabian Peninsula converged at the Nabataean commercial center of Medaʾin Salih (Hejrah) in the Hijaz, which is generally considered the southernmost point of Nabataean control. Goods also arrived by sea at the Nabataean port of Leuce Come, near the entrance to the Gulf of Aqaba, where a 25 percent tax was collected. Upon arriving in Nabataean territory, many of these goods were conveyed directly to Petra; they were then sent westward across the Negev desert to Gaza and to Rhinocolura (el-Arish) in the Sinai, both on the shore of the Mediterranean.

85. *Open Bowl.*
Nabataean, Jordan (Tawilan),
1st century A.D. Terracotta,
Diam. 8⅝ in. (22 cm)

Although extensively engaged in trade, the Nabataeans were also skilled in agriculture, irrigation, and industry. The very thin painted ware that is so closely identified with Nabataean culture began to appear in the first century B.C. It reflects the influence of Hellenistic wares, but because its shapes, colors, and decoration are unique, it forms a distinct type and was recognized early on as an accurate indication of Nabataean presence. Found primarily in southern Nabataea, the pottery has also turned up in the ports of Oman and Yemen, along the eastern coast of the Arabian Peninsula, and along the Incense Route. Consisting primarily of bowls and plates, Nabataean painted ware is usually decorated with floral motifs. The interior of the bowl illustrated here (fig. 85), which was excavated at Tawilan (ʿAin Musa), northeast of Petra, is divided into five segments, each marked with hatching, that meet at an X in the center. An abstract leaf is set in the middle of each segment, and large oval lozenges are placed over the lines dividing the segments. The bowl has a rounded bottom and an inverted rim. Its shape, its dark red-orange color, and its decoration, a radial, rotational design limited to two abstract motifs set against a hatched background, all point to a date in the first century A.D. It has been suggested that Nabataean painted ware was deliberately broken after use in religious ceremonies; the ware has also been connected with cultic meals for the deceased.

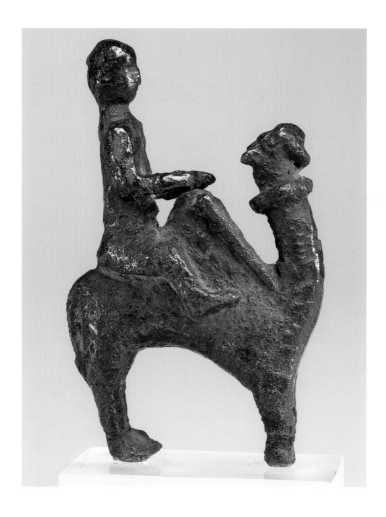

Camels, which had long been domesticated, were used to transport goods along the Incense Route. The South Arabian and Nabataean peoples both valued and identified with the dromedary, or single-humped camel, and in the Greco-Roman world too they were identified with this animal. In a spurious claim to Roman victory over Nabataea, Pompey's deputy Aemilius Scaurus issued coins in 58 B.C. depicting King Aretas III kneeling beside a camel, and a later provincial coin commemorating the Roman acquisition of Arabia shows a camel and the personification of Arabia on the reverse. There is also evidence that camels were grave goods for high-ranking individuals in South Arabia, buried with or near their owner to prevent their passing into the possession of someone else. Many South Arabian funerary reliefs show the deceased riding a camel, and Nabataean inscriptions scratched on rocks by travelers along the caravan routes are sometimes accompanied by the drawing of a camel. A bronze camel figurine of the first century B.C. or A.D. (fig. 86) shows an individual riding bareback behind the hump of his dromedary, which he guides with a long stick that he holds in his right hand. The rings around the muzzle and upper neck of the beast suggest a halter. Similar figurines of camels without riders are also known from South Arabian and Nabataean contexts. For example, the Amír, a tribe in Yemen, dedicated camel figurines to their deity to ensure the well-being of their herds, and the dedication of camel figurines is also recorded by the Nabataeans.

86. *Dromedary and Rider*.
Nabataean, probably Jordan,
1st century B.C.–1st century A.D.
Bronze, H. 2⅜ in. (6.2 cm)

PALMYRA

Palmyra was originally an oasis settlement in the northern Syrian desert. Although the Roman province of Syria was created in 64 B.C., the inhabitants of Tadmor, primarily Aramaeans and Arabs, remained semi-independent for over half a century. They profited from their control of the caravan routes between Roman coastal Syria and Parthian territory east of the Euphrates, which allowed them to provide the Roman Empire with goods coming from all directions. The most important of these were the routes that extended from the Far East and India to the head of the Persian Gulf, and the Silk Route, which stretched across the Eurasian continent to China.

Under the Roman emperor Tiberius (r. A.D. 14–37), Tadmor was incorporated into the province of Syria and assumed the name Palmyra, or "place of palms." After the Roman annexation of Nabataea in A.D. 106, Palmyra replaced Petra as the leading Arab city in the Near East and its most important trading center (fig. 7). About 129, during the reign of Hadrian, Palmyra rose to the rank of a free city, and in 212 to that of a Roman colony. With the foundation of the Persian Sasanian Empire in 224, Palmyra lost control over the trade routes, but the head of a prominent Arabian family who was an ally of the Roman Empire, Septimius Odaenathus, led two campaigns against the Sasanians and drove them out of Syria. When Odaenathus was murdered in 267, his Arab queen, Zenobia, declared herself Augusta (empress) and ruled in the name of her son, Vaballathus. She established Palmyra as the capital of an independent and far-reaching Roman-style empire, expanding its borders beyond Syria to Egypt and much of Asia Minor. Her rule was short-lived, however; in 272 Emperor Aurelian reconquered Palmyra and captured Zenobia, whose subsequent transport to Rome bound in chains of gold is legendary.

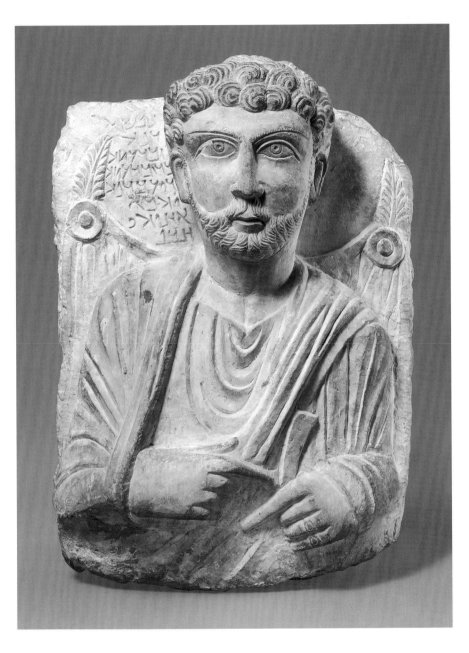

In the favorable cultural climate created by wealthy local merchants, Palmyrene artists produced an enormous corpus of sculpture, most of which dates to the first three centuries of the modern era. The two examples shown here are perhaps a century apart in date. Both are gravestones executed in high relief and depict the deceased at half length. The sculpture of Zabd-Athe (fig. 87) shows a bearded man against a curtain secured by palm fronds. The separate, curling locks of his hair end above his protruding ears; his beard is close cropped and patterned with striations. The iris of each large eye is placed high and drawn as an incised circle, and the pupils are drilled. Zabd-Athe wears the ample cloak called a himation, which he grasps in his right hand. The end of the garment crosses over his left shoulder, half concealing the chiton (tunic) that he wears beneath it. In his left hand, which is adorned with two rings, is a curved object, probably a scroll. The eight-line inscription in Aramaic to the left of his head reads, "This is the gravestone of Zabd-Athe, Son of Zabd-Athe, which was erected for him. Wahba, his brother. Alas!"

87. *Gravestone with Bust of a Man.*
Palmyra (Syria), 2nd century A.D. Limestone,
H. 20 in. (50.8 cm)

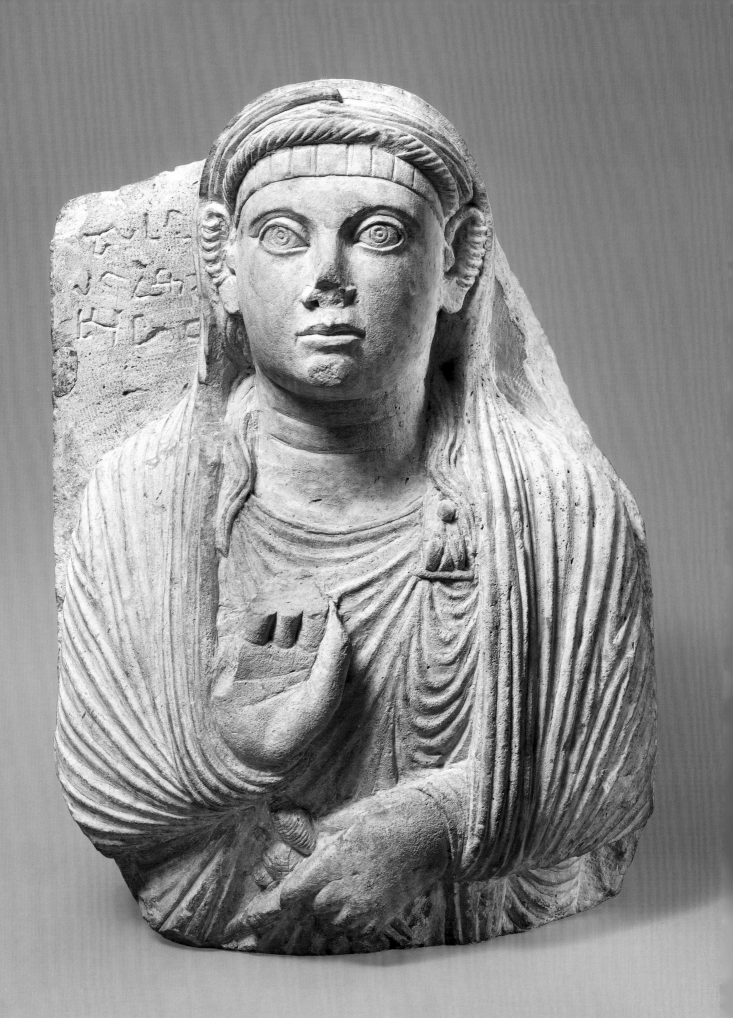

Like Zabd-Athe, the woman depicted on the second relief (fig. 88) seems to gaze upward, an effect emphasized by the tilt of her head. The irises and pupils of her eyes are indicated by concentric circles. She wears a tiara ornamented with vertical lines across her forehead, below a coiled band. A long veil covers her head, falls in sharp vertical folds from both shoulders, and passes over the forearms, below which it is snugly tucked. Wavy locks of hair fall at both sides of her neck. A fibula, or brooch, near the woman's left shoulder fastens her himation to the chiton worn underneath. Her ears are pierced along the rim with a row of small plain rings. In her left hand she holds two objects, a distaff and a spindle, most likely a reference to domestic tasks. Her right hand is raised with the palm turned outward. Two horizontal creases appear in the flesh of the neck. The three-line Aramaic inscription on the slab behind her reads, "To Jataba, son of Tanaron. Alas!"

Reliefs such as these were made to adorn family vaults. Many of the vaults consisted of vertical rows of burial compartments; each compartment contained a stone box sealed by a carved stone that depicted the deceased and carried an Aramaic inscription giving the subject's name and genealogy. These gravestones suggest the vivid presence of the deceased, whose image, with its direct, frontal posture and large, wide-open eyes, engages the viewer. Palmyrene art is at the same time stylized, iconic, and idealized.

The art of Palmyra represents a blend of Greco-Roman and Parthian elements. For example, the hand of Zabd-Athe protrudes from slinglike drapery in a pose reminiscent of Greek sculpture, while his frontal posture and spiral-patterned hair suggest an Eastern influence, and the female figure makes a gesture of worship seen in Parthian relief sculptures (see fig. 93). In contrast to Parthian sculpture, however, both of these figures from Palmyra are carved in extremely high relief and convey a distinct sense of volume. While the meticulous care lavished on details of dress and jewelry (which on many grave reliefs were also painted) recalls the Parthian approach to figural representation, the costumes of these figures from Palmyra are unmistakably Western.

88. *Gravestone with*
Bust of a Woman.
Palmyra (Syria), 2nd century A.D.
Limestone, H. 20 in. (50.8 cm)

THE PARTHIAN EMPIRE

When the Macedonian Greek general Alexander the Great died in Babylon in 323 B.C., he had established an empire that extended from the Mediterranean Sea to India. In the years that followed, as Greeks flocked to the newly founded Hellenistic cities in Asia, the Greek civilization they brought with them transformed the art and culture of the Near Eastern world. Even after the political weakening of the Seleucid dynasty, founded by one of Alexander's generals, the traditional Near Eastern art of the region continued to exhibit Western features under the Parthians.

The Parthians began as an Iranian tribe called the Parni, members of a seminomadic confederacy living in Central Asia. In about 250 B.C., under their leader, Arsaces, they invaded Parthia, a region of the Seleucid Empire southeast of the Caspian Sea in approximately the location of present-day Iran. Known as Parthians after their successful conquest of this land, they made their own imperial aspirations clear by instituting a dynastic era in 247 B.C., and subsequent Parthian rulers assumed the name Arsaces as a royal title. Under Mithradates I (r. ca. 171–139 B.C.) and his successors, the Parthians grew into a prominent power in the Near East by expanding their territory through a series of campaigns against the Seleucids, the Romans, the Greco-Bactrian kingdoms, and the nomadic peoples of Central Asia. The Romans, who were ambitious to dominate the Near East in the style of Alexander, underestimated the capacities of the Parthians. Parthia was in fact a rival power to Rome, and Rome had to settle for a negotiated peace, accomplished by Augustus.

Establishing a primary residence at Ctesiphon, on the Tigris River opposite Seleucia in Mesopotamia (present-day Iraq), the Parthians ruled for nearly half a millennium and exerted an influence that extended from Asia Minor to northern India until they were overthrown by another Iranian people, the Sasanians, in the early third century A.D.

The numerous caravan routes crossing Parthian territory were the backbone of the Parthian economy. The most important, the Silk Route, is described in the *Parthian Stations* by Isidoros of Charax, composed around the Year One. The archaeological evidence for trade with the Far East goes back much further; when the Chinese sent an embassy to the court of Mithradates II (r. ca. 124–88 B.C.), trade along the Silk Route already existed on a significant level. Over time, interchange on all these routes continued to increase. The Parthians exploited their location on the Silk Route to control the trade between the Roman and East Asian worlds and to levy taxes on it.

The Parthians absorbed the cultural traditions of Achaemenid Persia, the civilization that had flourished in that region from the sixth to the fourth century, and adopted elements of the Zoroastrian religion, which had taken firm root during the Achaemenid period. The mingling of Hellenistic and local traits in Parthian culture has been interpreted as a means by which the Arsacid rulers secured the loyalty of the two primary groups among the population under their rule.

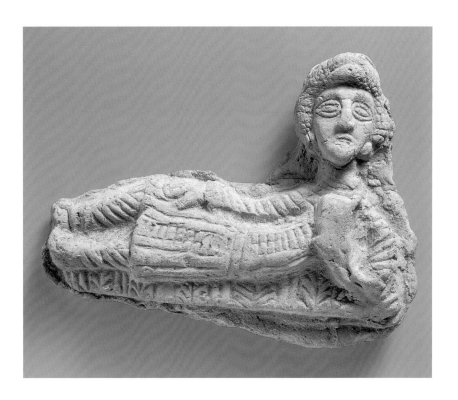

ABOVE

89. *Reclining Figure.*
Parthian, Mesopotamia,
1st century B.C.–1st century A.D.
Terracotta, W. 5¼ in. (13.3 cm)

FACING PAGE, TOP

90. *Reclining Woman.*
Parthian, Mesopotamia,
2nd century B.C.–2nd century A.D.
Alabaster, W. 7 in. (17.8 cm)

FACING PAGE, BOTTOM

91. *Standing Woman.*
Parthian, Mesopotamia,
2nd century B.C.–2nd century A.D.
Alabaster, H. 10⅝ in. (27 cm)

The reclining figurine, a type of sculpture introduced into Mesopotamia during Hellenistic times, was popular in the cities of Babylon, Seleucia, and Uruk. A terracotta example (fig. 89) represents a person reclining on a patterned couch on which a herringbone motif alternates with stripes. Although the figure is beardless and wears disk-shaped earrings, it must be male because it is dressed in the tunic and trousers of a Parthian man. He reclines on his left side supported by his elbow and holds a cup in his left hand; his right arm is extended along the side of his body, with the palm resting firmly on his thigh. The torso is twisted so that the entire figure is viewed from the front. A gridded pattern indicates curly hair, and the face shows a protruding chin and large eyes encircled by thick lids. The belted knee-length tunic has a panel of short horizontal lines down the front that is flanked by vertical stripes indicating folds of drapery. Incised diagonal lines denote pleats or folds in the cloth of the trousers and the sleeves. The flatness and emphasis on linear details of dress rather than anatomical form reflect characteristics of monumental Parthian sculpture (see fig. 93), but here the execution is rudimentary. Other terracottas of individuals dressed in Parthian costume are limited to only a few examples, which include horsemen, soldiers, and musicians.

A figurine in alabaster is of a nude woman reclining on her left side in roughly the same position as the terracotta figure (fig. 90). Her left arm, which would have supported her body, is missing. The right arm is extended along her side, with the tips of her fingers resting lightly on her thigh. Faint bands at the woman's neck indicate creases; the subtle folds of flesh along the right side of the torso emphasize the full curves of her body. Reclining figures are

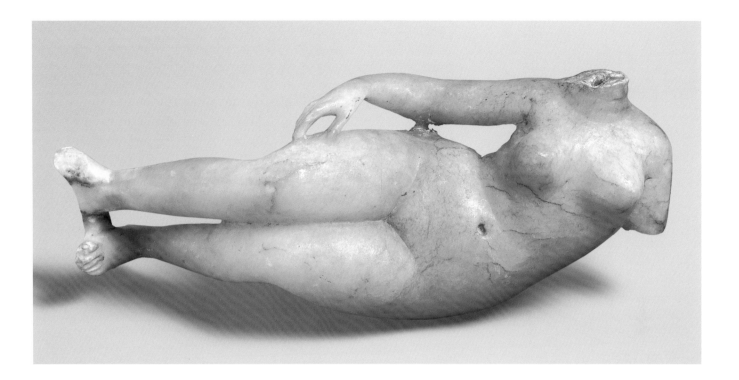

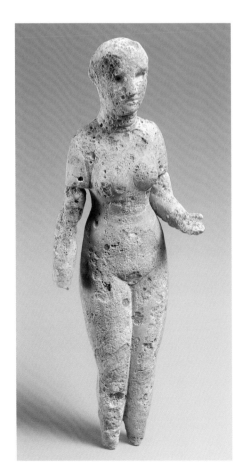

common among Greek terracottas, and the appearance of the posture in Mesopotamian sculpture may reflect the influence of Greek terracotta manufacturing centers along the eastern Mediterranean. The majority of Greek terracottas of this type are male, however, as are reclining figures depicted in Greco-Roman funerary reliefs. In Mesopotamia the opposite is true; whether the figurine is fashioned of alabaster or of terracotta, the subject is usually a woman. While the treatment of the body and graceful pose of the present sculpture undeniably betray a Hellenistic influence, the creases at the neck, the drilled navel, and the voluptuous form are in an established local tradition.

A standing female figure is also full-figured (fig. 91). Three horizontal lines suggest a fleshy neck, and similar rings of flesh appear at her waist. The hair is combed into a knot at the back of the head. The lower arms are pieces that were separately attached. Her left hand, open with the palm up, may have held an object. Like many other female figurines found in Mesopotamia, this one had inlaid eyes. Mesopotamian female figurines both reclining and standing were often given a plaster or bitumen wig, and, although there are no traces of color here, details such as sandals, necklaces, upper-arm bracelets, and lines around the navel and pubic triangle were frequently added in paint. Jointed female figurines were dedicated at Greek temples and sanctuaries. Similar pieces, also with the lower arms attached separately, have been excavated from Parthian graves and residences. These figurines have been variously described as goddesses, dolls, and fertility amulets.

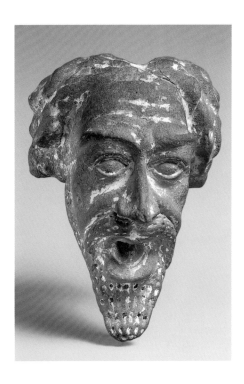

92. *Spout in the Shape of a Man's Head.*
Parthian, Iran, 1st–2nd century A.D.
Terracotta with traces of glaze,
H. 8¼ in. (20.9 cm)

93. *Standing Man.*
Parthian, Iran, 2nd century A.D. Gray
stone, H. 30¼ in. (76.8 cm)

During the Seleucid and early Parthian eras, artistic production in Iran was heavily influenced by the naturalistic style of Hellenistic Greece. At about the beginning of our era Eastern forms reemerged, but they incorporated elements borrowed from the West. "Parthian art" is not a stylistically unified manifestation; reflecting the political fragmentation of the empire, it contains an array of disparate styles whose characteristics are often a function of their region of origin. A comparison of the relief figure of a man and a terracotta head of a man, both from the period of the first and second centuries A.D., demonstrates this heterogeneity.

This fragmentary stone relief of a standing man (fig. 93) is a product of the resurgence of an Eastern aesthetic in Parthian art. The style it exemplifies, already seen in a less refined form in the reclining terracotta figure (fig. 89), is characterized by strict frontality and a concentration on linear details, in particular the careful rendition of textiles. The figure shown here, carved in extremely low relief, may be identified as a worshiper by the right hand raised palm forward in a gesture of reverence. Lines incised on the surface, rather than volumetric modeling, convey the quality of his clothes, mustache, and broad, square-cut beard. His prominent eyes are flat and outlined with ridges, and the nose is also flat. His hair is executed in tiers of thick spirals. The worshiper wears a belted tunic decorated with a row of lozenges containing circles; a braid of spirals runs down the front of his garment and others trim the cuffs. Two items are tucked under his belt, and in his left hand he holds an object. At his right hip another object is depicted, perhaps meant as a sword. Votive images of worshipers similar to this one adorned the terraces of sanctuary complexes such as those at Barde-e Neshandeh and Masjid-i Sulaiman, both in the Iranian province of Khuzestan.

In contrast, a spout in the shape of a man's head (fig. 92) exhibits the high degree of Hellenism that is also to be found in Parthian art. The mustache and beard were originally inlaid with shiny iron pyrites, a characteristically Near Eastern practice. Some of the piece's opaque gray glaze still remains. The circular opening at the mouth and the projection of the lower lip are exaggerated, presumably an aspect of its function as a spout. The central parting of the hair, which appears on Parthian coins, is considered a distinctly Parthian feature. The long, thin face and prominent nose suggest the likeness of an actual individual.

The practical purpose of this terracotta head combines with the eloquence of Greek naturalism to create an almost bizarre effect, uniting facial expression with function. The intense concentration suggested by the furrowed brow, creased forehead, compressed cheeks, and extended tongue is a realistic response to the mouth's being open extremely wide. In contrast, the male worshiper relief, with its formal, symbolic pose, is understood as a static, iconic type. The huge size of the hand, two-thirds the length of the upper torso, emphasizes the significance of the figure's gesture. While a conceptual approach characterizes the worshiper relief and a more literal approach underlies the terracotta man's head, each work is identified with its purpose in an exaggerated manner.

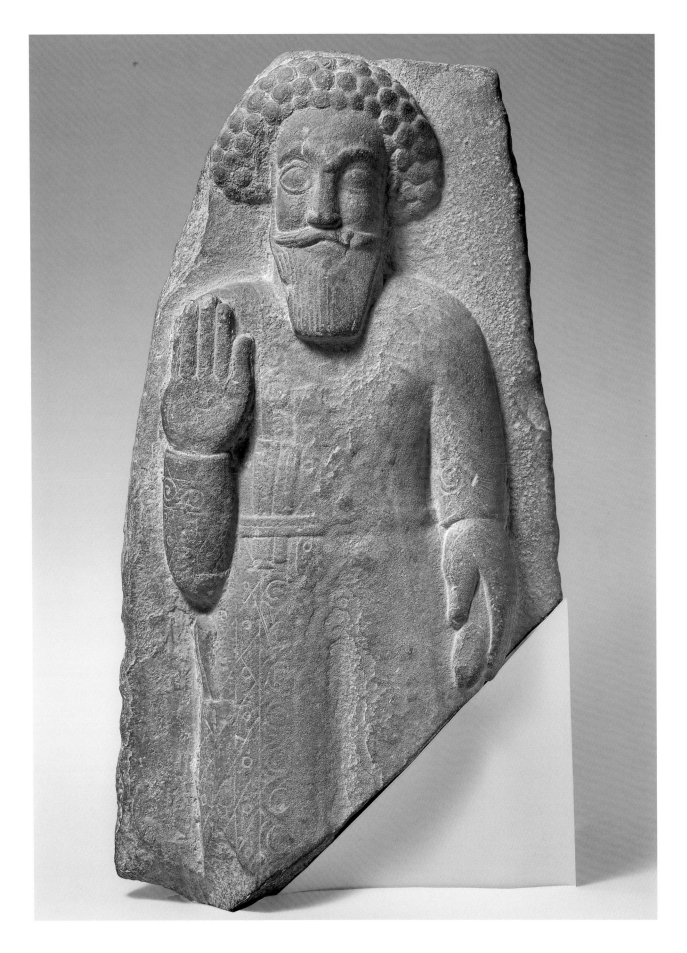

94. *Rhyton with Forepart*
of a Wild Cat.

Parthian, Iran, 1st century B.C.

Gilded silver, H. 10⅞ in. (27.5 cm)

Among the luxury wares produced for the Parthian royal court are horn-shaped vessels of ivory or metal with animal protomes (that is, depictions of an animal's head, chest, and front legs). Both Near Eastern and Greek elements are to be found in the objects' forms, imagery, and style. These drinking vessels, or rhyta, have a spout in the animal's chest through which liquid was transferred into the mouth in a steady stream or into a drinking cup, or possibly poured as a libation. An extraordinary group of such rhyta was discovered at the Parthian royal city of Nisa, about 250 miles east of the Caspian Sea. Made of ivory, those works combine protomes of fantastic winged and horned animals of Near Eastern derivation with Hellenistic figural friezes that encircle the rims.

The spectacular rhyton illustrated here (fig. 94) belongs to a group executed in silver with a protome in the form of a feline. The creature portrayed on this example has been identified as a lynx or a panther, but its appearance suggests that it is a caracal. Tall, slender, and lithe, this cat—indigenous to Africa and Asia—leaps at its prey with great force and agility and strikes with widely splayed claws. It has large, pointed ears, a short muzzle, and powerful jaw muscles that give it broad cheeks and a round face. The cat on the rhyton is snarling, with ears alert and claws spread, ready to pounce; the posture is just antecedent to that of a cat with a cock caught in its clutches on a rhyton in the Miho Museum in Shigaraki, Japan. The Metropolitan Museum example shows a collar around the animal's neck, perhaps indicating that it was a trained predator. In India and Iran in more recent times, the caracal was used for sport by the nobility—coursing after small game or released into a flock of domestic pigeons.

A gilt garland of ivy and grapevines with clusters of grapes encircles the cat's chest, and a gilt ivy frieze decorates the upper part of the horn below the everted rim. Both these motifs and wild felines are part of the imagery surrounding Dionysos, the Greek god of fertility and wine. Depictions of the popular Dionysiac cult were pervasive in the Greco-Roman world. A Hellenistic relief on a drinking cup showing centaurs celebrating Bacchanalia includes panther-headed rhyta set on stands, and Dionysos is seen leading spotted panthers and tigers in procession in mosaics from the city of Antioch on the Orontes in ancient Syria. In a second mosaic from Antioch, Dionysos, engaged in a drinking contest with Herakles, imbibes from a rhyton very similar in form to the present example but with a protome depicting another animal sacred to the god, the long-horned goat.

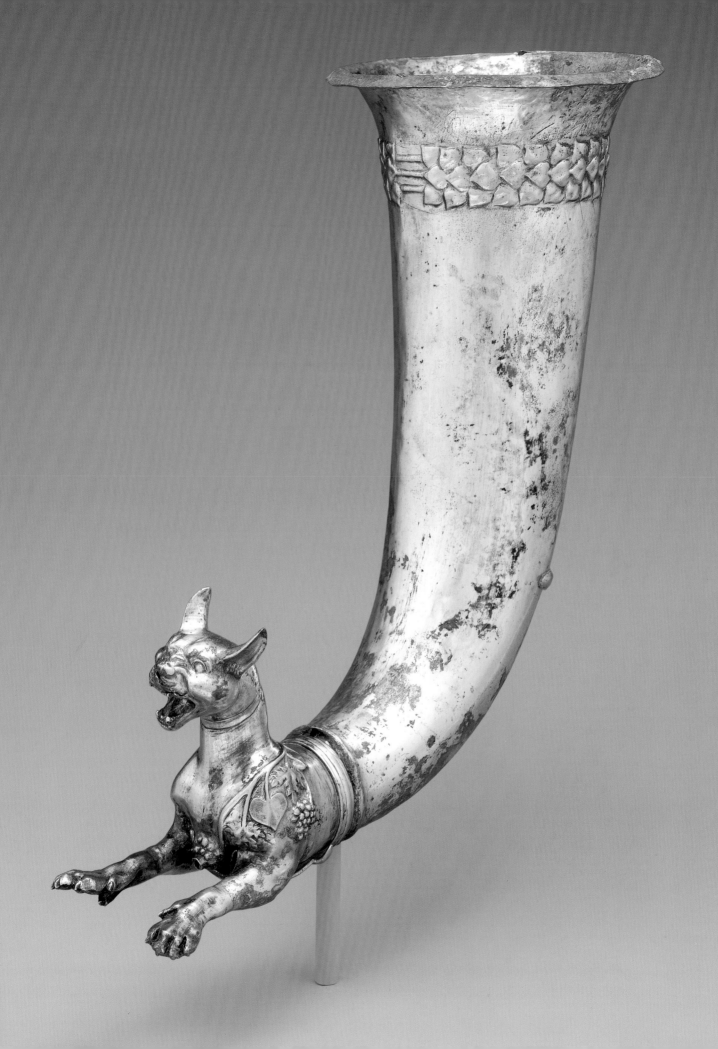

The art of the Parthians, Iranian nomads originally from Central Asia, reflects their contacts not only with the Greco-Roman world but also with the cultures along the Silk Route to China. Like the nomads of the Eurasian steppes—some of whom, according to the fifth-century-B.C. Greek historian Herodotus, "live in luxury and wear gold on their persons"—the Parthians displayed their riches in the form of precious jewelry. This solid gold ornament (fig. 95) is in the form of a roundel with two projecting elements that have slots for the attachment of a strap. The rim of the roundel, consisting of eighteen thumbnail-shaped cells for turquoise inlay in the manner of some Sarmatian roundels, frames the openwork figure of an eagle in very high relief. Grasping a small, crouching animal in its talons, the bird perches in a three-quarters view, facing left, with its chest extended and the rest of its body receding into the background. Its wings are outspread, the one to the left seen emerging from behind the swelling of the chest and the forward one on the right receding into the back plane. The body and legs carry ridges and linear patterning to suggest the texture of feathers. A heart-shaped cell for an inlay on the chest and teardrop-shaped cells on each wing are empty, but one triangular turquoise inlay survives on the tail feathers. The bird's head is in profile, with a cell for the prominent ear, a protrusion at the eye area, a curved beak, and a down-curved line for the mouth. The entire figure is worked in the round, although the back is distorted and not as carefully finished as the front.

The eagle's prey has been variously identified as an antelope, a goat, and a hare. Turquoise is inlaid in its large ear and in several places on its body. The tabs on either side of the roundel have cells for inlays at the corners in the form of debased acanthus leaves.

This piece is one of a pair; its mate, in the British Museum, London, depicts an eagle facing the opposite way. It was thought by Ernst Herzfeld to be part of a treasure found in 1910–11 in a chamber tomb near Nihavend in Iran. Herzfeld speculated that this trove had belonged to an aristocratic Parthian family and had originally included a group of Roman gold coins of the first to the second century A.D. that surfaced independently in modern times. Another related piece of jewelry, found in excavations at Dalverzin Tepe in Uzbekistan, can be dated archaeologically to the first century A.D.

95. *Clasp with Eagle and Its Prey.* Parthian, Iran, 1st century B.C.– 1st century A.D. Gold and turquoise, W. 3⅜ in. (8.6 cm)

96. *Ornament for Horse Trappings.*
Sarmatian, Western Central Asia or
Iran, 1st–2nd century A.D. Gilded
silver, vitreous material, and
garnets, Diam. 5⅞ in. (14.9 cm)

One of two nearly identical large roundels, this object (fig. 96) was probably part of a set of ornaments made for the horse trappings of a tribal chieftain living on the Eurasian steppes. Such metal disks were known as *phalerae* in Latin; these, of silver alloy burnished with gold, recall the remark made about one nomadic tribe by the Greek historian Herodotus, that for "the caparison of their horses they give them breastplates of brass, but employ gold for the reins, the bit, and the cheekpieces."

Evenly spaced on the ornament's circular field are three heads of griffins, mythical beasts that are part bird of prey and part lion. The heads, executed in repoussé, are all in left profile facing toward the center of the disk. Each has an elongated, pointed ear inlaid with garnet, a circular eye inlaid with

turquoise-colored vitreous material, a bulbous beak that hooks under the mouth (a sign of a bird of prey), two or three raised ridges at the base of the bill to mark the cere area, and curved lines to suggest the feathers of the throat. The heads are supported by elongated curving necks so that the overall design is a disconnected spiral whorl. A triangular motif in the center was probably cast and cut away for the insertion of a turquoise-colored inlay, of which only traces remain. The edge was a border of circular turquoise-colored inlays of vitreous material; about half of these survive. The surface of the disk is scratched. On the back are traces of a series of attachment loops that encircled the rim as well as of woven textile straps about five millimeters wide that apparently ran through the loops.

The bird of prey and the griffin are subjects that pervade the art of the steppes, from the lands of the Scythians in the Black Sea region eastward to Siberia. The combination seen here of pointed ears and a bird head may, however, indicate a derivation from Greek art. While in the Near East such ears are characteristic of the lion-headed griffin, they are prominent on bird-headed griffin cauldron attachments from the Orientalizing period (seventh century B.C.) found in Greek sanctuaries.

Scholars attribute the numerous known *phalerae*—many of which have designs like this one—to the Sarmatians, nomadic Iranian-speaking peoples centered in the southern Ural Mountains. In the late fourth century B.C. the Sarmatians began to migrate westward, perhaps in part as a result of the movement of other groups caused by the eastern conquests of Alexander the Great. They soon came to dominate a vast area of Eurasia. According to the Greek geographer Strabo, Sarmatian Aorsi tribesmen originally from the eastern steppes were in the northwest Caspian area of Astrakhan and were involved, along with other intermediary groups including the Armenians, in the caravan trade between India and Babylonia.

A burial in the northwest Caspian region at the site of Kosika yielded a disk that offers a particularly elaborate parallel to the *phalera* seen here and its mate. The Kosika disk also has the motif of an inlaid central triangle and a griffin-head whorl, but in this case each head nearly dissolves into the abstract forms of its component elements. An intricate border of detached griffin heads is itself encircled by a band of pattern derived from the Greek egg-and-dart motif. The design of the Metropolitan Museum pieces, by contrast, is simpler, more naturalistic in the rendering of the griffin heads, and without overall surface patterning. These features reinforce the possibility that these disks and similar horse ornaments were produced in Iran, in a style related to Sarmatian and ultimately to Siberian decorative arts. Polychrome metallurgy was known previously in Persia as well as in the Siberian tradition, where the combination of gold and turquoise was particularly prominent. The central motif of a griffin-head whorl is pervasive in the ancient world. It can be traced back to the second millennium B.C. in the Near East and the Aegean, and as far east as second-century-B.C. China.

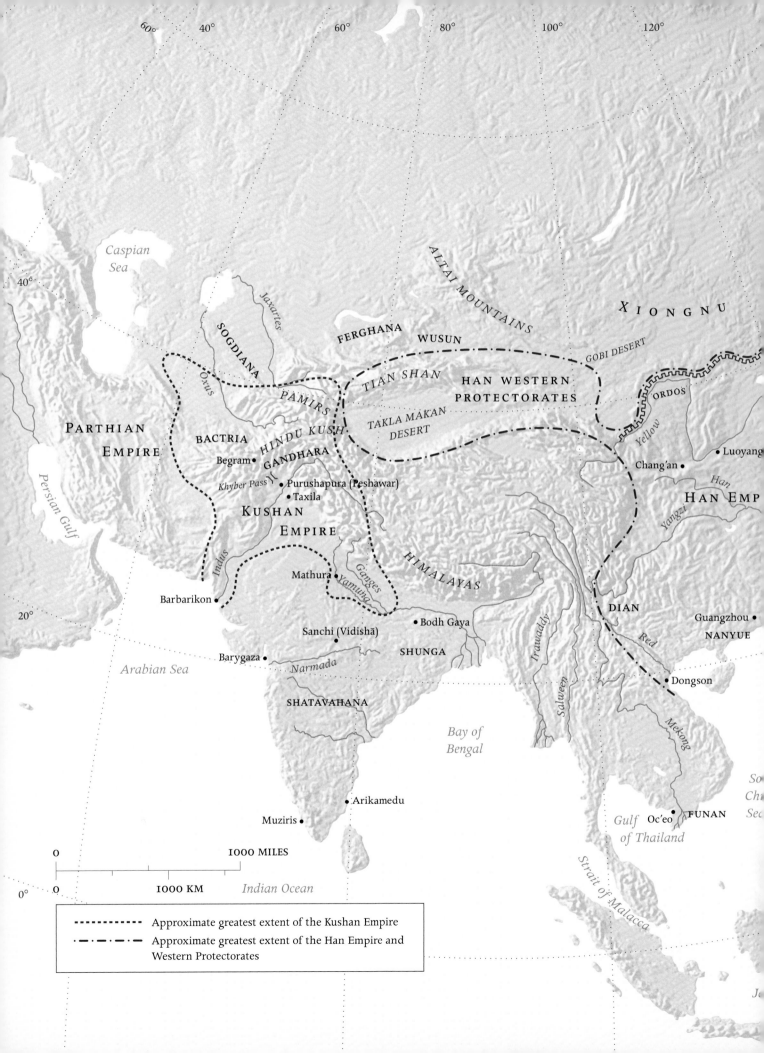

Caspian
Sea

60° 40° 60° 80° 100° 120°

40°

ALTAI MOUNTAINS

XIONGNU

Jaxartes

SOGDIANA

FERGHANA WUSUN

GOBI DESERT

TIAN SHAN

HAN WESTERN
PROTECTORATES

ORDOS

PARTHIAN
EMPIRE

Oxus

PAMIRS

TAKLA MAKAN
DESERT

Yellow

BACTRIA HINDU KUSH

Begram • GANDHARA

Chang'an •

• Luoyang

Persian Gulf

Khyber Pass • Purushapura (Peshawar)
• Taxila

HAN EMP

KUSHAN

Han

EMPIRE

Yangzi

Indus

Ganges

HIMALAYAS

Mathura •

Yamuna

20°

Barbarikon •

Irrawaddy

DIAN

Red

• Guangzhou

Sanchi (Vidishā)

• Bodh Gaya

NANYUE

SHUNGA

Barygaza •

Narmada

Salween

• Dongson

SHATAVAHANA

Arabian Sea

Bay of
Bengal

Mekong

So
Ch
Sea

• Arikamedu

Gulf
of Thailand

Oc'eo • FUNAN

Muziris •

Indian Ocean

0° 0 1000 MILES

0 1000 KM

Strait of Malacca

Je

0°

.......... Approximate greatest extent of the Kushan Empire

—·—·— Approximate greatest extent of the Han Empire and
Western Protectorates

ASIA

The transcontinental Silk and Spice Routes that provided the East and West with tantalizing glimpses of each other during the period between the second century B.C. and the second century A.D. also linked the nations of Asia together in unprecedented ways. The expansion of those routes intensified internal exchange along established land- and waterways in South, East, and Southeast Asia. Political changes and new economic opportunities also contributed to the movement of people and the interflow of luxury goods, technologies, visual traditions, and religious beliefs that characterize this vibrant period in Asian history.

160°

Sea of Japan

KOGURYO

P'yong'yang
● (Lolang Commandery)

SILLA
PAEKCHE
KAYA

Yellow Sea

East China Sea

Pacific Ocean

SOUTH ASIA: INDIA, PAKISTAN, AFGHANISTAN

Mauryas and Shungas

From the sixth to the third century B.C. a complicated system of trade and gift exchange linked the various republics and kingdoms that controlled the Indian subcontinent. The building of highways and the growth of urban centers, the minting of coins, the development of a script (Brahmi), the emergence of trade guilds, and the development of finance, banking, and usury also reflect the importance of trade in that era.

The expansion of earlier kingdoms in the northeast laid the groundwork for the emergence of India's first empire, ruled by the Maurya dynasty (321–185 B.C.). By 303 B.C. Chandragupta Maurya had gained control of an immense area ranging from Bengal in the east to Afghanistan in the west and as far south as the Narmada River. His son extended the empire into central and parts of southern India. The third emperor, Ashoka (r. 273–232 B.C.), is one of the most famous rulers in Indian history for his conversion to Buddhism, often likened in impact to the Roman emperor Constantine's acceptance of Christianity in A.D. 312. Ashoka actively promoted Buddhism and was determined to govern according to its principles.

Revered today as the Buddha Shakyamuni, the founder of Buddhism was an Indian prince named Siddhartha Gautama (d. ca. 400 B.C.; traditional dates ca. 556–483 B.C.). After studying with noted metaphysicians and ascetics, Siddhartha chose his own path and attained enlightenment while seated in meditation under the Bodhi (wisdom) Tree at Bodh Gaya, in northeast India.

His message is known as the Four Noble Truths: life is suffering; desire causes suffering; there is a way to end this torment; this way is the Eightfold Path of right opinion, right thought, right speech, right activity, right livelihood, right effort, right awareness, and right concentration. Buddhism, which eventually spread throughout Asia, evolved from this austere premise into a complicated religious tradition embracing the worship of multiple transcendent Buddhas, numerous saviors and guides known as bodhisattvas, and a panoply of protective deities.

At Ashoka's direction edicts promulgating the virtues of Buddhist thought were carved at enormous scale into rocks and caves throughout his empire. One records that he sent religious envoys, with no apparent results, to the Greek rulers of Syria, Egypt, Macedonia, Cyrene, and Epirus. Later he issued seven additional edicts carved on towering sandstone pillars with animal-form capitals, which were strategically placed throughout the empire. Ashoka is also credited with building eighty-four thousand stupas to enshrine the relics of the Buddha and commemorate key events in Siddhartha's life. The stupa, which derives from pre-Buddhist traditions, is a semicircular burial mound marking the remains of a great leader or teacher. Although none of those stupas survive, the core of the Great Stupa at Sanchi, in Madhya Pradesh, is thought to date from Ashoka's time. It was enlarged to its present diameter of 120 feet during the rule of the Shunga dynasty (second–first century B.C.), one of the powerful families that controlled north and northeast

India after the dissolution of the Mauryan empire. The stupa's stone casing, the balcony and three umbrellas at its top, and the encircling stone railing also date from the Shunga reconstruction. The railing marks the enclosure as a sacred space and demarcates a path for the circumambulation that is the principal form of worship at the site. Four gateways, each about thirty-five feet high, were built in the first half of the first century B.C. in a form that derives from earlier wooden architecture. They are carved front and back with densely peopled narratives depicting moments from the lives of Siddhartha Gautama (fig. 5). Siddhartha himself is always symbolized by motifs such as wheels, stupas, thrones, and footprints.

The Kushan Empire
The Shungas were succeeded by the short-lived Kanva kingdom (72–28 B.C.); thereafter the history of northeast India is little known until the early fourth century A.D., when the Guptas came to power. Other regions of the subcontinent are better documented. Central and southern India flourished under the rule of the Satavahanas (ca. 235 B.C.–A.D. 225) and played an important role in the maritime trade that linked East and West in the first three centuries A.D. Under the rule of the Kushans (first century B.C.–third century A.D.), northwest India and adjoining regions participated both in seagoing trade and in commerce along the Silk Routes to China.

The name Kushan derives from the Chinese term *Guishang,* used in historical writings to describe one branch of the

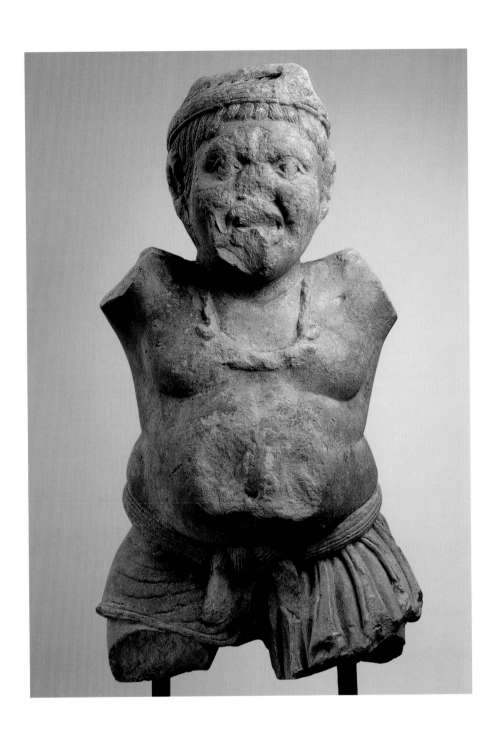

97. *Yaksha.*
India (probably Madhya Pradesh),
Shunga period, ca. 50 B.C.
Sandstone, H. 35 in. (88.9 cm)

Yakshas, and female *yakshis*, are ubiquitous subjects in Indian art. Originally local deities associated with potent or sacred sites, they evolved to become supernatural protectors of the earth and its treasures and were thought to influence such perennial human concerns as fertility, wealth, and health. Specific *yakshas*, such as Kubera, the leader of these earth spirits, were the focus of widespread cults as early as the third or second century B.C., when images of *yakshas* and *yakshis* predominate among anthropomorphic stone sculptures. Several of the most famous examples are nearly lifesize.

His dwarflike proportions, pendulous stomach, open gaze, and tooth-filled mouth define this figure as a *yaksha* (figs. 97, 98). Since his arms, now lost, were once raised to support a bowl or other container placed on his

which, refined during the Gupta period (ca. A.D. 320–550), provided much of the foundation for Buddhist imagery throughout the Indian subcontinent and in Southeast Asia.

The enormous stupas, shrines, and monasteries constructed during the Kushan period were partly an outgrowth of long-standing ties between Buddhism and the merchant class in India. It is likely that monasteries played a crucial role in mercantile activities, serving as safe havens for travelers, meeting places, and possibly banks or treasuries. Although both Chinese and Roman records exist detailing an international trade in luxury goods, including silk, glass, coral, pearls, and exotic botanical products (such as frankincense and myrrh), little material evidence of this trade survives from the Kushan era. One exception is a cache discovered in 1937 in a palace in Begram, near Kabul. Thought to have been hidden about A.D. 240 in anticipation of an invasion by the Sasanians—who in the following century destroyed the Kushan Empire—the hoard included Roman and Syrian glass comparable to the Roman glass vessels illustrated in this volume, plaster casts (emblemata) used by silversmiths, a bronze mask of Silenus, a weight in the shape of Athena, Chinese lacquers, and Indian ivories—an intriguing sample inventory of the trade that linked Rome and China and united the ancient world.

The Gandhara region at the core of the Kushan Empire was home to a multiethnic and religiously tolerant culture. Desirable for its strategic location, with direct access to the overland Silk Routes and links to the ports on the Arabian Sea, Gandhara had suffered many conquests and had been ruled by the Mauryas, Alexander the Great (329–326 B.C.), his Indo-Greek successors (third–second centuries B.C.), and a combination of Scythians and Parthians (second–first centuries B.C.). The eclectic culture of the region is vividly expressed in the visual arts produced during the Kushan period. Themes derived from Greek and Roman mythology were common initially, while later on Buddhist imagery dominated: the first depiction of the Buddha in human form dates to the Kushan era, as do the earliest depictions of bodhisattvas. Within the empire two distinctive traditions evolved simultaneously for the representation of Buddhist divinities. Sculptures produced in the Gandharan region illustrate the strength of Greco-Roman ideals, with their references to Apollo imagery and heavy drapery in lush folds clothing the body. Works from the Mathura area, on the other hand, are characterized by thin drapery designed to reveal the underlying forms and rely on Indian prototypes such as the fertility figures known as *yaksha*s. While the Gandharan style influenced early Chinese art, it was largely eclipsed by the Mathuran tradition,

Yuezhi—a loose confederation of Indo-European people who had been living in northwestern China until they were driven west by another group, the Xiongnu, in 176–160 B.C. The Yuezhi reached Bactria (present-day northwest Afghanistan and Tajikistan) about 135 B.C. There their disparate tribes were united by Kujūla Kadphises in the first century B.C. Gradually wresting control of the area from the Scytho-Parthians, the Yuezhi moved south into the northwest Indian region traditionally known as Gandhara (now parts of Pakistan and southeast Afghanistan) and established a capital near Kabul. They had learned to use a form of the Greek alphabet, and Kujūla's son was the first Indian ruler to strike gold coins in imitation of the Roman *aureus* exchanged along the caravan routes. The late-first–early-second-century-A.D. rule of Kanishka, the third Kushan emperor, was administered from two capitals, Purusha-pura (Peshawar), near the Khyber Pass, and Mathura, in northern India. Kanishka's rule, at the height of the dynasty, saw Kushan control of a large territory ranging south from the Aral Sea through areas that include present-day Uzbekistan, Afghanistan, and Pakistan and into northern India as far east as Benares and possibly as far south as Sanchi at Vidishā. It was also a period of great wealth marked by extensive mercantile activities and a flourishing of urban life, Buddhist thought, and the visual arts. In a famous lifesize portrait sculpture from the dynastic shrine at Mat, near Mathura, Kanishka stands with his feet splayed, wearing the heavy boots and long tunic suitable for life in the colder climate north of India and holding a sword and a club.

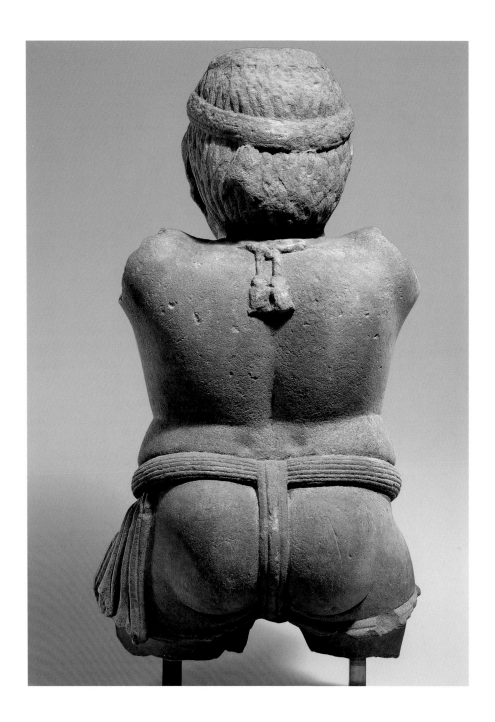

head, he can be identified as a "carrier *yaksha*," or *bharavahaka yaksha*. A headband covers his wavy hair, and a braided rope supports the heavy torque at his neck. He wears a thick, knotted sash and a loinclothlike garment that is drawn up and over the sash in back. The *yaksha*'s vitality, the boldness and firmness of the carving, and the heavy folds and flaring hem of the drapery at his left hip are typical of the period.

The earliest examples of Buddhist art in India date from the Shunga period. Stylistic parallels to this figure are found in the decoration of the Great Stupa at Sanchi, where four potbellied dwarfs serve as capitals of two pillars supporting a carved architrave on the west gate (fig. 5).

98. *Yaksha,* back view

99. *Plaque with Royal Family.*
India (West Bengal), Shunga period,
1st century B.C. Terracotta,
H. 12¾ in. (32.4 cm)

The figures on this remarkably well preserved plaque (fig. 99) wear elegant clothing and extraordinary jewelry, which are represented with great care. This kind of detail is characteristic of works produced in or near Chandraketugarh—north of Calcutta, in West Bengal—an excavated site noted for the large number of terracottas it has yielded. The small holes at the upper corners of this example are a common feature of terracotta plaques; perhaps such works were hung on walls for decorative or devotional purposes (most have religious imagery).

This family scene and the touching intimacy that permeates it are unusual in Indian terracottas. The figures are placed in an architectural setting delineated by long, narrow columns. The man, seated on a chair, wears a short, bejeweled hip wrap, or *dhoti*, a scarf draped over his shoulders, and an elaborate turban. With his left hand he holds the back of his wife's head: she stands before him and gently caresses his knee. She wears a long, nearly transparent skirt with a jeweled girdle and a harness of jeweled strands that falls from her shoulders to a rosette beneath her breasts and then is looped over her left arm. Her large turban and its horn-shaped appendage are typical of the fantastic headgear seen in art of the Shunga period. Both she and the man wear large round earrings, numerous bangles on their arms, and thick ankle ornaments.

In the foreground a small figure, thought to be the couple's son, is shown seated beside a dog, which he holds by its leash. Two ducks appear at the lower right, while on the somewhat damaged left side can be seen traces of a monkey that is probably climbing the leg of the chair on which the man sits.

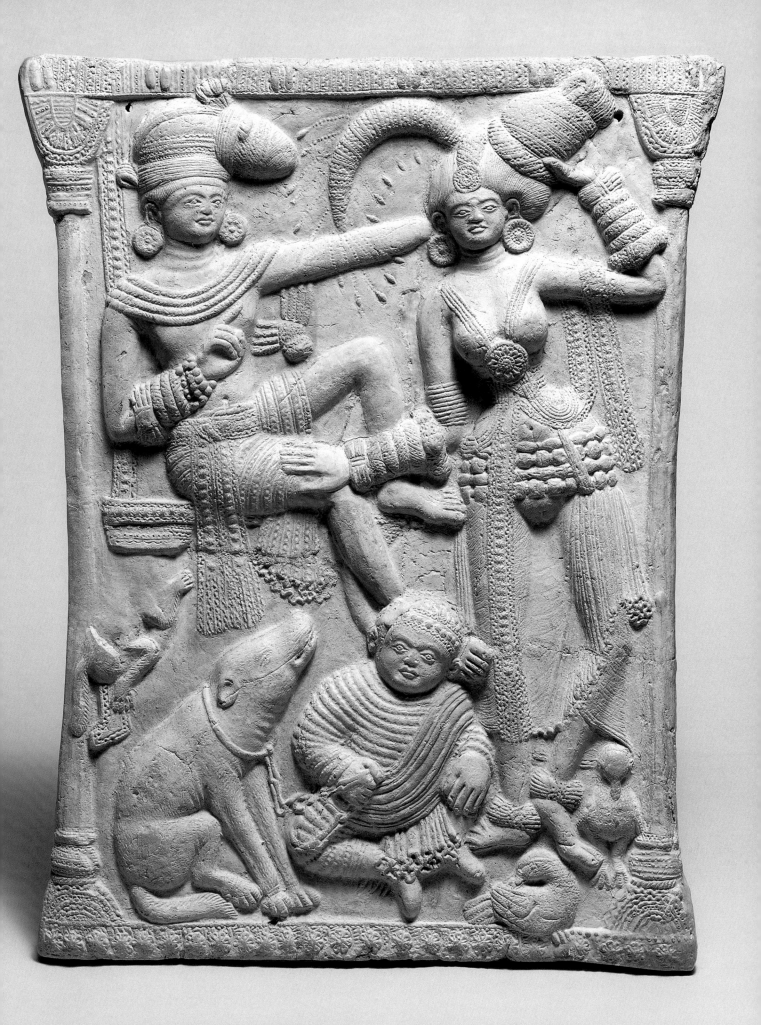

This exquisite pair of gold earrings (figs. 100, 101) is rare in having survived. While splendid jewelry adorns the regal and divine figures represented on stone sculpture and terracotta plaques of the Shunga period, few of the ornaments themselves still exist. It is thought that jewelry was not kept and reused but instead was melted down, to avoid transmitting the karma of the former owner to another person.

The earrings were made from thin sheets of gold and then embellished with more gold, both rolled into wires and applied as tiny balls in a technique known as granulation. In addition to clusters and rows of "pearls," each earring is decorated with a winged lion, an elephant, and two vases filled with vegetation. The animals are in high relief and covered with granulation. A saddle cover decorated with a swastika, a traditional Indian symbol of good luck, is on the back of each elephant. Put on by slipping through a pierced and distended earlobe from the back, the earrings are worn with the lion facing the wearer's cheek and the elephant on the outside.

There is evidence that ornaments like these existed in widely scattered parts of India. A copper earring of the same shape was a surface find at Kaushambi, a Shunga-period center in north central India. Comparable earrings are worn by a fertility *yakshi* sculpted on a railing pillar from the early-first-century-B.C. stupa at Bharhut, in north central India (Madhya Pradesh), and a "universal ruler" represented on a white marble first-century-B.C. relief from Andhra Pradesh, in the south, wears earrings of the same type. Their manufacture in gold and their extraordinary workmanship indicate that these adornments were made for a member of the ruling elite in either north or south India.

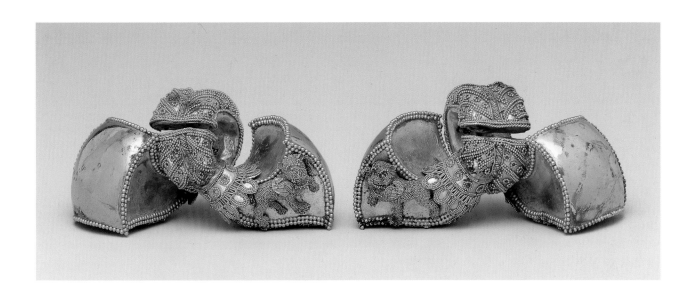

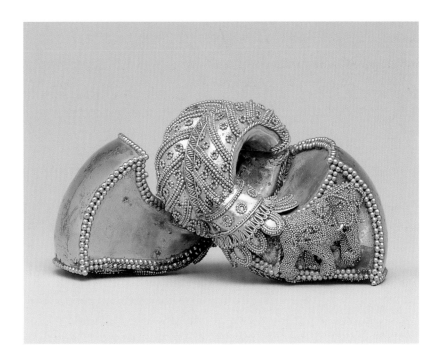

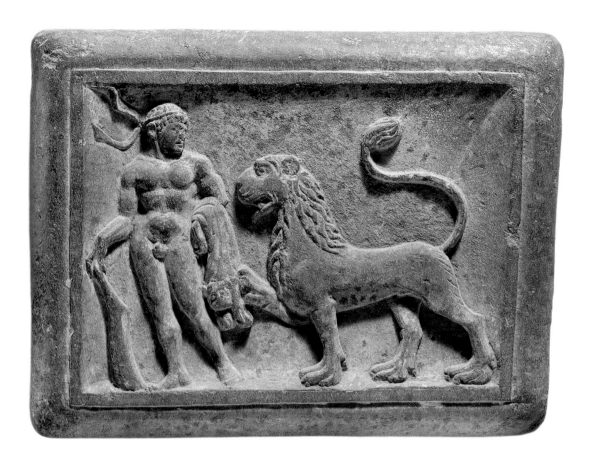

102. *Weight Depicting Herakles
and the Nemean Lion*.
Pakistan (ancient region of
Gandhara), 1st century B.C. Schist,
10¼ × 13¾ in. (26 × 34.9 cm)

As the first of his twelve labors for the king Eurystheus, the Greek mythic hero Herakles was ordered to slay the monstrous Nemean lion. Since the beast's adamantine skin was impervious to spears and arrows, Herakles strangled it. He then skinned the lion, taking the pelt as a cloak, the head as a helmet, and one of the hindquarters as a club. The lion skin slung over his left arm and the club he holds in his right hand suggest that the muscular figure who stands in a relaxed contrapposto pose on this weight is Herakles (fig. 102), although there is no obvious explanation for the charmingly tame lion that accompanies him.

Two half-moon–shaped indentations for gripping and a wrestling scene on the back make it likely that the object is an athlete's weight. The scene, of two wrestling figures watched by a third competitor and two spectators, may allude to one of the feats of the Hindu boy god Krishna, who was revered for his physical prowess. A similar composition on a later weight from the Mathura area depicts an episode from the Hindu scripture *Bhagavata Purana* in which Krishna defeats two gymnasts in the service of the demon king Kamsa. Krishna was often conflated with Herakles in the mixed culture of northwest India, where ties with the Mediterranean world had long existed.

Although wrestling, boxing, and bodybuilding played an important role in the lives of ancient Greeks and Romans, comparable practices are not usually associated with Indian culture. The existence of this and other athlete's weights suggests that such activities were known, probably practiced, and of sufficient importance to become a subject of representation.

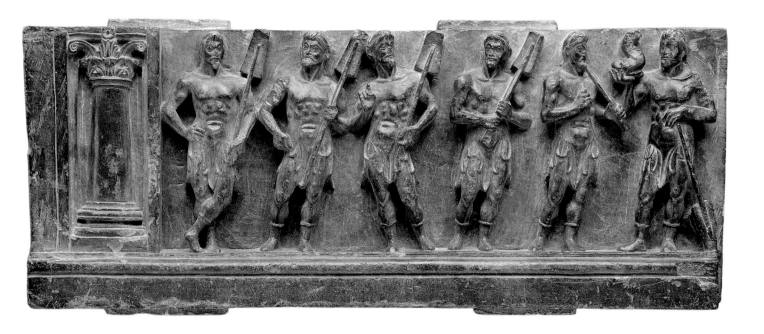

From the first to the third century A.D. the Gandhara region in the northwest of ancient India flourished as a major commercial and cultural center under the rule of the Kushans, a nomadic people of Central Asian origin who after a protracted migration had settled in Gandhara. Art produced there during the Kushan period illustrates the multiculturalism that had long defined this region. Greek styles and images were first introduced with Alexander the Great's conquest of the area and remained vigorous through contact with the expanding Roman Empire. They joined indigenous Indian traditions and those associated with Parthian and other cultures in a great pool of stylistic forms available to artists during the period.

The oars they carry and the acanthus leaves that appear to grow out of their bodies suggest that the six athletic, bearded figures standing in casual poses along the front of this stair riser are marine deities (fig. 103). They have broad shoulders and strong legs, and particular care has been taken to depict the schematized musculature of their upper chests and abdomens. The deity at the extreme right holds a dolphin. In what has been identified as a gesture of good luck, the third figure from the left holds up his right hand with the index and fifth fingers extended.

Flanges at the top of the panel were used to fit this riser into a staircase. It is one of a set of sixteen thought to have been part of a Buddhist monument in Buner, in the north, and sculpted with scenes of celebrations, processions, and rows of demigods such as the marine deities. The Greco-Roman themes and stylistic treatment help date the risers to the first century A.D., before Buddhist imagery came to dominate Kushan art.

One riser similar to this piece but with the column at the opposite end is in the British Museum, London; it is very likely that the two originally formed a single wide riser.

103. *Stair Riser with Marine Deities.*
Pakistan (ancient region of
Gandhara), 1st century A.D. Schist,
6⅝ × 17 in. (16.9 × 43.2 cm)

104. *Torso of a Bodhisattva.*
Pakistan (ancient region of
Gandhara), Kushan dynasty, late
1st–2nd century A.D. Schist,
H. 64½ in. (163.8 cm)

By the time of the Kushans in the first centuries A.D., Buddhism's austere emphasis on personal effort had evolved to include the possibility of the transfer of merit from one sentient being to another. Bodhisattvas, who, like Buddhas, are enlightened, play a particular role in this process. While a Buddha has transcended human concerns and entered into nirvana, a bodhisattva remains on earth to help and guide others in their quest for spiritual perfection.

In early Buddhist art the Buddha and his teaching were represented by symbols such as wheels and footprints. The earliest extant anthropomorphic images of Buddhas and bodhisattvas appeared in the first century A.D. While works from the Mathura region are in the indigenous styles of north central India, those made in Gandhara reflect the eclectic artistic practices of that area.

This magnificent bodhisattva (fig. 104) is dressed in a long, heavy hip wrap that is tied at the front with a rope. A stole draped over his left shoulder and arm falls below his waist and loops up onto his right hip. On his bare chest he wears an elaborately decorated torque, a longer necklace, and other bejeweled strands that cross from his left shoulder to his right side. The back of the figure is uncarved, which suggests that it was made to be placed against a wall or in a niche, probably on the exterior of a stupa or shrine. The bodhisattva's heroic, muscled torso, weighty garments, and deeply cut drapery folds follow conventions that derive from Roman prototypes. However, the schematization of the musculature and the regular patterning of the folds are elements that draw on local stylistic traditions.

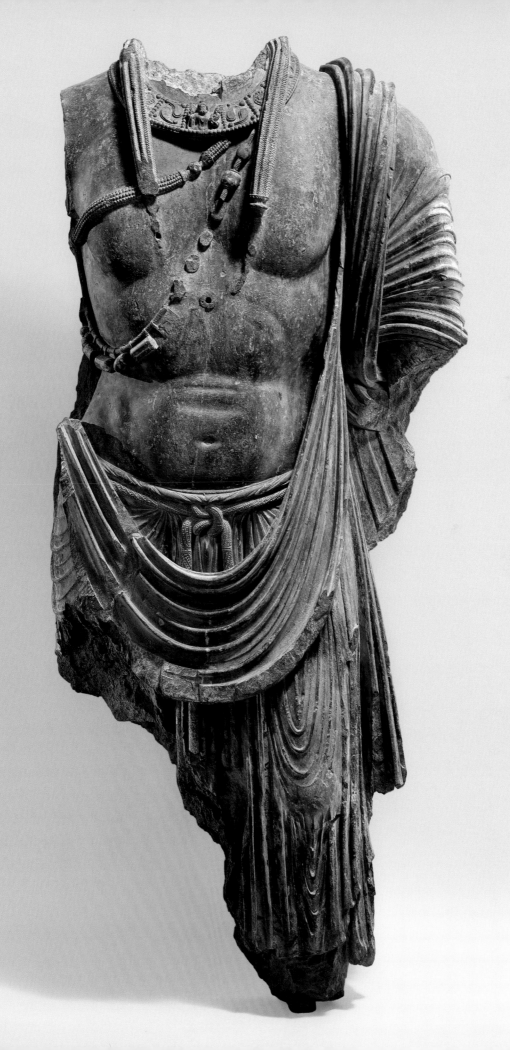

EAST ASIA: CHINA, KOREA, JAPAN

China: Qin and Western Han Dynasties

During the Qin (221–206 B.C.) and Han (206 B.C.–A.D. 221) dynasties China was the source of the fabled silk for which the overland trade routes are named as well as the military might behind the *pax sinica* that made them feasible. Although northern and central China had earlier been a united land, the area was divided into smaller polities in the Warring States period (475–221 B.C.). During this era of political and philosophical turmoil, continual warfare spurred advances in military technology and the desire for courtly display inspired the development of regional styles in the arts.

By pursuing a harsh policy aimed at the consolidation and maintenance of power, Qin, previously a minor state in the northwest, had by the mid-third century B.C. seized the territories of small states on its southern and western borders. Soon thereafter Ying Zheng, who would reunite China, came to the Qin throne as a boy of nine. He captured the remaining six of the "warring states," expanding his rule eastward and as far south as the Yangzi River, and proclaimed himself First Emperor of the Qin, or Qin Shihuangdi. Qin, pronounced "chin," is the source of the Western name China.

Throughout his rule Qin Shihuangdi continued to extend the empire, eventually reaching into Vietnam. He divided the country into commanderies and prefectures administered jointly by civil and military officials under the direction of a huge central bureaucracy. This administrative structure served as the model for government in China until the collapse of the Qing dynasty in 1911. Qin Shihuangdi also standardized the Chinese script, currency, and system of measurements and expanded the network of roads and canals. He is renowned for creating the Great Wall of China by uniting several preexisting defensive walls on

the northern frontier to form a barrier some fifteen hundred miles long as a protection against nomadic attacks (fig. 3); he is reviled for a state-sponsored burning of Confucian works and other classics in 213 B.C.

An accidental discovery in 1974 brought to light a vast army of over six thousand lifesize terracotta figures guarding the emperor Qin's tomb (fig. 4). The spectacular find was one of many made in mainland China during the last fifty years—archaeological advances that have utterly transformed the study of Chinese art and thought. Recensions of classic texts, bronze, jade, and lacquer vessels, musical instruments, paintings on silk, and suits made of jade (then believed to preserve the corpse) have been unearthed, as well as innumerable ceramic models depicting servants and entertainers or made as substitutes for objects of more precious materials.

After the civil war that followed the death of Qin Shihuangdi in 210 B.C., China was reunited under the rule of the Han dynasty, which is divided into two major periods, the Western or Former Han (206 B.C.–A.D. 9) and the Eastern or Later Han (A.D. 25–220). The boundaries established by the Qin and maintained by the Han have more or less defined the nation of China until the present day. The Western Han capital, Chang'an, in modern Shaanxi Province—a monumental urban center laid out on a north-south axis with palaces, residential wards, and two bustling market areas—was one of the two largest cities in the ancient world. (Rome was the other.)

During the rule of the emperor Wudi (141–87 B.C.) a flowering of poetry, literature, and philosophy took place. The monumental *Shiji* (Historical Records), written at this time by Sima Qian, was a work that set the standard for later government-sponsored histories. Among many other things it recorded information

about the various peoples, invariably described as "barbarian," who lived on the empire's borders. Wudi also established Confucianism as the basis of correct official and individual conduct and of the educational curriculum. Kong Qiu, or Confucius (ca. 551–479 B.C.), had espoused a moral philosophy centered on the concept of *jen*, usually translated as "perfect goodness" or "benevolence," and had envisioned an ideal cosmos based on the virtue of the monarch and on proper and harmonious relationships between ruler and subjects, parents and children, husbands and wives, and different segments of society. The reliance of the bureaucracy on members of a highly educated class grounded in Confucian writings and other classics defined China's statecraft for centuries.

Under Wudi, Han China regained control of territories first conquered by Qin Shihuangdi in southern China and the northern part of Vietnam, new commanderies were established in Korea, and contacts were made with the western regions of Central Asia. An envoy sent to the West in 139–138 B.C., Zhang Qian, years later reached Bactria and the Ferghana Valley (in present-day Uzbekistan and Tajikistan) and brought back to the Chinese their first information about other "civilized" states—for example, that these lands contained fortified cities and that wheat and grapes were grown there. The conquest of Ferghana and neighboring regions in 101 B.C. allowed the Han to seize a large number of "heavenly" long-legged horses, valued for cavalry maneuvers. It also gave China control of the east-west trade routes running on both sides of the Takla Makan desert north of Tibet, along which, in return for silk and gold, China received wine, spices, woolen fabrics, grapes, pomegranates, sesame, broad beans, and alfalfa.

Zhang Qian discovered that silk, bamboo, and other goods were traded to the West, probably from the Sichuan region (most likely via Burma), by wealthy, independent non-Han states in southwestern and southeastern China. One of these was the Dian culture on the Yunnan plateau, where excavations have now yielded bronze ornaments, weapons, tools, and vessels, including containers that carry astonishing three-dimensional scenes on their covers depicting agricultural activity, weaving, processions, and perhaps the pledging of allegiance. Large kettle-drums that figure in these scenes represent a type commonly known as Dongson drums, which may have been used in warfare and are thought to symbolize political power and agricultural fertility. Dongson drums were made in Vietnam as well as China and have been found throughout mainland Southeast Asia, while imported examples and local variants are known from Indonesia. The common use of these drums, of certain types of vessels, and of particular images, such as those of feathered or winged beings, is an aspect of the distinctive cultural continuum that for centuries united parts of southern China and northern Vietnam.

The Xiongnu, a confederation of pastoralists and nomads of mixed ethnic and linguistic backgrounds inhabiting the grass-lands, mountains, and deserts of Inner Mongolia, were the most vexatious of the Western Han's neighbors. Their incursions had earlier spurred the creation of the Great Wall. According to the *Shiji,* they lived without cities or permanent homes, had no family names, lacked writing, and excelled in horsemanship and warfare. In the second century B.C., under the leadership of the brilliant chief Maodun, the Xiongnu united into a vast empire rivaling in size both Han China and Rome. Their threat resulted

in 198 B.C. in the *Hequin*, or "harmonious kinship" accord, which assigned equal status to the Han and the Xiongnu and awarded the latter tribute in the form of food and textiles and, when necessary, the hand of a Chinese princess in marriage. The accord was renegotiated at least nine times before its dissolution by Wudi in 135 B.C. Silk, as many as thirty thousand bales, one of the most important "gifts" offered to the Xiongnu, then probably made its way to the West via overland trade. Border trade flourished between the Xiongnu and the Han, with the former providing furs, carpets, horses, and pack animals in exchange for grains, silk, metalwork, and lacquer. Chinese craftsmen made specialty items, such as bridle or chariot fittings, for their northern neighbors. Belt buckles of gold, silver, and bronze, worn over tunics, were among the most coveted items. In the mid-first century B.C. the Xiongnu coalition eroded and the Xianbei confederacy, which would prove equally problematic to the Han and their successors, rose to power.

China: Eastern Han Dynasty
Disputes among factions, including the families of imperial consorts, contributed to the dissolution of the Western Han Empire. A generation later China flourished again under the Eastern Han dynasty (A.D. 25–220), which ruled from Luoyang, a capital city farther east, in present-day Henan Province. Also organized around a north-south axis and covering an area of approximately four square miles, the city was dominated by two enormous palace complexes.

The Eastern Han was extensively interconnected with the world beyond its borders. Chinese dominance in Central Asia was reasserted in the years 73–94. Trade, less rigorously controlled than in the first part of the dynasty, flourished, with

caravans reaching Luoyang every month. There was also an expansion of diplomacy: in 94 fifty envoys from Central Asia are recorded, and Japanese envoys visited in 57 and 107. A direct link to Rome in 166 is suggested by the reported arrival of an emissary from Antun (the emperor Marcus Aurelius) bringing ivory, rhinoceros horns, and tortoiseshells. The earliest known Buddhist images in China, thought to date from the first or second century A.D., are carvings on the cliffs at Gongwangshan in Jiangsu Province, southeast of Luoyang. The signs of a growing understanding of this religion reflect China's strengthened relations with India and Central Asia as well as the practice of Buddhism by foreigners living in designated wards in the Eastern Han capital.

Although the Han dynasty collapsed in 220 and China was not reunited until the end of the sixth century, the cohesion that developed during the Qin and Han eras created much of the cultural continuity underlying the long-lasting Chinese civilization.

Korea

Early relations between China and the Korean peninsula consisted of economic and technical exchanges and intermittent immigration, especially from China to Korea. During the third and second centuries B.C. the influx of Chinese and other refugees into Korea intensified as a result of the political turmoil that accompanied the establishment of the Qin and Han dynasties. One of the few immigrants whose name was recorded, Weiman Chaoxian (in Korean, Wiman Chosŏn), arrived with over one thousand followers in about 195 B.C. and eventually gained control of the northern state subsequently known as Chosŏn.

Chosŏn was one of the powerful confederated kingdoms, often centered on walled cities, that existed throughout the Korean peninsula in the second and first centuries B.C. Concerned about shifting power relationships among these states and with the Xiongnu to the north in China, the Han emperor Wudi invaded the northern part of Korea in 109 B.C. and established four commanderies there. Han control of these far-flung posts was frequently challenged, and by 82 B.C. only two remained. Lelang (in Korean, Nangnang), near P'yong'yang, was the largest and most influential; it served as a bastion of Chinese culture and technology for over four hundred years.

Between the second century B.C. and the first century A.D., the more powerful Korean states conquered and amalgamated smaller polities. By the end of the first century A.D., Koguryŏ to the north of the Han River, Paekche in the southwest, Silla to the south, and Kaya in the south central area had emerged with control of the peninsula, which they maintained until the unification of Korea centuries later. Buddhism, introduced from China beginning in the late fourth century A.D., would soon become the basis of a new cultural cohesion between China, Korea, and, ultimately, Japan.

Japan

From the seventh to the fourth century B.C., immigrants to Japan, primarily from southern China and Korea, brought wet-rice agriculture, bronzeworking, and other technologies that formed the basis of Japanese culture during the subsequent Yayoi period (fourth century B.C.–third century A.D.). Elegant, thin-bodied ceramics and the distinctive bronze bells known as *dōtaku* were produced during this period.

As they do for early Korea, Chinese records often augment the information about early Japan provided by archaeological

discoveries. Compiled about A.D. 297 by the official Chen Shou, the *Wei Zhi* (Annals of the State of Wei) describes Wa (Japan) as a land of over thirty communities settled on mountainous islands in the middle of the ocean. According to this source, the warfare plaguing the archipelago between A.D. 170 and 180 was resolved by the election of a queen named Himiko. Presumably less bellicose than her male counterparts, Himiko sent an embassy to Wei in northern China in 239 and was granted the title Xin Wei Wa Wang (Queen of Wa, friendly to the Wei). The *Wei Zhi* also describes Japanese palaces, watchtowers, and palings, the existence of which has been confirmed by recent excavations at the ancient site of Yoshinogari on Kyūshū Island. A rice-farming population had lived there earlier; the settlement at Yoshinogari flourished from the first century B.C., when its outer moat was constructed, to the third century A.D. An access path lined with clay ritual vessels led to a mound at the north of the site, and it is thought that people from villages under Yoshinogari's control were obliged to visit this spot and pay their respects to deceased members of the ruling class. An inner moat, a large burial mound, a palace, and watchtowers in the center of the site, as well as enormous storehouses for rice to the west, date from the second and third centuries A.D.

Throughout the subsequent Kofun, or Tumulus, period (ca. 250–600), named for the construction of gigantic moated burial mounds, regional centers were gradually incorporated into a larger state centered on the Nara plain. Chinese systems of government and writing, brought with Buddhism in the sixth century A.D., contributed to the development of the Japanese nation and its increasing participation in the culture of East Asia during this formative period.

Intriguing metal artifacts such as this silver plaque (fig. 105) and scattered references in Chinese and Western histories are our only sources of information about the numerous pastoral, seminomadic, and horse-riding tribes who inhabited the vast reaches of Central Asia traversed by the Silk Routes.

Most likely used as an adornment on a bridle or other equine accoutrement, this small plaque illustrates the dissemination of artistic motifs across Asia. The beaklike shape of the horse's muzzle, the dramatic twist of its hindquarters, and the lively openwork frame all reflect an imagery and stylistic approach found in objects made earlier by Indo-European Scythian peoples living on the Iranian plateau and in the area around the Black Sea. Comparable motifs appear in tattoos on the body from tomb 2 at Pazyryk, in the Altai Mountains of southern Siberia. Eight of the twenty-five burial mounds at that site, currently dated between the late fourth and the early third centuries B.C., have yielded textiles and metalwork from West and Central Asia as well as silk, lacquer, and metalwork from China.

This plaque was cast in silver and has remnants of gilding on its surface. It was probably made in north China for a member of the Yuezhi or one of the other confederacies in Central Asia that maintained an active trade with various Chinese centers, exchanging fur and carpets for commodities such as grain and for luxuries such as silk and metalwork.

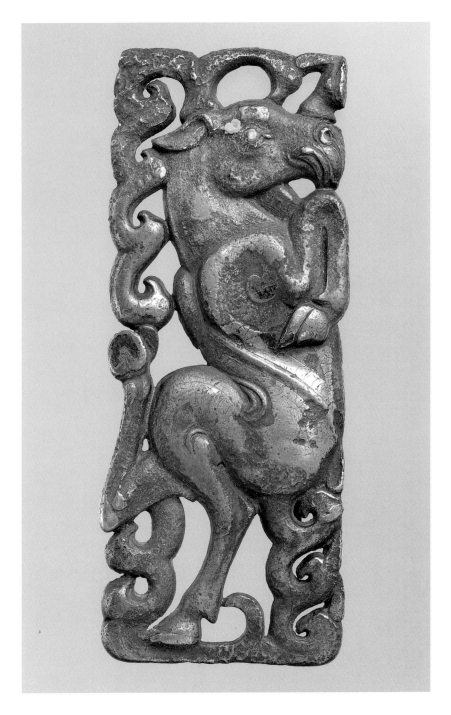

105. *Horse Plaque.*
Northwest China or Inner Mongolia, 4th–3rd century B.C.
Silver with mercury gilding, H. 5 in. (12.7 cm)

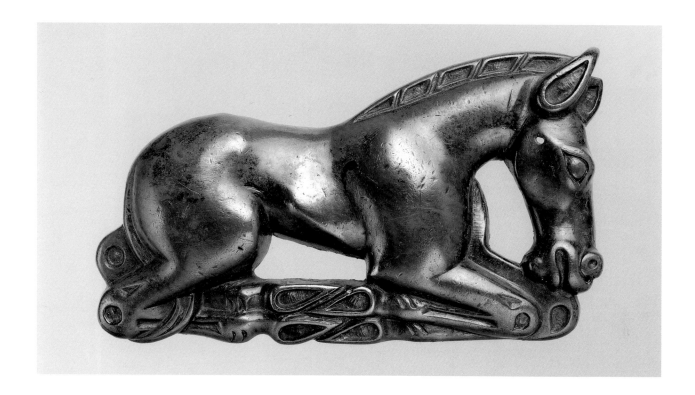

The winsome personality and well-defined muzzle, forequarters, and hindquarters of this horse (fig. 106) typify the treatment of animals in Chinese metalwork of the fourth through the second century B.C. However, the creature's recumbent position and the careful placement of its upturned hooves show that the artist was familiar with conventions observed by metalworkers farther west, in Central Asia. The teardrop shape of the hooves and ears and the cartouchelike treatment of the mane also derive from Central Asian visual traditions.

The woven pattern impressed in the back of this plaque indicates that it was made by the lost-wax–lost-textile technique. In this method, heated metal introduced into the mold during the casting process replaces both the wax that filled the mold and the textile that lined and reinforced it. Devised for the casting of thin plaques, the lost-wax–lost-textile process was used in making high-quality objects, primarily of gold or silver. Plaques so produced have been excavated in some numbers in northwest China and Inner Mongolia. Crafted by Chinese artisans for high-ranking members of the Yuezhi, the Xiongnu, and other confederacies that inhabited these areas, they were most likely used as decorations for bridles and other horse gear.

106. *Plaque in the Shape of a Horse.*
North China, 3rd–1st century B.C.
Silver with gilding, H. 3⅛ in.
(7.8 cm)

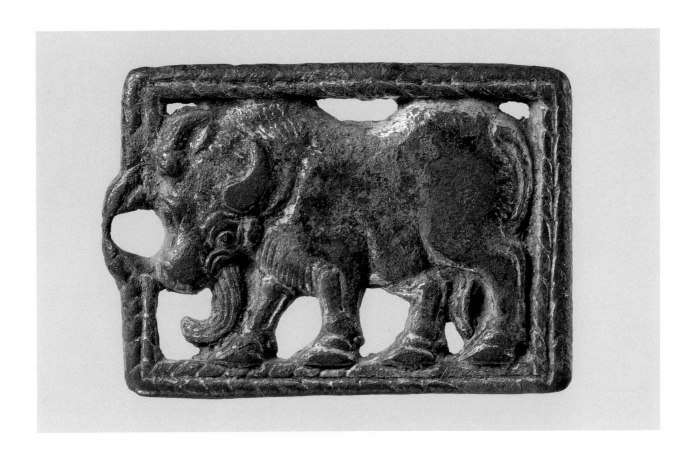

107. *Belt Buckle.*
North China, Xiongnu type,
3rd–2nd century B.C. Gilt bronze,
H. 2¼ in. (5.7 cm)

This small ornament (fig. 107) is one of a pair of belt buckles designed as mirror images. Enclosed in a braided frame, an ox stands with its lowered head in three-quarters view and its tail tucked between its hind legs. Numerous objects of this type have been found in both northern China and Inner Mongolia. They were made in China for the seminomadic people known as the Xiongnu, who wore them on belts buckled over long tunics as a decoration and mark of status. Different techniques and metals were used in the production of the buckles; it is probable that those of gold and silver were prized above gilded examples such as this one, which in turn were more highly valued than tinned or plain bronze pieces.

Although references to the Xiongnu are common in early Chinese histories, their origins remain unclear. During the third century B.C. this confederacy, of mixed ethnic and linguistic stock, controlled a vast Central Asian territory that extended west as far as the Caucasus. Relations between the Chinese and these powerful northern neighbors were always complicated and included military conflict, tribute payments of grains and silk, official exchanges of other goods, and trade both sanctioned and unsanctioned.

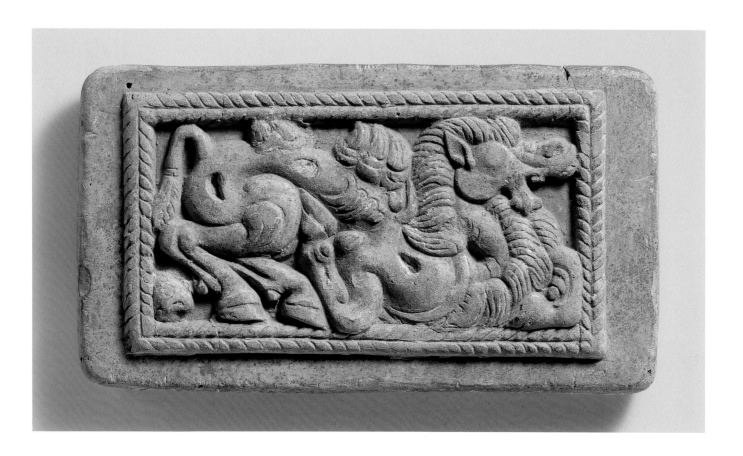

This camel's unlikely posture and the fanciful treatment of its chest, head, and mane illustrate the influence of Eurasian imagery on the art of north China in the third and second centuries B.C. Although it was a principal beast of burden on the Silk Routes, the camel plays a surprisingly minor role in the early visual arts of Central Asia and northern China. It is rarely represented in metalwork associated with Central Asian tribes, and it only joined the repertory of subjects for Chinese funerary sculpture between the sixth and the eighth centuries A.D., a period when contacts among West Asia, Central Asia, and China were renewed.

The choice of a recognizable animal rather than a fantastic one and the use of a braid-patterned frame place this plaque (fig. 108) in the third or second century B.C. Both features reflect the taste of the Xiongnu, who dominated Central Asia during that period. It seems likely that this plaque served as a model for the making of molds used to cast belt plaques and other personal adornments as well as ornaments for horse trappings and chariots, ubiquitous objects among the Xiongnu and other inhabitants of Central Asia.

108. *Model for a Plaque.*
North China, 3rd–2nd century B.C.
Earthenware, W. 4 in. (10.2 cm)

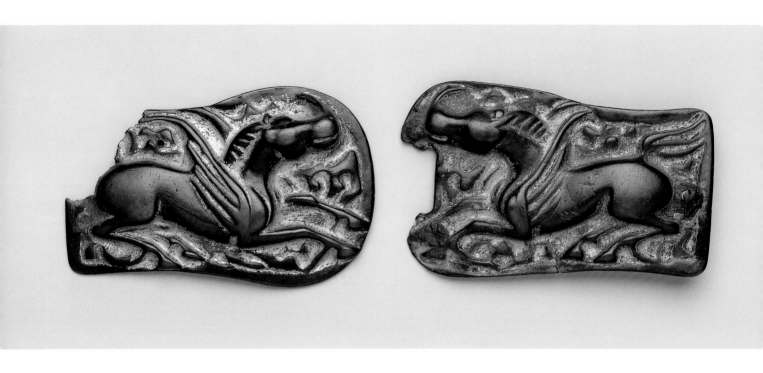

109. *Pair of Belt Plaques.*
North China, Xianbei type, ca. 1st
century A.D. Silver plate and gilt,
W. of each ca. 4⅜ in. (11.1 cm)

Unlike the ornaments favored by the Xiongnu, few plaques or other adornments used by the Xianbei are known. Gilt plaques embellished with images of flying horses similar to these (fig. 109) have been excavated at sites on the Manchurian plain, in northeast China. However, it is rare for a pair with facing horses to survive.

The name Xianbei refers to a confederation of tribes who spoke different languages and came from different regions. Originally part of the Xiongnu empire, the Xianbei broke away and assumed control of their lands in the middle of the first century B.C. From that time until the sixth century A.D. they played a complicated role in Central Asian and Chinese history. The Xianbei were the rulers of many of the small states that vied for control of north China from the third to the mid-fifth century A.D. The Tuoba, a subsidiary branch of the eastern Xianbei, established the powerful Northern Wei dynasty that ruled north China from the mid-fourth to the mid-sixth century.

The first chapter of the *Wei Shu* (History of the Wei), written in the mid-sixth century by the Chinese historian Wei Shou, preserves most of what little is known about the Tuoba prior to the establishment of the Northern Wei dynasty. According to this source, a mysterious animal spirit that was shaped like a horse and bellowed like an ox led the Tuoba south on the perilous journey from their homeland in Heilongjiang Province (in the far northeast of China) over the Daxing'an range and into the Inner Mongolian plain. It is possible that the winged horses on this pair of plaques illustrate that legendary event.

110. *Short Sword,* detail showing reverse side of pommel and grip

From its inception in the third millennium B.C., the sword served both as a weapon and as a symbol of societal status and power. During the first millennium B.C., in the hands of the nomadic peoples of the Eurasian steppes, it became, along with the bow, one of the primary cavalry weapons of the ancient world. Such groups as the Scythians, the Yuezhi, the Xiongnu, and the Xianbei were able to achieve a succession of federations and kingdoms in Eurasia by combining the use of sword and bow with an unparalleled skill in horsemanship. Archaeological investigations of burial sites have established the importance of the sword as both a valued possession and a sign of rank in various nomadic societies. While some sword forms can be identified with specific nomadic peoples through consistent characteristics of the burials in which they are found, the owners of other examples, such as the one shown here (figs. 110, 111), remain less certain. The bronze hilt of this sword has several distinctive features, including a domed pommel with nonzoomorphic ornament, a pebble-textured hourglass grip, and, extending from the grip, a socket with concave sides from which the double-edged steel blade emerges. The socket is divided into compartments, a number of which are inlaid with gold foil. The hilt is made in two halves seamed longitudinally up the sides. It has been brazed or cast directly onto the tang of the blade, which passes up through the entire length of the socket. The complex techniques required for the manufacture of this sword, the combined use of bronze and steel, and the presence of gold decoration all indicate its origin in a society with advanced metalworking skills and a relatively high level of material wealth. The technology to produce iron and steel existed in China by about the sixth century B.C., although those metals were not used for weapons before the fourth century B.C. Swords similar to this one have been found in Yunan in southwestern China and in Ningxia in northwestern China. Since the Ningxia finds also include many other examples of similarly advanced metalworking, this sword may have originated in that region, perhaps around the time of the late Warring States period.

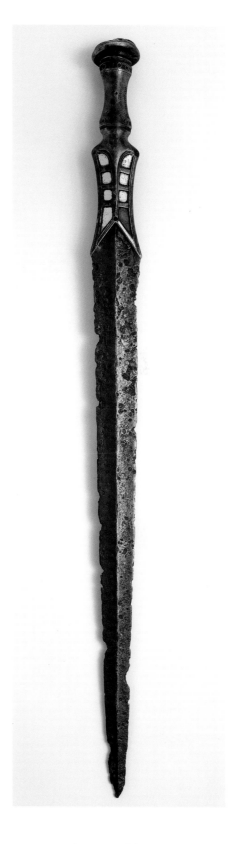

111. *Short Sword (Duan Jian).* Eastern Central Asia, ca. 4th–1st century B.C. Steel, bronze, and gold, L. 26⅜ in. (67 cm)

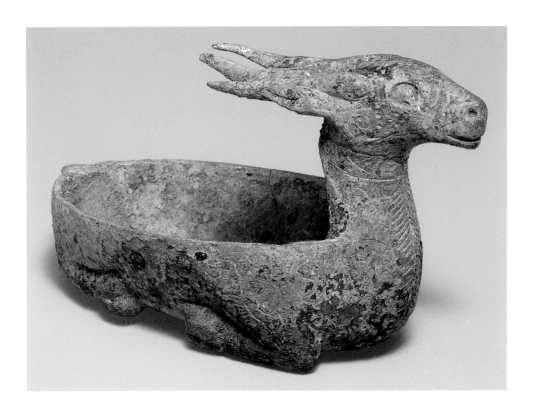

112. *Mat Weight in the Shape of a Doe.*
North China, Han dynasty,
1st century B.C.–1st century A.D.
Bronze, H. 2⅞ in. (7.3 cm)

Sketchy parallel incisions at the throat, neck, and face and along the haunches enhance the simple but elegant form of this recumbent doe (fig. 112). Her uplifted head and alert expression belie the quiet pose, hinting at her ability to flee instantaneously.

A low bed, a small table, and a screen were often the only furnishings in a Han-dynasty room. The floor was generally covered with mats kept in place by weights in the shape of single animals, fighting beasts, or storytellers or other entertainers. Deer-shaped weights comparable to this one excavated in north China contain a large shell, and it seems likely that the back of this example was once similarly decorated. The large shells were probably exotic imports to the interior from regions in south China that had been incorporated into the Han Empire.

Deer have a long history in Chinese and Central Asian art as apotropaic images as well as symbols of power, wealth, and good luck. Additionally, the Chinese character for *deer* (*lu*) is a homonym for the words "official" and "income," which would have made this weight a particularly appropriate item for the use of someone such as a scholar-official, whose knowledge and skills were crucial to the maintenance of Han hegemony. The extensive production of luxury goods in metal and lacquer under the Han dynasty reflects China's peace and prosperity during that time.

Bronze and lacquer were extensively used for vessels during the Han dynasty (206 B.C.–A.D. 220), and the containers known as *hu* were produced in some numbers in both materials. This example (fig. 113) is of the type termed a *fang*, or square, *hu* because its horizontal cross section is square; thus its sides are angular rather than rounded. The bronze was decorated in a three-step process. Gold mixed with mercury was applied to the surface; when the vessel was heated, the mercury vaporized and the gold fused to the bronze; bands of silver were then applied over the gold surface.

Hu, used for wine, are first found among Chinese bronze ritual vessels dating from the Shang dynasty (ca. 1500–1050 B.C.). The masklike shapes holding the ring handles on the four sides of this example derive from the ubiquitous *taotie* (mask motif) of bronzes of the Shang and Zhou (ca. 1050–221 B.C.) dynasties. The triangular motifs at the neck and foot and the horizontal bands that divide the body of this jar into four registers also reflect earlier metalworking traditions. The austerity of the decoration, which differs noticeably from the fanciful and detailed imagery employed during the later Warring States and early Han periods, is typical of art of the Eastern Han and late Western Han and may reflect the growing importance of Confucianism, which prescribes a restrained style of life. The change in taste may also be tied to the burgeoning demands made on the bronze industry at a time when workshops in the palace and at selected regional centers were producing objects both for the imperial family and for wealthy landowners and merchants.

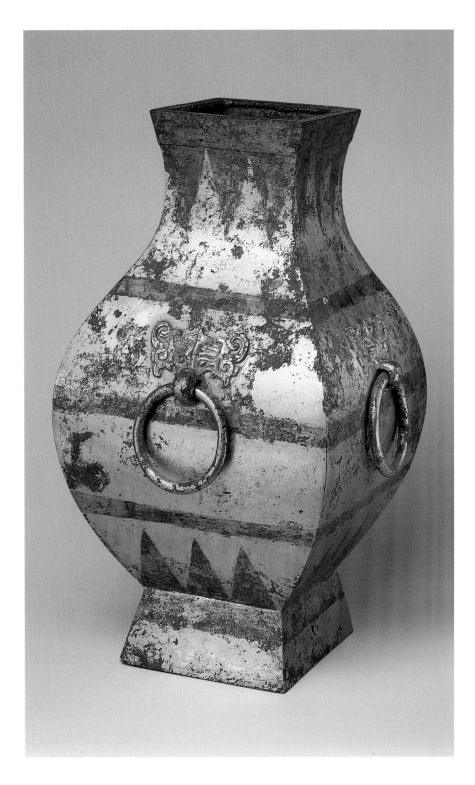

113. *Square Jar (Fang Hu).*
China, Western Han dynasty, 2nd century B.C.–early 1st century A.D.
Bronze with gold and silver, H. 19 in. (48.3 cm)

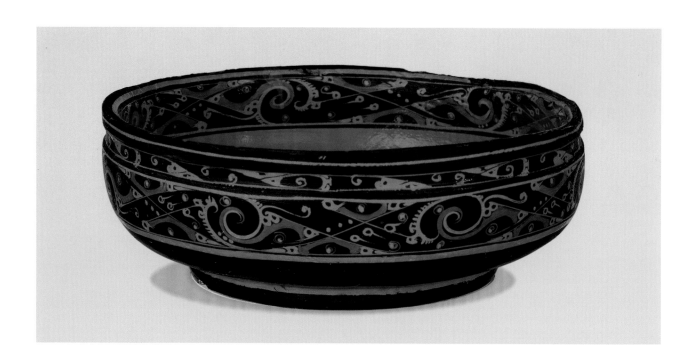

114. *Basin.*
China, Western Han dynasty, 2nd
century B.C.–1st century A.D.
Lacquered wood,
Diam. 10⅜ in. (26.4 cm)

Lacquer has a long history in China. Processed and dried, the sap of the native lacquer tree (*rhus verniciflua*) is resistant to heat, water, and acids. During the Han dynasty, luxury goods and tomb furnishings made of wood, bamboo, or other materials were coated and decorated with colored lacquers.

Two earlier centers influenced the shape and decoration of Han lacquerware. In the west, the Ba and Shu peoples in Sichuan Province were noted for a diversity of vessel types and for the geometric organization of the designs that embellished them. In the south, the Chu kingdom, centered in the city of Changsha in Hunan Province, produced a wider range of lacquered objects—including musical instruments and openwork screens—but had a smaller inventory of shapes for eating and drinking. The decoration of Chu lacquers is characterized by fluid cloudlike designs that often incorporate human beings, immortals, and mystical animals. On this basin (fig. 114), cloud motifs appear but are presented within a geometrical framework.

Basins similar to this example in shape and ornamentation along with matching ladles have been excavated at several sites in China, which suggests that the type was used for serving a liquid such as wine or soup. This example has a black lacquer ground with designs painted in red lacquer and is further enhanced by touches of black and brown.

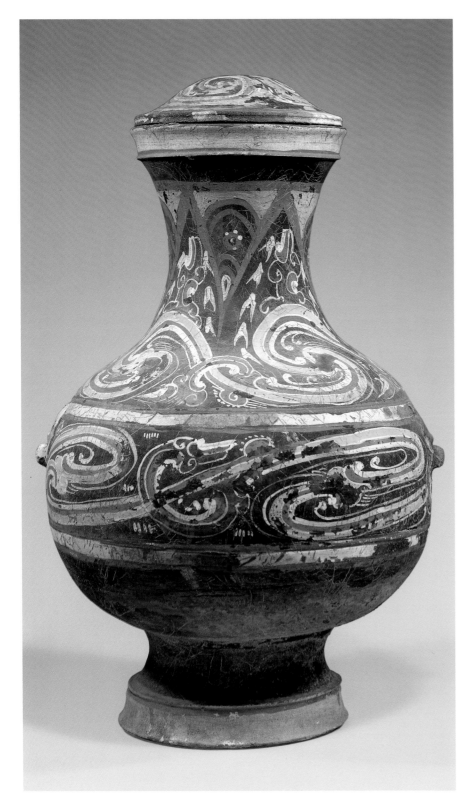

During the Warring States period, jades, bronzes, textiles, musical instruments, books, and other luxuries were often placed in tombs to serve the needs of the deceased in the afterlife, which was understood to be a continuation in some form of quotidian existence. Soon thereafter, in the early Han dynasty, pottery models known as *mingqi*, or "spirit goods," began to be produced as substitutes for more valuable possessions and to provide servants, entertainers, livestock, pets, vessels, and other necessities for the afterlife. The looting of tombs contributed to an increase in the burial of "spirit goods" rather than valuables. The production of these ceramic models in considerable numbers also points to the fact that tomb building, previously a right limited to the ruling class, had now expanded to become a practice of the landed gentry and wealthy merchants.

Made of low-fired gray earthenware and painted with chalky mineral pigments that flake off when handled, this covered jar, or *hu* (fig. 115), is too porous to be usable. White, pale violet, and bright red create the swirling cloudlike decorations, which are based on motifs found in earlier Chu lacquerware. These designs are thought to represent the celestial mists, through which the deceased would travel to join the immortals.

115. *Jar with Cover (Hu).*
China, Western Han dynasty, 2nd–1st century B.C.
Earthenware with painted decoration, H. 22½ in. (57.2 cm)

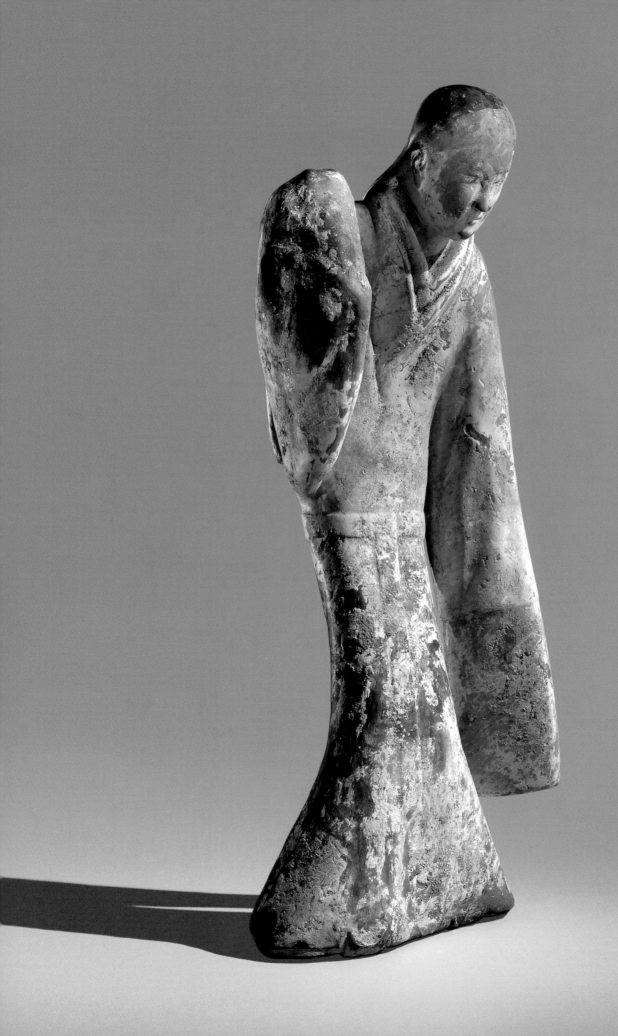

In early China, dance and music played an important part in court rituals designed to harmonize the cosmos with the world of man. These presentations were limited to court banquets and other upper-class festivities. According to the *Liji* (Book of Rites), assembled in the first century B.C., keeping a large troupe of dancers was the prerogative of the emperor, and the number of terpsichorean performers available to nobles was based on their rank.

Small figurines of dancers carved of jade are often found in tombs dating to the first half of the Han dynasty. Accompanied by musicians playing reed or stringed instruments, dancers are also depicted on the three rare silk paintings excavated in Western Han tombs. Performers with percussionists appear on bricks from contemporary tombs in Sichuan in western China and in Henan Province to the east.

Perfectly poised, this extraordinary figure (fig. 116) captures a hushed instant when, one long sleeve thrown back and the other trailing almost to the floor, the dancer stands motionless with knees bent before beginning the next part of her performance. Such figures are thought to be performing the slow, elegant *changxiu* (long-sleeve) dance movingly described in Han-dynasty poetry. In earlier writings such as the *Chu Ci,* or *Songs of Chu,* attributed to Qu Yuan (340?–278 B.C.), the dancer serves, metaphorically, as a priestess or shaman able both to invoke the gods and to guide souls on their journey between earth and the heavens. It seems likely that the funerary sculptures allude to presentations of this dance as an element of burial practices, thereby demonstrating a continuing belief in its transformative powers.

116. *Female Dancer.* China, Western Han dynasty, 2nd–1st century B.C. Earthenware with pigments, H. 21 in. (53.3 cm)

117. *Mortuary Pillar,*
detail of side view

Crowned by a squatting figure, this pillar (fig. 118) served as a support for a lintel at the entrance to a brick tomb. Older, wooden pit tombs were succeeded during the early part of the Han dynasty by tombs made of hollowed bricks—first, large, hollow bricks made from clay molded around a wooden core that was withdrawn before firing, and later, smaller, solid bricks. The tombs were modeled on the homes of the elite. They had a front or reception hall, a back hall or bedchamber (which held the coffins), and smaller "ear" or side chambers.

Low-relief decorations consisting of geometric forms and sinuous dragons are stamped and incised onto the front and sides of this doorway pillar. The creatures chase one another, each grasping the tail of the hissing figure in front of it. On the right and left sides just before the legs of the squatting figure appear small depictions of an official carrying a large rectangular object in front of a *que* tower (fig. 117). The significance of these scenes is unclear; they may illustrate some part of the elaborate funerary rites.

The unusual squatting figure
has a thin body articulated by curv-
ing shapes and an overlarge head
with pronounced eyebrows and
eyes, a half-moon design on his
cheeks indicating cheekbones or
some type of facial decoration, a
prominent nose, and a thin beard.
The facial hair, often present in rep-
resentations of foreigners of non-
Han origin, here further suggests
the anomalous nature of this crea-
ture, who most likely served some
protective function or as a link to
the realm of the immortals.

118. *Mortuary Pillar*.
China, late Western–early Eastern
Han dynasty,
1st century B.C.–1st century A.D.
Earthenware, H. 50½ in. (128.3 cm)

119. *Pair of Seated Figures
Playing Liubo.*
China, late Western–
early Eastern Han dynasty,
1st century B.C.–1st century A.D.
Painted earthenware,
H. 13¾ in. (34.9 cm)

Liubo Board with Pieces.
China, Han dynasty,
206 B.C.–A.D. 220. Painted
earthenware and bone,
W. 14¼ in. (36.2 cm)

The tense shoulders and focused expressions of these two figures demonstrate the animation that characterizes the best Han funerary painting and sculpture (fig. 119). Deeply involved in their game of *liubo* (sometimes translated "six rods"), the two kneeling gentlemen, one of whom calls out his throw, wear thick robes with traces of an undergarment visible at the neck and sleeves. They are modeled of light gray earthenware and painted with touches of white, red, green, and blue. Black ink, now largely worn away, highlighted the eyes and colored the topknots.

Although historical records suggest that *liubo* was played toward the end of the Shang dynasty, little visual evidence exists for the game prior to the late Warring States period. Both written records and archaeological finds attest to its popularity during the Han and its subsequent decline. A board marked with roads, twelve pieces or rods (six for each player), and dice thrown to determine moves (missing from this set) constitute the basic equipment for the game.

In its early history the rods were thrown in a manner reflecting the practice of divinatory casting, and it is thought that the structure of the pattern on the board has cosmological significance. These overtones of meaning help explain the popularity of *liubo* during the early Han, when practices designed to ensure immortality were prevalent, along with the recording and analysis of natural phenomena, portents, and auspicious symbols.

The fabulous birds and the winged immortal on the central roof of this building suggest a paradisiacal rather than an earthly realm (fig. 120). Four towers—the larger ones decorated with a tiger (left) and dragon (right), the pair at the back with standing attendants—flank the open, two-storied pavilion. Columns with tripartite capitals support the platform of the second level and the roof. The figure at right center, distinguished by her large size, bird-headed cap, and flowing gown, represents Xiwangmu, known as the Queen Mother of the West. A complicated and multivalent figure, Xiwangmu was thought to rule the land of the immortals (located somewhere west of China) and played a major role in Han beliefs.

Significant changes occurred in Chinese funerary practices during the first century A.D., as tombs replaced ancestral temples as the focus of rites. Family cemeteries filled with lavish tombs constructed prior to the owners' deaths became the settings for banquets, musical performances, and the display of art. Stone began to be used, possibly reflecting the influence of growing ties with India, and replaced brick as the principal architectural medium. This relief was probably on the interior side of the wall of a tomb or cemetery. State sponsorship of Confucianism led to the development of a new funerary iconography that extolled such virtues as proper conduct and filial piety. The hierarchical placement of Xiwangmu and her attendants in the pavilion is typical of later Han representations of heavenly courts, which under the influence of Confucianism began to parallel the organization of earthly ones.

120. *Tomb Panel with Relief of a Pavilion.* China (probably Shandong Province), Eastern Han dynasty, early 1st century A.D. Limestone, 31¼ × 50 in. (79.4 × 127 cm)

Footed vessels of this type, produced in Korea during the late second and early third centuries A.D., may have derived their form from earlier Chinese bronzes. The fanciful bird shape may also have Chinese origins. In Western Han funerary art, birds with fantastic (and sometimes multiple) tails and heads serve as vehicles that carried souls from the earthly realm to that of the immortals. Footed bird vessels—this one is filled through a hole in the back, and the tail serves as a spout—are almost always found in tombs. Their refined grayish white earthenware distinguishes them from objects intended for everyday use. This whimsical example (fig. 121) illustrates the sophisticated blending of the naturalistic and the formal that defines Korea's enduring ceramic tradition. The bird's curvaceous shape provides a striking contrast to the prominent angular crest, overlarge ears, almond-shaped eyes, and narrow beak.

121. *Bird-Shaped Vessel.*
Korea, late 2nd–3rd century A.D. Earthenware, L. 14 in. (35.6 cm)

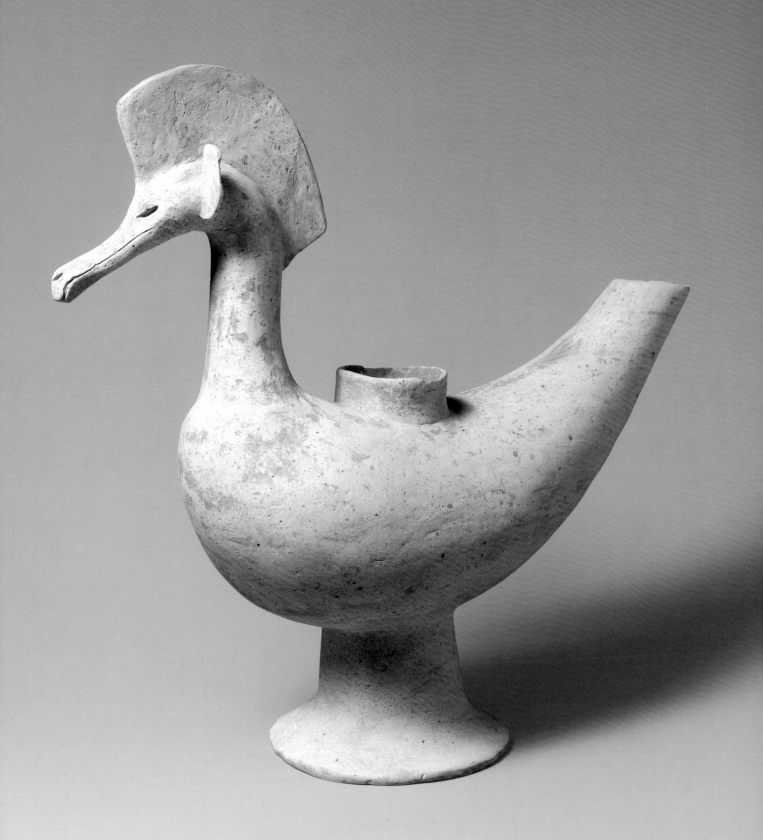

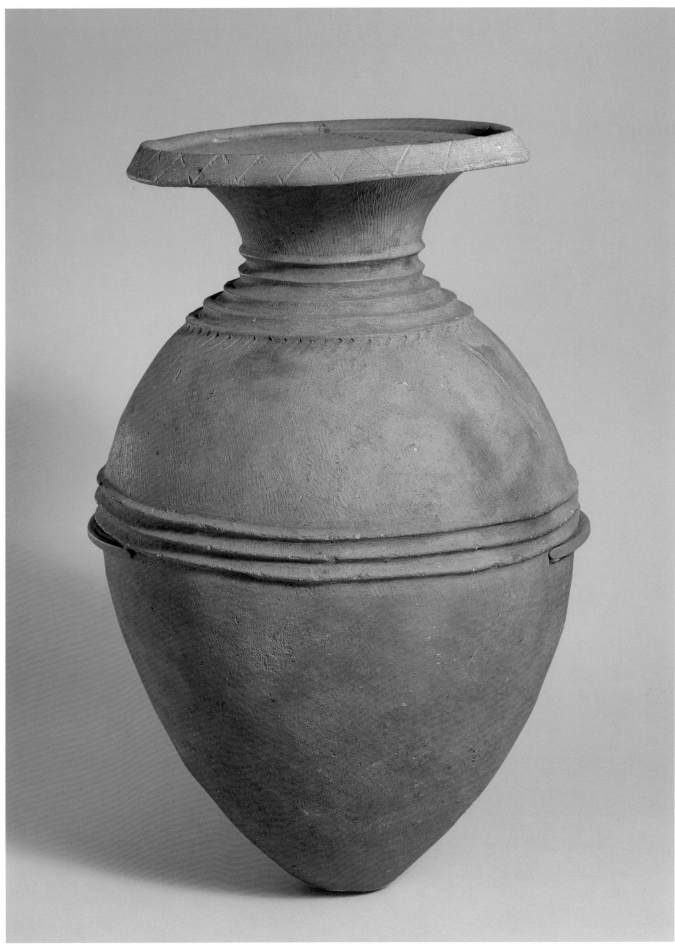

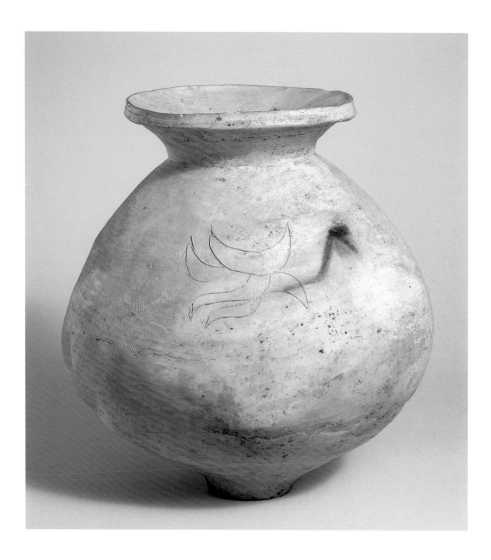

The name Yayoi, which refers to a historical period and its early culture, derives from the site in Tokyo where pottery of this type was first discovered in 1884. Storage jars, cooking vessels, and footed dishes, unearthed in many places throughout the Japanese archipelago, are the most common forms in Yayoi pottery. Both of the storage jars shown here are from the area that encompasses present-day Kyoto, Osaka, and Nara. They were made by the coil method, and the surface was then smoothed and hardened by paddling and shaving. The precisely curved reddish jar (fig. 122) is embellished with thin horizontal bands applied at the shoulders and center and a combed pattern at the neck. Other jars made of buff earthenware and painted red, some with a decoration of applied bands, were often set apart as ritual wares; the red color of this piece indicates that perhaps it too had a ceremonial use, as does its conical base, which may have required an indented pedestal or comparable support.

A tiny foot carries the bulbous body of the second jar (fig. 123). It was potted in a light buff earthenware that turned red and black in spots during firing. Outlines of crescent shapes are incised into the center of one side, presumably the front. They may reflect an earlier tradition of impressing shells into a clay body for decorative effect.

FACING PAGE
122. *Storage Jar.*
Japan, Middle Yayoi period,
100 B.C.–A.D. 100. Earthenware,
H. 16½ in. (41.9 cm)

ABOVE
123. *Storage Jar.*
Japan, Late Yayoi period,
A.D. 100–200. Earthenware,
H. 10¾ in. (27.3 cm)

124. *Bell (Dōtaku).*
Japan, Late Yayoi period, 1st–2nd century A.D. Bronze, H. 43½ in. (110.5 cm)

Produced during the late Yayoi period, the distinctive Japanese bronze bells known as *dōtaku* are thought to derive from earlier, smaller Korean examples that adorned horses and other domesticated animals. This *dōtaku* (fig. 124), one of the finest known, is now believed to have been found in 1814 at Shimogō, Mikazuki-machi, Hyōgo Prefecture. The body, shaped like a truncated cone, is decorated with rows of horizontal bands divided in the center by vertical bands. The elaborate flange, filled with sawtooth designs and further enhanced by projecting spirals, extends along the sides and arches across the top.

The first recorded discovery of a *dōtaku* occurred in A.D. 662 at a temple in Shiga Prefecture. Over four hundred examples, ranging in height from four to fifty-one inches, are known today. Most are from the Kyoto-Nara area. The earliest bells, cast in sandstone molds, are small and thick. Some make a rattling sound when struck with a clapper or stick; others have clappers hanging inside. From the first century A.D. on, larger, thinner bells were cast in clay molds that allowed for finer detailing. There is no evidence that the large ones were functional. They are thought to be purely ceremonial objects.

Dōtaku were buried singly, in pairs, and in large groups—occasionally with bronze mirrors and weapons—in isolated locations, often on hilltops. They have not been discovered in graves or near dwellings. Their placement suggests that they were communal property rather than owned by individuals. The rationale for the burial of the bells remains unclear, although it is often hypothesized that they were included in rites to ensure a community's agricultural fertility.

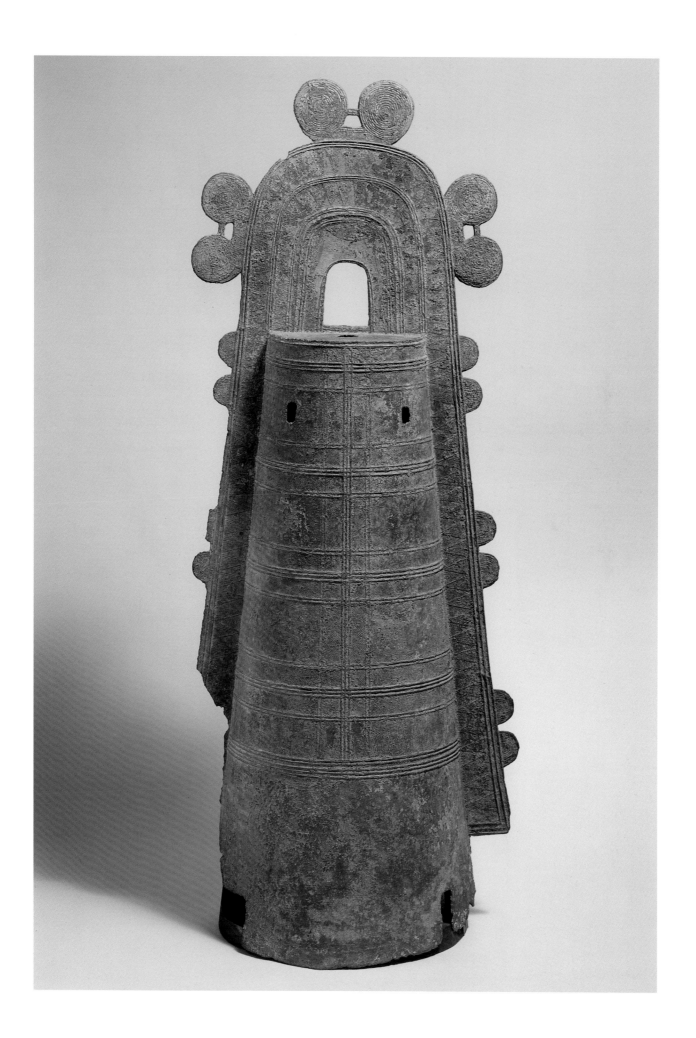

SOUTHEAST ASIA: THAILAND, CAMBODIA, VIETNAM, INDONESIA

Archaeological findings in present-day Thailand, Cambodia, and Vietnam have shown that as early as the sixth century B.C., the various communities in mainland Southeast Asia were linked (by rivers) in a complicated system of trade and gift exchange featuring vessels and adornments made of bronze. Mainland Southeast Asia is thought to have also played a role in international trade by the fourth century B.C., when ships may have come across the Bay of Bengal to the Isthmus of Kra, on the Malay Peninsula, and unloaded their goods for transport overland to the Gulf of Thailand, thus avoiding the arduous sixteen-hundred-mile voyage around the peninsula.

Little is known about the states and cultures of Southeast Asia before the sixth century A.D., except for the information that exists about Funan, a land located principally in present-day Cambodia and southern Vietnam. In the third century A.D. two Chinese travelers were sent by the ruler of Wu, a southern Chinese state, to bring back a report on Funan, and their descriptions are preserved in later texts. "Funan" is thought to be a Chinese transcription of the term *bnam*, which evolved into the Khmer *phnom,* or mountain. The capital at Vyadhapura (near Ba Phnom in Cambodia) contained palaces and houses; a type of script was used, and there were repositories for books and other treasures. Funan collected taxes in gold, silver, pearls, and perfumes. Excavation of the coastal site of Oc'eo in Cambodia has revealed a rectangular city measuring one by almost two miles and connected to its large port by a canal. Chinese Han-dynasty mirrors, Roman coins from the reigns of Antoninus Pius (A.D. 138–61) and Marcus Aurelius (161–69), and early wooden sculptures have been unearthed at Oc'eo, which served as a meeting point for traders from India, China, and, beginning in the third century A.D., Sasanian Persia.

The Chinese travelers' reports also contain references to the lands of Zhiaying and Sitiao—possibly in Sumatra or Java—and their entry into international trade with the development of a route though the Strait of Mallaca in the third or fourth century A.D. Sitiao is described as a place with cities and paved roads. A ruler in Zhiaying is said to have imported horses from the Yuezhi (Kushans) in Central Asia, an intriguing, somewhat later parallel to the Han Chinese desire to obtain heavenly horses from Ferghana.

Southeast Asian traders added new products and local equivalents to the inventories of international trade. The physician of the Kushan emperor Kanishka is said to have valued the healing properties of Southeast Asian cloves, while Chinese patrons were eager to acquire rhinoceros horns, sandalwood, and the feathers of kingfishers and other birds. The resin of Sumatran pines was a substitute for frankincense, and benzoin, the sap from a plant of the laurel family, served the same purposes as myrrh.

The first mention of Southeast Asia in Indian records occurs in Buddhist sources that describe Ashoka's third-century-B.C. mission to Survanabhuma, often identified as the area of lower Burma and central Thailand. Buddhism and also Hinduism were further introduced by Indian merchants, many of whom intermarried with the local elite. By the sixth century A.D. these religions, as well as Indian concepts of kingship and statecraft, dominated the region. The development of a pan-Asian Buddhist culture that linked Southeast Asia to South and East Asia coincided with the reemergence of transcontinental trade in the seventh and eighth centuries, when China's powerful Tang dynasty (618–907) once again established ties to the Western world.

Beginning in Southeast Asia's Neolithic period (ca. 3600–2000 B.C.), riverine networks, by which pottery and other luxuries were exchanged for exotic items such as marine shells, linked communities located along the seacoast and farther inland. The existence of such routes contributed to the rapid diffusion of bronzeworking about 1500 B.C. and to the subsequent introduction of iron technology during the second half of the second millennium B.C. Archaeological evidence, particularly burials, indicates that in the years around 500 B.C. the settlements became larger and more stratified, with an elite class that controlled mining resources. These developments led to the widespread manufacture of vessels and adornments in a greater range of forms and shapes, and with more elaborate decoration, than had existed earlier in Southeast Asia's Bronze and Iron Age.

The large, flowing spirals covering the surface of this elegant container (fig. 125) are among the most prevalent of the geometric motifs that decorate bronze ritual and luxury objects produced in present-day Thailand from the fourth century B.C. to the third century A.D. An edging motif possibly derived from ropes or basketry decorates the top and bottom of the slightly flared vessel and the base of the cover. Two small loops and remnants of a third, for suspending the container from a cord, are at the upper corners of the base. The large size of the cover implies that it may have served as a cup and that the vessel stored a beverage, but another function, such as holding darts, is also a possibility.

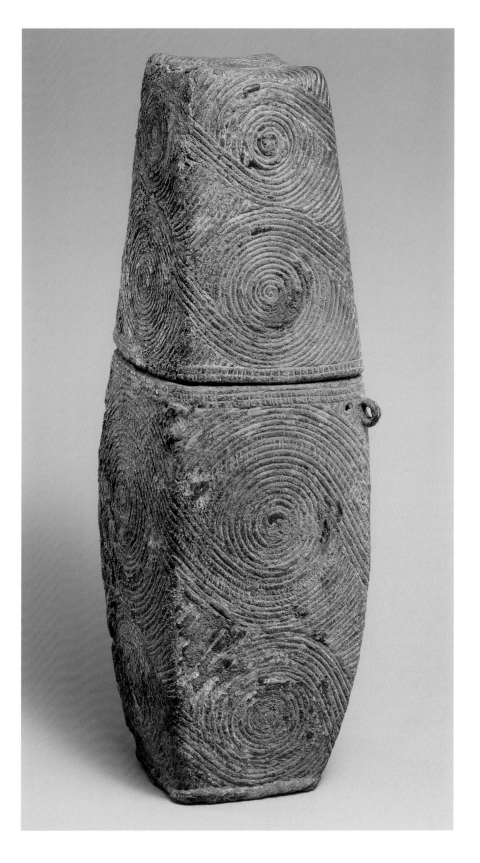

125. *Container with Spiral Decoration.*
Thailand, 300 B.C.–A.D. 200.
Bronze, H. 8¾ in. (22.2 cm)

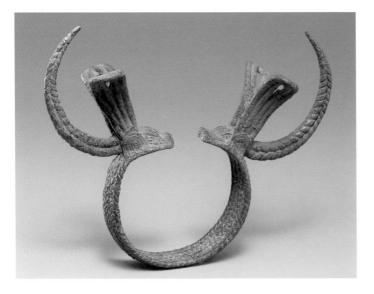

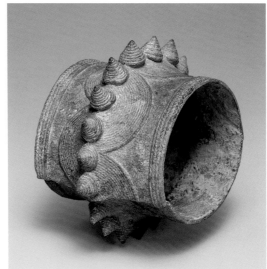

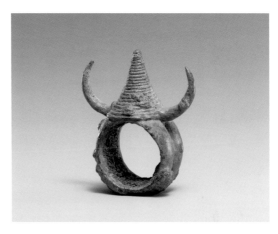

ABOVE

126. *Bracelet with Dragonflies.*
Thailand, 300 B.C.–A.D. 200.
Bronze, W. of armband 2¾ in. (7 cm)

TOP RIGHT

127. *Bracelet.*
Thailand, 300 B.C.–A.D. 200.
Bronze, W. 4¾ in. (12.1 cm)

BOTTOM

128. *Ring.*
Thailand, 300 B.C.–A.D. 200.
Bronze, H. 1¾ in. (4.5 cm)

Bracelets are the ornaments most frequently excavated from burials at archae-ological sites throughout Thailand. Early examples were made from highly polished stones or rare seashells, while later ones were created in bronze, a material much used for ornaments and regalia throughout mainland and island Southeast Asia during the latter part of their Bronze and Iron Age. The location of the bracelet finds in graves indicates that several were often worn together on the forearm. Many of them are small in diameter; it is conjectured that they were put on in childhood and probably could not be removed later, which would suggest that their purpose was to denote rank as well as to adorn.

The imagination and craftsmanship lavished on such bracelets are evi-dent in these two examples. A braid design decorates the edges of the intriguing larger bracelet (fig. 127), which is embellished principally with wavelike concentric rings capped by spiky coiled cones. The articulated ends of the smaller bracelet (fig. 126) represent dragonflies with uplifted wings and long, curving tails. Braided motifs enhance the body of the bracelet and the tails. After the fourth century B.C., rings and anklets joined the jewelry repertory. This ring (fig. 128) displays a conical motif like that on one of the bracelets and upward-curving elements similar to those on the other.

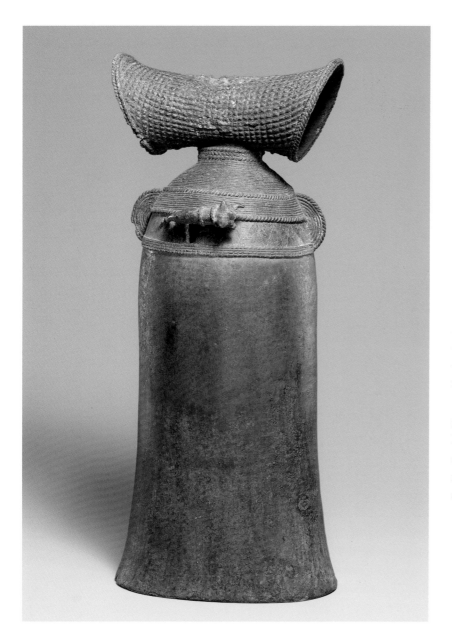

Its shape and the form of the animal in high relief standing with the top of its back toward the viewer indicate that this exquisitely cast bell (fig. 129) once adorned an elephant. Indian elephants, also native to mainland Southeast Asia, were used for transportation and treasured for their ivory. Closely textured patterns in low relief decorate the upper part of this beautifully shaped, slightly flared bell. The hollow crosspiece, which accommodated a rope or chain for suspending the bell, is edged with a herringbone braid and covered with a grid of small rectangles that follows the curves of the surface. Further braiding encircles the neck of the bell and frames the sections of horizontal bands. Triangles are incised into the ground behind the elephant, while half-circle flanges project from the sides. The refined ornamentation, restricted to the topmost areas, is set off by the bell's plain surface below.

129. *Elephant Bell.*
Thailand, 200 B.C.–A.D. 200.
Bronze, H. 9 in. (22.9 cm)

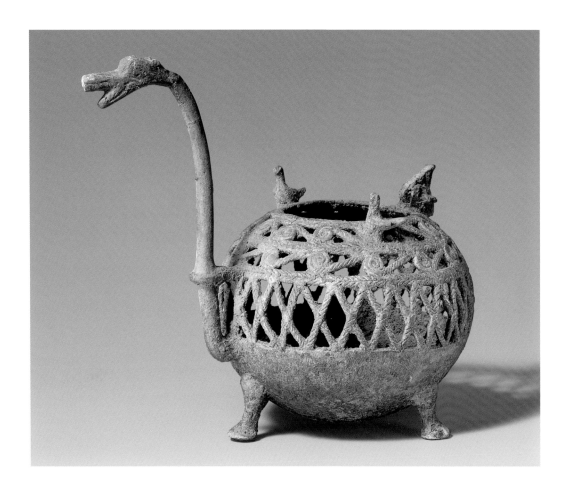

The openwork of this charming vessel (fig. 130) identifies it as an incense
burner. A damaged hinge at the back indicates that it once had a lid. Three
sturdy legs support the body, and two small birds sit on the rim. The two
rows of spirals at the top and the trellis pattern in the center are marked with
diagonal lines that create texture and a sense of movement. The long, slightly
curved handle terminates with an open-mouthed dragon's head.

Incense burners that similarly have three legs, hinged covers, and long
handles ending in animal heads have been excavated from Chinese tombs dat-
ing to the late Western and early Eastern Han periods. Handles with quite fan-
ciful dragon's heads are also common on footed vessels known as *jiaodou*, used
to warm liquids, which were produced in China during the Han dynasty and
later. Birds often decorate the tops of contemporary pottery incense burners
from southern China, which also have openwork decoration. Thus, ties
between southern China and regions of mainland Southeast Asia, such as
Thailand, are evidenced by similarities of visual imagery, among them the use
of dragon's heads and birds. The nature of the relationships between these areas
remains unclear. It is worth noting, however, that the present-day provinces of
Guangxi and Guangdong in southeast China and the area of the Yunnan
plateau in the southwest were inhabited by cultures distinct from those in the
central plain of northern China. It is likely that the artistic parallels between
southern China and Southeast Asia reflect trade and possibly a shared ethnicity
among the peoples living there.

130. *Incense Burner with Dragon's
Head and Birds.*
Thailand, 100 B.C.–A.D. 200. Bronze,
H. 6¼ in. (15.9 cm)

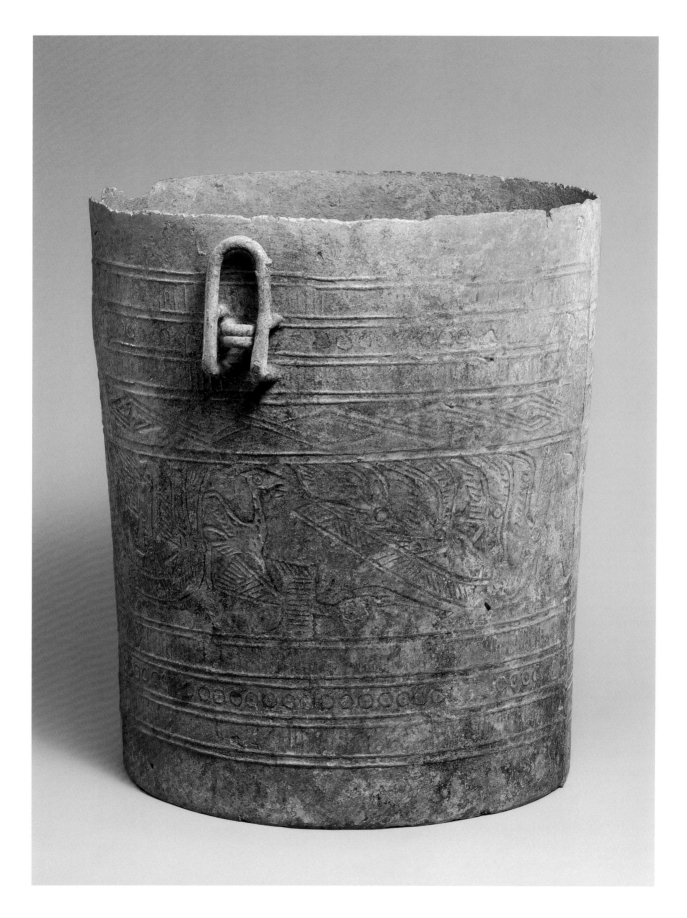

Axes, situlae (buckets), and drums play an important role in Vietnam's Dongson culture, named after a site on the coastline south of Hanoi that was first excavated in 1924. Many questions remain about the development of this civilization, which first flourished in northern Vietnam perhaps about 700 B.C. and had links to regions as diverse as south China and Indonesia.

Crisp in form and thinly cast, this vessel (fig. 131) has two loop handles attached to the sides with crossbars. Its bucket shape may derive from that of a wooden prototype. Lines in low relief divide the surface into horizontal bands (fig. 132). In the smaller registers at top and bottom, hatching, trellis, and chain-link patterns appear. The larger central band carries a depiction of four long boats with curving prows and sterns; aquatic birds occupy the spaces between the boats. Seated in the boats are warriors wearing prominent feathered headdresses. There has been much speculation about the meaning of the imagery combining boats, warriors, and birds, a mix also frequently represented on the splendid drums and other items produced by the Dongson culture (see fig. 133). The images have been interpreted as symbols of shamanism or as representations of military or imperial processions or a soul's journey to the afterlife.

Situlae, sometimes filled with bronze and stone implements, have been found in burials in both Vietnam and south China. An important group of nine such vessels was excavated in 1983 from the tomb near Guangzhou (Canton) of the Chinese leader Zhao Mo (r. 137–122 B.C.), who briefly ruled areas of both present-day Guangdong and northern Vietnam. Three of these situlae were unearthed nestled into one another; two show stylized warriors and boats like those seen on this example. Buckets with similar shapes and motifs are also found in south China in Guangxi and Yunnan Provinces, in graves datable to the first centuries B.C. and A.D.

FACING PAGE
131. *Situla with Design of Ships.*
Vietnam, Dongson culture,
100 B.C.–A.D. 100.
Bronze, H. 8¼ in. (21 cm)

ABOVE
132. *Situla Design,*
shown in rubbing

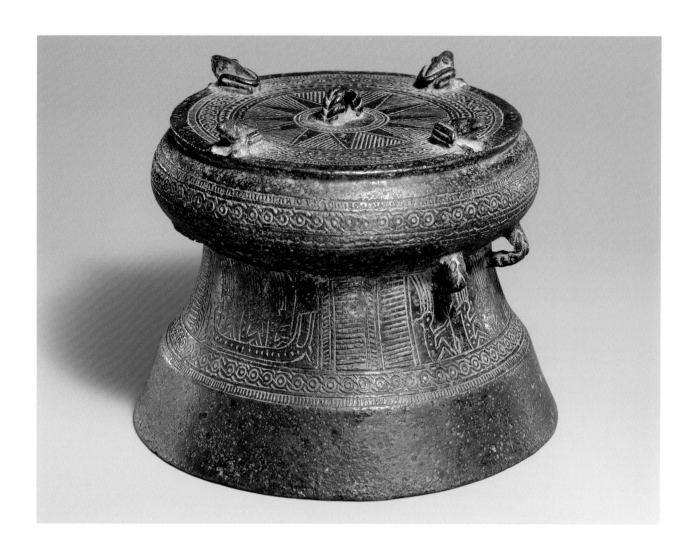

133. *Drum Model with Four Frogs.*
Vietnam, Dongson culture,
300 B.C.–A.D. 200. Bronze,
H. 4 in. (10.2 cm)

The discovery in the late seventeenth century of large, elaborately incised drums in mainland and island Southeast Asia first alerted Western scholars to the existence in the region of distinctive early bronzeworking cultures. Ranging in height from a few inches to over six feet, reaching four feet in diameter, and often of considerable weight, these drums are the most widely dispersed products of the Dongson culture. While some of them were made locally, examples produced in Vietnam have been found in south China, throughout mainland Southeast Asia, and in Sumatra, Java, Bali, and Irian Jaya. The function of the drums remains unclear; they may have been used in warfare or as part of funerary or other ceremonial rites. According to the *Hou Han Shu* (History of the Later Han), when the Chinese general Ma Yuan subdued a Vietnamese uprising in A.D. 40–43, he confiscated and destroyed the bronze drums of the local chieftains who were his adversaries, actions that attest to the drums' political significance.

Models of the drums, fashioned of bronze or clay, were made to be included in burials. This small bronze example (fig. 133) has the rounded top, curved middle, and splayed base often found in drums from Vietnam. The central loop

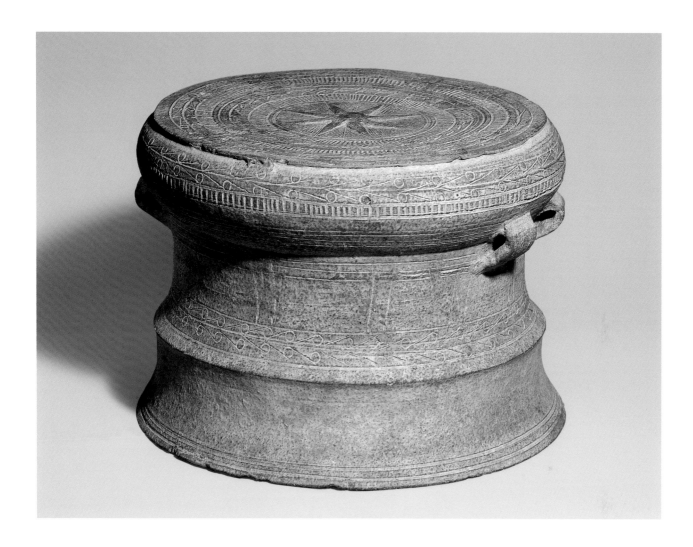

and the four small frogs on the tympanum are characteristic features of examples produced from the third century B.C. to the first century A.D. The starburst pattern in the center of the tympanum, a standard motif on Dongson drums, is surrounded by a row of linked concentric circles and cross-hatching. These designs are repeated around the side of the top section and just above the base. On the midpart of the drum, four stylized scenes showing warriors with feathered hats—some seated in boats, some on the ground—alternate with hatched areas.

The articulated shape and incised geometric motifs on the tympanum of the ceramic drum model (fig. 134) are similar to those on the bronze piece. Models of drums, houses, and other necessities for the afterlife made of fine gray earthenware are found in brick tombs dating from the second century B.C. to the third century A.D. The use of brick tombs and the introduction of pottery models illustrate the impact of Chinese culture that followed the annexations of the northern part of Vietnam, first under the Qin dynasty in 211 B.C. and then under the Han in 111 B.C.

134. *Ceramic Model of
a Bronze Drum.*
Vietnam, Dongson culture,
100 B.C.–A.D. 100. Earthenware,
H. 5¼ in. (13.3 cm)

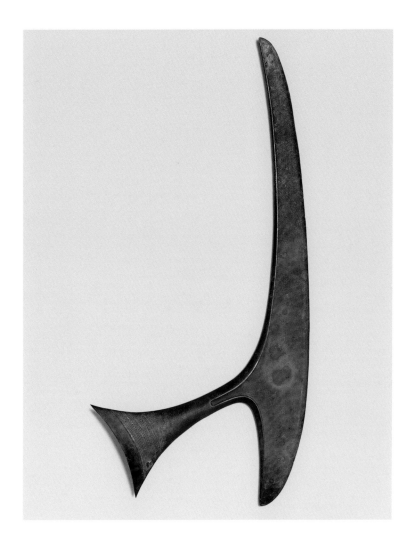

The flamboyant curved blade and asymmetrically placed splayed socket of this piece (fig. 135) are typical features of ax heads from Java and Sulawesi, which were produced in full size and as miniatures; they were used as funerary gifts and for ceremony and display and perhaps were also functional. This example's powerful, ridged blade presents an interesting contrast to its decorated socket, whose horizontal bands carry fine embellishments. Herringbones, spirals, and chain-link designs fill the smaller bands, while the large bands contain latticework on one side and curving spirals set against a herringbone background on the other (fig. 136). Because of the blade's size and the placement of the socket, an angled handle, inserted into the socket, would have been required for the weapon to actually be usable.

Ax heads made of both stone and bronze are common to the early cultures of south China, Thailand, Vietnam, and Indonesia. Examples dating from the Neolithic period and the early part of the Bronze Age, with rounded heads and simple sockets, are often found in burials, which suggests that from early times axes were valued as tools, weapons, and items of prestige. Axes are often carried by the warriors depicted on drums and situlae of the Vietnamese Dongson culture. Late Dongson ax heads with pediform or boatlike shapes and comparable pieces from south China are often thought to have provided prototypes for the exaggerated crescent-contoured blades produced in Indonesia.

TOP

135. *Crescent-Shaped Ax Head with Decorated Socket.*
Indonesia, 200 B.C.–A.D. 200. Bronze, L. 25 1/8 in. (63.8 cm)

BOTTOM

136. *Ax Head,* detail of socket

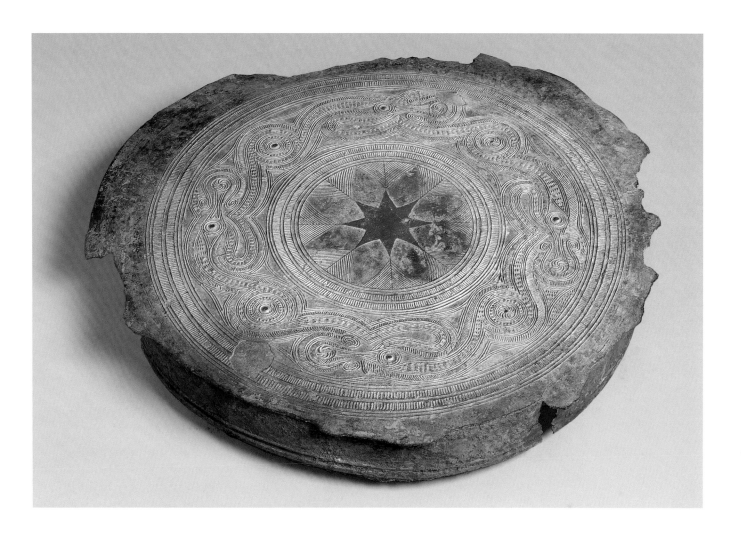

While Dongson-style drums may have been made in Indonesia, another distinct type was also produced there, of which the largest and finest extant example is the "Moon of Pejeng" in Bali. These hourglass-shaped instruments have double strap handles set above the waist and a tympanum overhanging the body that was cast separately and soldered on. Only a small portion of this drum's cylindrical body survives, and the tympanum has a chipped edge (fig. 137). However, its beautiful decoration is in an excellent state of preservation. The design is composed of a central circular field surrounded by a wide decorated band. As on the Moon of Pejeng, the center of the tympanum displays an undecorated eight-pointed star encircled by marquiselike forms flanked by striations. In the Moon of Pejeng these forms have "eyes" like those on peacock feathers. In our example this specific reference to a bird is not present, but the outer band is filled with a series of interlocking meanders, whose pattern, repeated four times, probably represents stylized birds. The eyes and attached trumpet-shaped beaks are the only recognizable features, but the identification is confirmed by later examples in which the avian design is less stylized. It is interesting to note that Dongson drums usually have a star in the center, often encircled by a band decorated with small flying birds. The Indonesian variant is probably derived from that model but has taken on an extravagant new form.

137. *Tympanum of a Pejeng-Type Drum.*
Indonesia, 300 B.C.–A.D. 200.
Bronze, Diam. 28 in. (71.1 cm)

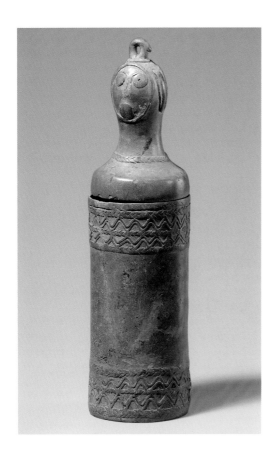 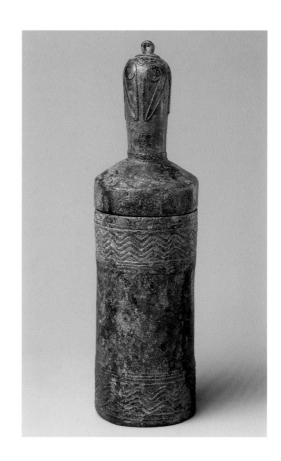

LEFT

138. *Lime Container.*
Indonesia (East Java), 300 B.C.–
A.D. 200. Bronze, H. 6 in. (15.2 cm)

RIGHT

139. *Lime Container.*
Indonesia (East Java), 300 B.C.–
A.D. 200. Bronze, H. 6¾ in. (17.1 cm)

The function of these amusingly anthropomorphic vessels is made clear by traces of quicklime in their interiors. Along with spoons and other paraphernalia associated with the preparation of betel (areca) nuts, containers like these were part of an extensive surface find on the beach at Lamajang in northwestern Java. Throughout South and Southeast Asia the leaves of the betel plant, a type of pepper, are wrapped around a mixture of lime and the seed kernel of the betel palm and chewed. Quicklime is a natural antacid, and the concoction provides both a stimulant and a tonic.

It is not known precisely when the practice of chewing betel began. An intriguing early reference is found, however, in the Chinese first-century-B.C. work *Shiji* (Historical Records) by Sima Qian. Chapter 116 of this monumental book describes the appearance and activities of the non-Han people living in southwestern and southeastern China. It includes a discussion of a substance known as *jujiang*, thought to be betel nuts, which was transported from the southwestern province of Sichuan to the southeast. Recent research in Vietnam points to the early use of betel in mainland Southeast Asia as well.

Both containers have a cylindrical body ornamented at the foot and shoulder and a lid with a handle fashioned as a humanoid head. An oval face with circular mouth and eyes decorates the handle of the vessel with trellis patterning (fig. 138), while a more exaggerated visage consisting of round eyes and extended triangles is seen on the container with wave patterns (fig. 139). Suggestions of ears and hair, depicted as a series of vertical lines, are part of the design on both containers.

The open mouth and staring eyes of this charming unclad figure (fig. 140) give him a somewhat astonished expression. Made of reddish brown earthenware, the man stands frontally and holds his arms aloft, bent at the elbows. His stomach and posterior are noticeably solid and his arms and legs well rounded. In Southeast Asia earthenware sculptures appear at this time to be unique to Indonesia. In addition to standing figures such as this one, several statuettes of seated figures with their knees pulled up and wearing lugubrious expressions are known. Some of them have a short tang on the bottom, which suggests that they served as bottle stoppers. Others, however, have no evident function.

It is interesting to note that a distinctive type of figural imagery—also found, for example, in the masklike faces on Pejeng-type drums or the quasi-human features on lime containers (see figs. 138, 139)—is characteristic of Indonesian art during Southeast Asia's Bronze and Iron Age. Figures with uplifted arms are often identified as images of ancestors among the indigenous cultures of Indonesia and Oceania. Representing both actual and legendary forebears, such figures were probably intended to contain the spirit of an ancestor during rituals.

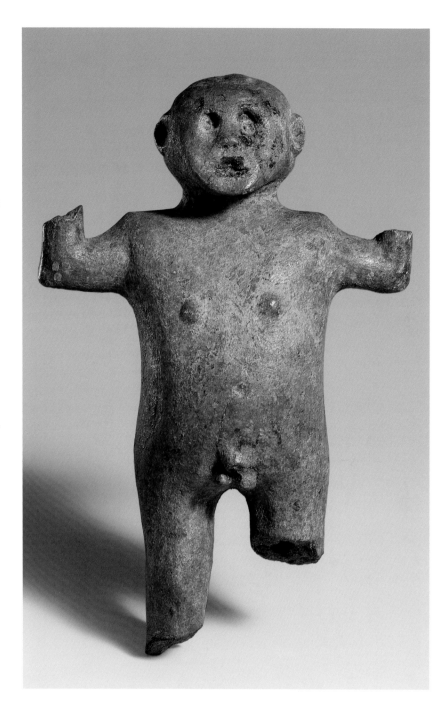

140. *Standing Male Figure.*
Indonesia (East Java), 300 B.C.–A.D. 200. Earthenware, H. 5⅜ in. (13.7 cm)

This monumental ceremonial object is in the shape of an ax head standing on its blade (fig. 141). Where it was made and how it was used are unknown; only one similar example has been found, in Makassar in southwest Sulawesi. A remnant of a tang at the base was probably used to stabilize the vessel, and two struts inside the mouth make it likely that the ax head was held upright by means of ropes. Several related basket-shaped objects supplied with tangs and suspension rings are Vietnamese; one has been found in Indonesia (Asserjaran, Madura Island). Aside from the great bronze drums, these mysterious objects of both types are the largest and most complex castings from the metal ages known in Southeast Asia. They, like the drums, must have been ceremonial objects imbued with great prestige and perhaps spiritual power. It is possible that they were also struck to produce a sound, although the fragile state of our example does not permit this hypothesis to be tested.

Extraordinary skill and technological prowess were required to create these bronzes, and it is unlikely that such resources were widely available. Since the decoration of the two ax-shaped objects is closer to designs found in island Southeast Asia than to those in Vietnam, it is likely that they were cast at some Indonesian center, but probably not on Sulawesi, where comparatively few large-scale bronzes have been discovered. It is possible that they were made for trade to tribal chiefs on the island. The low-relief motif of a quatrefoil harks back to designs seen in the ancient Lapida culture of Melanesia and Polynesia (2000–500 B.C.), as does the stylized head on the obverse, which unfortunately is very deteriorated and overlaid with modern engraving. The rows of elongated teardrop-shaped bosses on the sides may allude to the horns of water buffalo, animals that still play an important symbolic and economic role among the tribes of Indonesia.

141. *Ceremonial Object in the Form of an Ax Head.*
Indonesia (Sulawesi), 500 B.C.–A.D. 300.
Bronze, H. 41⅜ in. (105.1 cm)

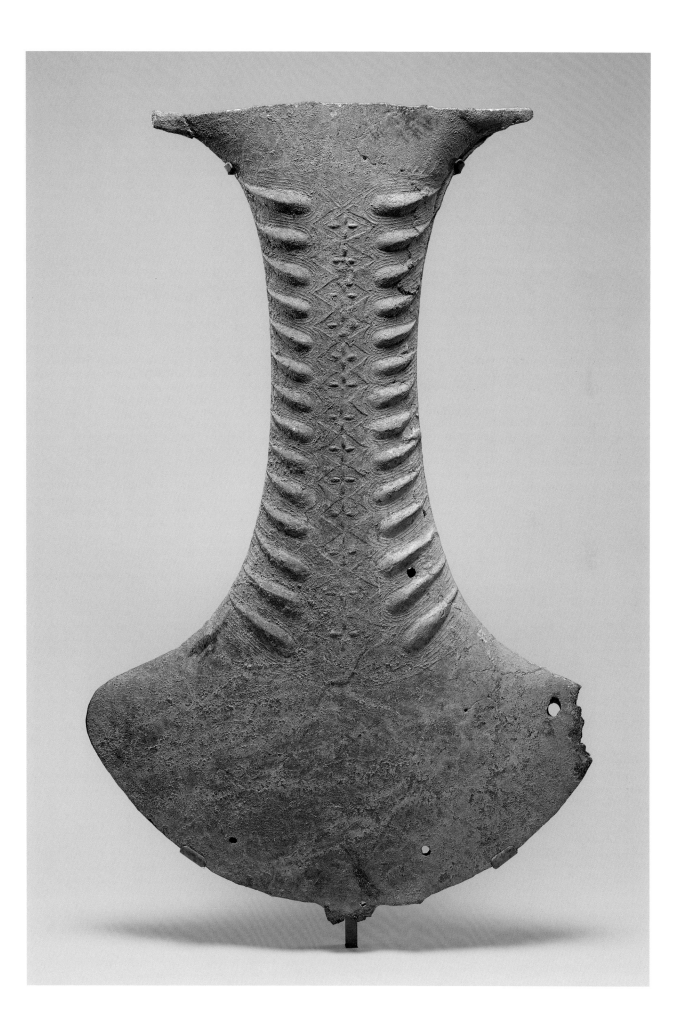

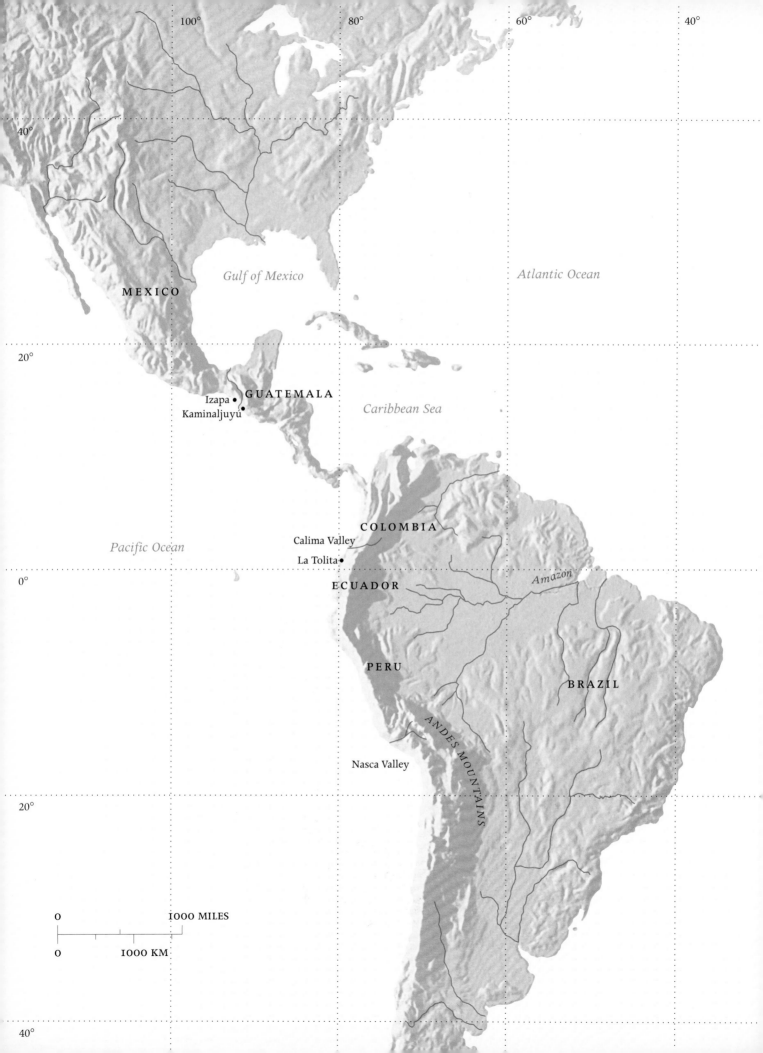

THE AMERICAS

For several millennia before the Year One, civilizations flourished on the two great continents of the Western Hemisphere. By the first millennium B.C., art and architecture of scale and permanence had emerged in several regions. Particularly significant are the achievements of the Olmecs in present-day Mexico and the Chavin peoples in present-day Peru, both of whom originated artistic traditions that would remain strong for centuries to come.

Olmec centers of the first millennium B.C. were located primarily in the humid coastal swamps of the Mexican Gulf Coast. The culture traveled far, spreading throughout Mesoamerica (principally Mexico and Guatemala) and south into parts of Central America. The Olmecs were master sculptors who left a pervasive sculptural legacy in all the media they employed, including basalt, jade, and fired clay. Their ceremonial and public pieces were characterized by concern for form and volume and elaborate surface treatment.

The Maya peoples of southern Mexico and Guatemala were among the inheritors of the traditions begun by the Olmecs. Although the civilization of the Maya reached its high point centuries later, by the Year One they were well on the way to their era of greatness. Forming into rivaling city-states, they elaborated and embellished their complexes to produce some of the most accomplished works of art and architecture of the ancient Americas. In the centuries immediately before the Year One, the Maya had in place a writing system that recorded historical and esoteric information, a calendar with a fixed starting

point and two intermeshed cycles of days, and a counting system based on the number twenty that included the concept of zero. A complex cosmology, numerous gods requiring appeasement, sacred proscriptions, and the fear of death kept priest, ruler, and commoner alike engaged in almost constant ritual activity. Fears of the underworld—the realm of the lords of death—led to the inclusion of many works of art in burials of the wealthy and powerful, whose tombs, dug into the hearts of temple platforms, were filled with precious objects of jade, shell, bone, obsidian, stone, and other materials.

Activities of a similar type were taking place during the same period in the northern parts of South America, among the regional chiefdoms of Colombia and Ecuador. These chiefdoms are poorly known today compared with those of the Maya area because their sacred and palace structures were far less durable. If records of any type were kept, they too are now gone. The area was, however, rich in gold—which ancient Mesoamerica was not—and has yielded an abundance of gold objects. One of the first metals to be used in the Americas, gold was initially worked in the second millennium B.C. A thousand years later substantial works of art were being made in the prized metal, principally items of individual adornment such as pendants, necklaces, ear and nose ornaments, diadems and crowns (these would continue to be the focus of goldworking in the Americas until shortly before the conquest). By the time of the Year One,

gold ornaments were grand in conception and detail. In both legend and reality, Colombia was the land of El Dorado—the "Gilded Man."

The gold-using peoples of northern South America were also adept sculptors in clay. The border area between modern-day Colombia and Ecuador is one region noted both for its work in gold and for its abundant ceramic production. In the early Tolita-Tumaco style, which flourished there during the Year One, dynamic three-dimensional sculptures in clay often reached a substantial size. They most frequently depict people in intriguing seated postures. These sculptures represent just one out of an abundance of ceramic types and styles found in Precolumbian South America, manifestations that grew out of very old and deeply ingrained traditions.

Another of those distinctive styles that rest on millennia of tradition flourished on the southern coast of Peru at about the Year One. In that region a preference for ceramic vessels with many-colored surfaces had been in place for several hundred years and would remain so for hundreds more. A high point was the ceramic production of the Nasca peoples of the coastal valleys around Nasca and Ica. The smooth, luminous colors of these works had no later equal in ancient Peru; nor were their iconographically rich images ever surpassed in complexity during the remaining fifteen hundred years of Precolumbian Andean civilization.

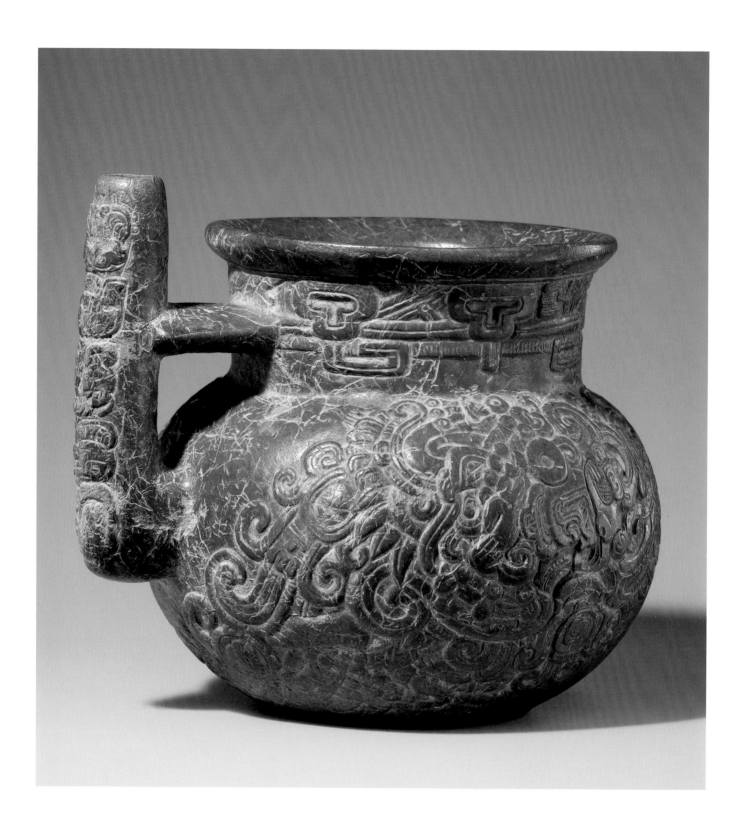

Vessels of carved stone are not common among the great many types of containers made by the ancient Maya. While countless bowls, baskets, and covered vessels must originally have been made of perishable organic materials, they have not endured, and those that exist now are primarily of ceramic. Of the stone examples that in rare instances also survive, the most complex—among them this spouted vessel (fig. 142)—display elaborately carved exteriors. They are chiefly identified with the Guatemalan-Mexican highlands and the period of the first centuries B.C. and A.D., when the important centers of Kaminaljuyú and Izapa flourished.

This vessel is almost completely covered with decoration. Two complex images of deities spread across the body of the bowl. Facing in opposite directions, one toward the bottom of the vessel (fig. 143) and the other toward the top, their heads are seen in profile. Carved around the neck is a band of motifs similar to Maya sky bands, but while those contain a variety of symbols for individual stars and constellations, this one is a pattern of repeating symbols. Five glyphs that read from top to bottom adorn the spout. As is the case with Maya hieroglyphs, they are in block shape, and each glyph is composed of a central "main" sign and a number of "affixes" that appear on the sides of the main sign, sometimes on all four sides. The inscription, which has not been completely read, includes a dedication of the vessel.

FACING PAGE
142. *Spouted Vessel*.
Maya, Mexico or Guatemala,
mid-1st century B.C.–1st century A.D.
Indurated limestone,
H. 5¼ in. (13.5 cm)

ABOVE
143. *Spouted Vessel*, detail

The hilly, temperate Calima region of southwest Colombia centers around the wide valley of the upper Calima River, where gold was found in alluvial deposits and was initially worked sometime in the mid- to late first millennium B.C. Personal adornments of the precious metal, such as necklace elements and face-sized masks, come from funerary contexts dating to an archaeological phase named Ilama, which extended from 500 B.C. to A.D. 100. Found in small cemeteries on the tops of hills, the gold-bearing tombs are large, well-equipped burials at the bottoms of shafts. They were the resting places of important members of the ancient communities, who were laid out with mortuary goods at their heads and feet. The most impressive of the offerings are the hammered gold masks (fig. 144), many of which were placed over the faces of the deceased. Simple and straightforward of feature, they exhibit a considerable range in style, a fact that implies differences among them in time or place of manufacture. While primarily associated with funerary functions, the masks usually have eye and mouth openings that would permit the wearer to see and breathe, and it is conjectured that they played a life role as well.

144. *Funerary Mask.*
Colombia (Calima), Ilama period,
1st century B.C. Gold, W. 9½ in. (24.2 cm)

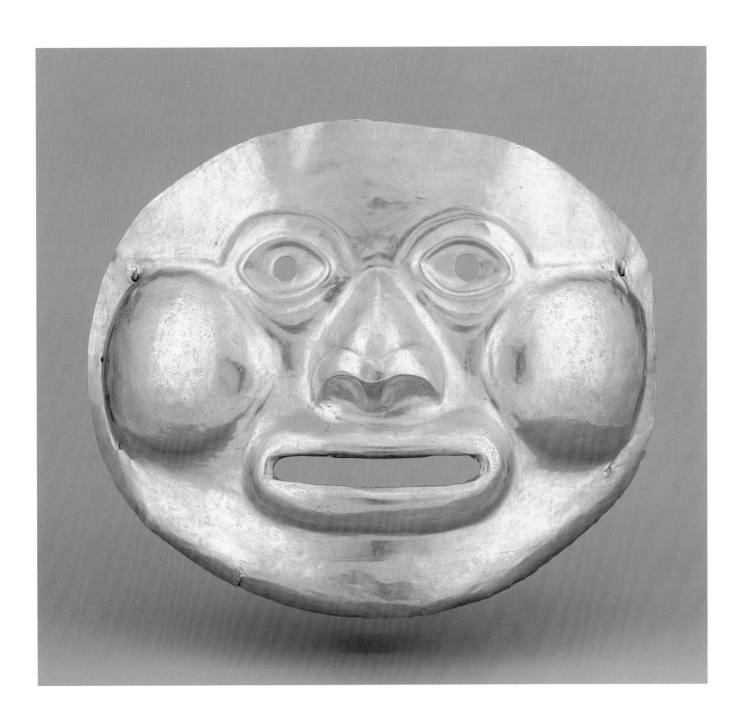

This vivid figure is representative of a well-known type of seated male figure from the Pacific coast region of northern Ecuador and southern Colombia. Low-lying and swampy—and inhospitable to the Spanish colonists of the 1500s—the area was home in the Year One to the people of the Tolita-Tumaco culture, who made large ceramic sculptures with great skill. These three-dimensional works of impressive size, which today are usually fragmentary, stand out within the larger corpus of Precolumbian South American ceramic works primarily for their size and their uncommonly expressive portrayal of the human face and figure. The example seen here (fig. 145) has the face of old age, with wrinkles, baggy skin beneath the eyes, only a few remaining teeth, and stubble on the chin; but these features only enhance the presence and heighten the drama of the forward-thrusting figure. Clearly a man of high status, he wears bracelets and a collar and originally had other ornaments in his ears and nose that may have been made of gold.

145. *Seated Figure.*
Tolita-Tumaco, Ecuador, 1st century B.C.–1st century A.D.
Ceramic, H. 25 in. (63.5 cm)

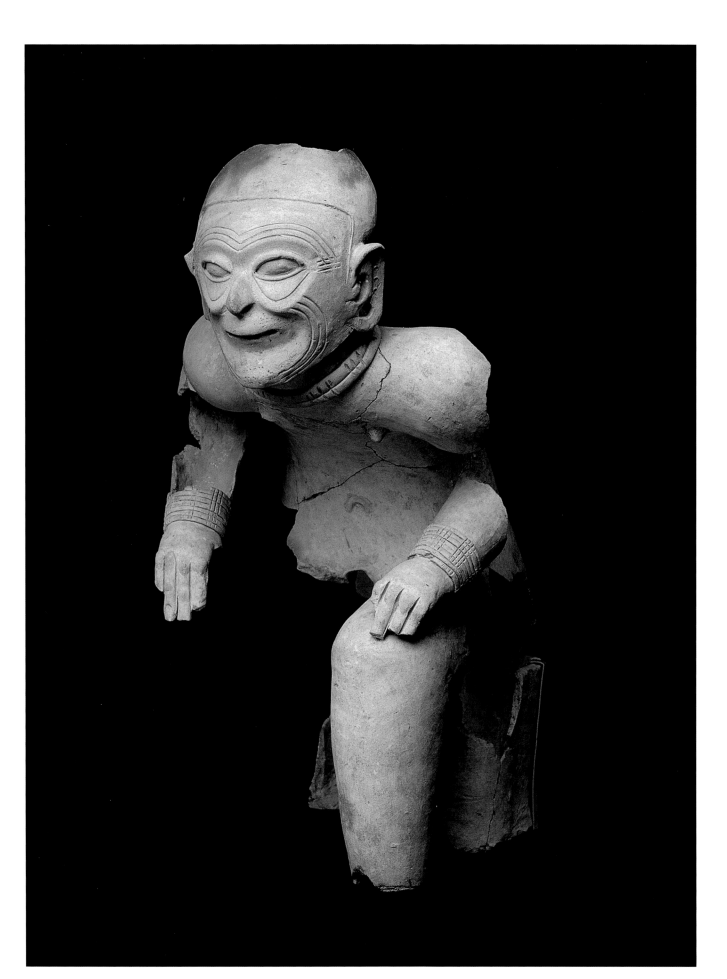

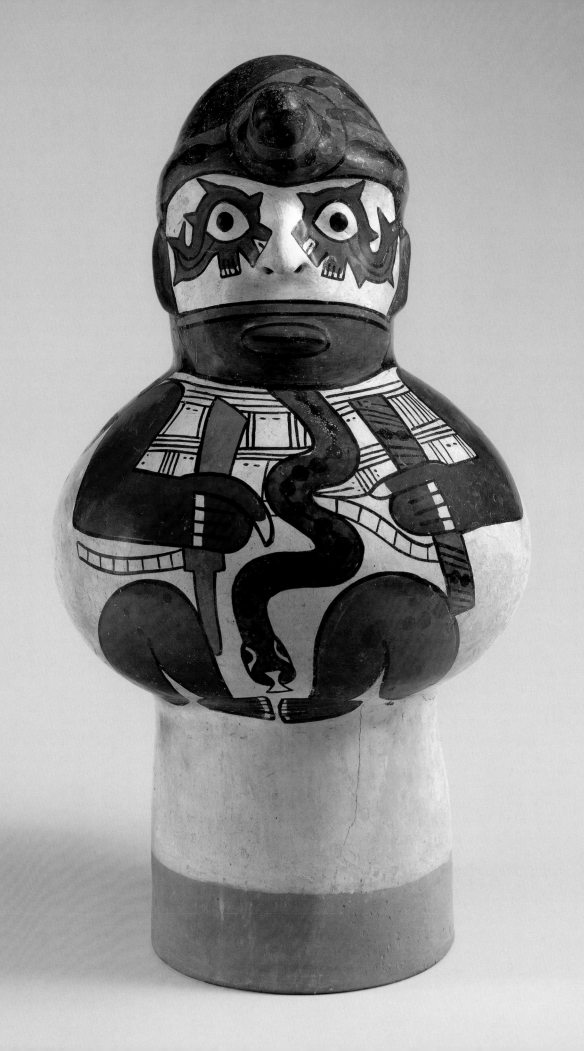

A group of liberally decorated ceramic drums with a bulbous sounding chamber that constitutes the "body" of a mythical being come from the region of Río Grande de Nasca in southern Peru. A large, arid Pacific coastal valley, Nasca has given its name to the culture that flourished there in the centuries between 200 B.C. and A.D. 600. Colorfully slipped ceramics, produced in considerable quantity, were the Nasca hallmark, and the images that embellished them became ever more detailed over time. The ceramic drums carry some of the most complex imagery.

Nasca iconography revolved around a number of mythological themes. In this object's decoration (fig. 146) a salient mythological reference is to the killer whale, or orca, the most powerful sea creature known to the Nasca, the significance of which is believed to be based on its role as a predator. The whales are represented in profile surrounding each eye of the drum figure and are anthropomorphized by the addition of a human hand with four straight fingers pointing downward. The rotund drum figure, who sits with his legs drawn up under him, has a snake issuing from beneath his chin. A tool of some sort is in each hand. His hair is composed of snakes and is tied in place with a band that forms a knot at the forehead.

The drumhead was stretched across the bottom of the instrument, which was held under the arm when played.

146. *Drum.*
Nasca, Peru, 1st century A.D. Ceramic, H. 17¾ in. (45.1 cm)

CHECKLIST OF WORKS ILLUSTRATED

All objects are in the collections of The Metropolitan Museum of Art, New York, unless noted otherwise. Checklist numbers correspond to the book's figure numbers.

1–8. See Photograph Credits, p. 220.

9. *Portrait of a Man*. Roman, early Augustan period, late 1st century A.D. Marble, H. 12⅜ in. (31.5 cm). Rogers Fund, 1921 (21.88.14)

10. *Portrait Bust of a Man*. Roman, Julio-Claudian period, mid-1st century A.D. Marble, H. 17½ in. (44.3 cm). Fletcher Fund, 1926 (26.60.3)

11. *Head of a Man from a Funerary Relief*. Roman, early Augustan period, late 1st century B.C. Marble, H. 9⅝ in. (24.5 cm). Rogers Fund, 1917 (17.230.133)

12. *The Emperor Augustus*. Roman, Tiberian period, A.D. 14–37. Marble, H. 11 in. (27.8 cm). Rogers Fund, 1908 (08.258.47)

13. *The Emperor Augustus*. Roman, Tiberian period, A.D. 14–37. Marble, H. 12 in. (30.5 cm). Rogers Fund, 1907 (07.286.115)

14. *The Emperor Gaius Julius Caesar Germanicus, Known as Caligula*. Roman, Julio-Claudian period, A.D. 37–41. Marble, H. 20 in. (50.8 cm). Rogers Fund, 1914 (14.37)

15. *Portrait Statue of a Boy*. Roman, Augustan period, late 1st century B.C.–early 1st century A.D. Bronze, H. 48½ in. (123.2 cm). Rogers Fund, 1914 (14.130.1)

16. *Portrait of a Man*. Roman, Julio-Claudian period, early 1st century A.D. Bronze, H. 12¼ in. (31 cm). Rogers Fund, 1914 (14.130.2)

17. *Veiled Head of a Man*. Roman, Julio-Claudian period, first half of the 1st century A.D. Marble, H. 10 in. (25.4 cm). The Bothmer Purchase Fund, 1991 (1991.11.5)

18. *Camillus (Acolyte)*. Roman, Claudian period, ca. A.D. 41–54. Bronze, H. 46⅛ in. (117.1 cm). Gift of Henry G. Marquand, 1897 (97.22.25)

19. *Statue of a Togatus*. Roman, Augustan period, ca. 14–9 B.C. Marble, H. 6 ft. 5⅝ in. (1.97 m). Gift of John D. Crimmins, 1904 (04.15)

20. *Corner Acroterion with Acanthus Scrolls*. Roman, Julio-Claudian period, first half of the 1st century A.D. Marble, H. 35⅜ in. (89.8 cm). Rogers Fund, 1917 (17.149.1, 2)

21. *Pilaster Capital*. Roman, Julio-Claudian period, first half of the 1st century A.D. Marble, H. 21 in. (53.3 cm). Fletcher Fund, 1926 (26.60.84)

22. *Section of a Pilaster with Acanthus Scrolls*. Roman, Julio-Claudian period, first half of the 1st century A.D. Marble, H. 43½ in. (110.5 cm). Rogers Fund, 1910 (10.210.28)

23. *Trapezophoros (Table Support)*. Roman, early Augustan period, ca. 30–13 B.C. Marble, H. 34⅝ in. (88 cm). Rogers Fund, 1913 (13.115.1)

24. *Funerary Altar*. Roman, Julio-Claudian period, A.D. 14–68. Marble, H. 31¾ in. (80.7 cm). Fletcher Fund, 1925 (25.78.29)

25–27. *Three Panels from the Black Room at Boscotrecase, North Wall*. Roman, Augustan period, last decade of the 1st century B.C. Fresco, H. 7 ft. 8 in. (2.33 m). Rogers Fund, 1920 (20.192.1–3)

28. *Landscape with Polyphemus and Galatea from the Villa at Boscotrecase*. Roman, Augustan period, last decade of the 1st century B.C. Fresco, H. 6 ft. 2 in. (1.88 m). Rogers Fund, 1920 (20.192.17)

29. *Landscape with Perseus and Andromeda from the Villa at Boscotrecase*. Roman, Augustan period, last decade of the 1st century B.C. Fresco, restored H. 6 ft. 2 in. (1.88 m). Rogers Fund, 1920 (20.192.16)

30. *Handle Attachment in the Form of a Mask*. Roman, Julio-Claudian period, first half of the 1st century A.D. Bronze, H. 10 in. (25.4 cm). Bequest of Walter C. Baker, 1971 (1972.118.98)

31. *Handle Attachment in the Form of a Mask*. Roman, Julio-Claudian period, first half of the 1st century A.D. Bronze, H. 8½ in. (21.7 cm). Gift of Norbert Schimmel Trust, 1989 (1989.281.63)

32. *Statue of Pan*. Roman, 1st century A.D. Marble, H. 26⅝ in. (67.6 cm). The Bothmer Purchase Fund, 1992 (1992.11.71)

33, 34. *Calyx Krater with Relief of Maidens and Dancing Maenads*. Roman, 1st century. A.D. Marble, H. 31¾ in. (80.6 cm). Rogers Fund, 1923 (23.184)

35. *Portrait Head of the Emperor Augustus*. Roman, Augustan period, late 1st century B.C.– early 1st century A.D. Ivory, H. 1⅝ in. (4 cm). Rogers Fund, 1923 (23.160.78)

36. *Statuette of a Man Wearing a Toga*. Roman, Julio-Claudian or Flavian period, 1st century A.D. Jasper, H. 7⅜ in. (18.7 cm). Rogers Fund, 1917 (17.230.54)

37. *Portrait Bust of a Roman Matron*. Roman, late Julio-Claudian period, mid-1st century A.D. Bronze, H. 9½ in. (24.1 cm). Edith Perry Chapman Fund, 1952 (52.11.6)

38. *Set of Silverware (the Tivoli Hoard)*. Roman, late Republican period, mid-1st century B.C. Silver. Ladle, L. 6⅞ in. (17.5 cm); Spoons, L. 4½–6⅛ in. (11.5– 15.7 cm); Drinking cups, H. to top of rim, 3¾ in. (9.5 cm), Diam. 4¼ in. (10.7 cm); Spouted pitcher, H. to top of rim, 2⅝ in. (6.7 cm). Rogers Fund, 1920 (20.49.2–9, 11, 12)

39. *One of a Pair of Drinking Cups*. Roman, Augustan period, late 1st century B.C.–early 1st century A.D. Silver with gilding, H. 3⅞ in. (9.9 cm). Purchase, Marguerite and Frank A. Cosgrove Jr. Fund and Lila Acheson Wallace Gift, 1994 (1994.43.1)

40, 41. *One of a Pair of Drinking Cups*. Roman, Augustan period, late 1st century B.C.–early 1st century A.D. Silver with gilding, H. 3¾ in. (9.5 cm). Purchase, Marguerite and Frank A.

Cosgrove Jr. Fund and Lila Acheson Wallace Gift, 1994 (1994.43.2)

42. *Intaglio of a Gladiator Fighting a Lion*. Roman, late Augustan to Flavian period, 1st century A.D. Carnelian, H. ⅝ in. (1.5 cm). With modern impression. Bequest of W. Gedney Beatty, 1941 (41.160.710)

43. *Ring with Intaglio Portrait of the Emperor Tiberius*. Roman, Tiberian period, A.D. 14–37. Gold and carnelian, H. ⅞ in. (2.1 cm). Purchase, The Bothmer Purchase Fund and Lila Acheson Wallace Gift, 1994 (1994.230.7)

44. *Intaglio Portrait of a Roman Lady*. Roman, Julio-Claudian period, 1st century A.D. Jasper, H. 1⅜ in. (3.5 cm). Rogers Fund, 1907 (07.286.124)

45. *Cameo Head of the Emperor Augustus*. Roman, Augustan or Tiberian period, first quarter of the 1st century A.D. Glass, H. 1⅛ in. (2.9 cm). The Cesnola Collection, Purchased by subscription, 1874–76 (74.51.4297)

46. *Gold Ring with Glass Cameo Portrait of the Emperor Augustus*. Roman, Augustan or early Julio-Claudian period, first half of the 1st century A.D. Gold and glass, H. ¾ in. (2 cm). Gift of Robert Haber and The Artemis Group, 1995 (1995.85.1)

47. *Cameo Portrait of the Emperor Augustus*. Roman, Claudian period, A.D. 41–54. Sardonyx, H. 1½ in. (3.7 cm). Purchase, Joseph Pulitzer Bequest, 1942 (42.11.30)

48. *Cameo of a Double Capricorn with a Portrait of the Emperor Augustus*. Roman, Augustan period, 27 B.C.–A.D. 14. Gold and sardonyx, H. 1⅛ in. (2.9 cm). Gift of Milton Weil, 1929 (29.175.4)

49. *Four Cast Glass Vessels*. Roman. Monochrome glass.

Left to right: *Green Bowl*. Augustan or early Julio-Claudian period, early 1st century A.D. Diam. 4¾ in. (12.1 cm). Gift of Henry G. Marquand, 1881 (81.10.128). *Brown Box with Lid (Pyxis)*. Julio-Claudian period, first half of the 1st century. H. 2⅛ in. (5.4 cm). Fletcher Fund, 1925 (25.78.118). *Blue Beaker*. Julio-Claudian period. H. 3½ in. (8.9 cm). Edward C. Moore Collection, Bequest of Edward C. Moore, 1891 (91.1.1238). *Opaque Blue Pitcher (Oinochoe)*. Augustan or early Julio-Claudian period. H. 7⅛ in. (18.1 cm). Gift of J. Pierpont Morgan, 1917 (17.194.170)

50. *Three Cast Glass Ribbed Bowls*. Roman. Glass. Left to right: *Mosaic Ribbed Bowl*. Late Augustan or early Julio-Claudian period, early 1st century A.D. Diam. 5⅛ in. (13 cm). Gift of J. Pierpont Morgan, 1917 (17.194.561). *Bluish Green Ribbed Bowl*. Julio-Claudian period, first half of the 1st century A.D. Diam. 6⅝ in. (16.8 cm). Gift of Henry G. Marquand, 1881 (81.10.33). *Blue Ribbed Bowl*. Said to be from Syria, Julio-Claudian period. Diam. 5¼ in. (13.2 cm). Gift of Henry G. Marquand, 1881 (81.10.38)

51. *Four Cast Polychrome Glass Vessels*. Roman, late Augustan through Julio-Claudian period, ca. A.D. 1–68. Glass. Left to right: *Composite Mosaic Dish*. Diam. 6¼ in. (16 cm). Fletcher Fund, 1959 (59.11.6). *Striped Mosaic Bowl*. Diam. 3⅝ in. (9.2 cm). Gift of J. Pierpont Morgan, 1917 (17.194.260). *Composite Mosaic Plate*. Diam. 6⅞ in. (17.3 cm). Gift of J. Pierpont Morgan, 1917 (17.194.1481). *Composite Mosaic Bowl*. Said to be from near Emesa (Homs), Syria.

Diam. 3⅞ in. (9.9 cm). Rogers Fund, 1912 (12.212.1)

52. *Gold- and Color-Band Mosaic Glass Bottles.* Roman, late Augustan to Julio-Claudian period, ca. A.D. 1–40. Glass. Left to right: *Gold-Band Mosaic Bottle,* cast. H. 4⅛ in. (10.5 cm). H. O. Havemeyer Collection, Bequest of Mrs. H. O. Havemeyer, 1929 (29.100.88). *Gold-Band Mosaic Bottle,* cast. H. 1⅞ in. (4.8 cm). Gift of Henry G. Marquand, 1881 (81.10.328). *Color-Band Mosaic Bottle,* cast and blown. H. 3½ in. (9 cm). Edward C. Moore Collection, Bequest of Edward C. Moore, 1891 (91.1.1260). *Color-Band Mosaic Bottle,* cast and blown. H. 2⅜ in. (6.2 cm). Gift of Henry G. Marquand, 1881 (81.10.325)

53. *Four Free-Blown Glass Vessels.* Roman. Glass. Left to right: *Shallow Bowl.* Claudian–Neronian period, mid-1st century A.D. Diam. 7⅛ in. (18 cm). Gift of Henry G. Marquand, 1881 (81.10.32). *Trailed and Ribbed Cup.* Claudian–Neronian period. Diam. 3½ in. (9 cm). Edward C. Moore Collection, Bequest of Edward C. Moore, 1891 (91.1.1346). *Two-Handled Drinking Cup (Kantharos).* Said to be from Rome. Tiberian–early Flavian period, ca. A.D. 20–80. H. 4⅝ in. (11.9 cm). Gift of Henry G. Marquand, 1881 (81.10.60). *Pitcher with Multicolored Specks of Glass.* Neronian–early Flavian period, ca. A.D. 50–80. H. 4¼ in. (10.7 cm). Gift of J. Pierpont Morgan, 1917 (17.194.276)

54. *Four Mold-Blown Glass Vessels.* Roman. Glass. Left to right: *Date Bottle.* Flavian–Hadrianic period, mid-1st–early 2nd century A.D. H. 2⅞ in. (7.3 cm). Edward C. Moore Collection, Bequest of Edward C. Moore,

1891 (91.1.1295). *Jug Signed by Ennion.* Julio-Claudian period, first half of the 1st century A.D. H. 7¼ in. (18.4 cm). Gift of J. Pierpont Morgan, 1917 (17.194.226). *Gladiator Cup.* Found in 1855 at Montagnole, France. Neronian–early Flavian period, ca. A.D. 50–80. H. 3⅛ in. (7.9 cm). Gift of Henry G. Marquand, 1881 (81.10.245). *Beaker Decorated with Dolphins, Rosettes, Shells, and Crescents.* Neronian–Flavian period, second half of the 1st century A.D. H. 4¾ in. (12.2 cm). Gift of J. Pierpont Morgan, 1917 (17.194.232)

55, 56. *Sword.* Celtic, France (?), 1st century B.C. Iron (blade) and copper alloy (hilt and scabbard), L. 19¾ in. (50.2 cm). Rogers Fund, 1999 (1999.94)

57. *Coins.* Celtic, Belgium, 1st century B.C. Gold. Anonymous Loan (L.53.43.3–11)

58. *Torque.* Celtic, Belgium, 1st century B.C. Gold, Diam. 5⅜ in. (13.6 cm). Anonymous Loan (L.53.43.2)

59. *Torque.* Celtic, Belgium, 1st century B.C. Gold, Diam. 8¼ in. (21 cm). Anonymous Loan (L.53.43.1)

60. *Terret (Rein Guide).* Celtic, Britain, 1st century A.D. Bronze with champlevé enamel, H. 2¼ in. (5.7 cm). Purchase, Harris Brisbane Dick Fund; Joseph Pulitzer Bequest; Pfeiffer, Rogers, Fletcher, Louis V. Bell, and Dodge Funds; and J. Richardson Dilworth, Peter Sharp, and Annette Reed Gifts, 1988 (1988.79)

61. *Wing Fibula.* Provincial Roman, Pannonia (present-day Hungary), 2nd century A.D. Silver, gold, and carnelians, L. 7¾ in. (19.6 cm). Purchase, Alistair B. Martin, William Kelly Simpson, Scher Chemicals

Inc., Levy Hermanos Foundation Inc., Shelby White, and Max Falk Gifts, in honor of Katharine R. Brown, 1998 (1998.76)

62. *Temple of Dendur.* Egypt, lower Nubia, ca. 15 B.C. Sandstone, H. 21 ft. (6.4 m). Given to the United States by Egypt in 1965, awarded to The Metropolitan Museum of Art in 1967, and installed in The Sackler Wing in 1978 (68.154)

63. *Temple of Dendur* in situ, ca. 1865–85. Photograph by Antonio Beato. Archives, Department of Egyptian Art

64, 65. *Torso of a Ptolemaic King Inscribed with the Cartouches of a Late Ptolemy.* Egypt, 80–30 B.C. Dark basalt, H. 36⅝ in. (93 cm). Purchase, Lila Acheson Wallace Gift and Rogers Fund, 1981 (1981.224.1)

66, 67. *Torso of a Ptolemaic King.* Egypt, 332–30 B.C. Dark basalt, H. 31⅛ in. (79 cm). Purchase, Lila Acheson Wallace Gift and Rogers Fund, 1981 (1981.224.2)

68. *Head of Augustus.* Egypt, said to be from Memphis, 30 B.C.–A.D. 14. Faience, H. 2⅝ in. (6.8 cm). Purchase, Edward S. Harkness Gift, 1926 (26.7.1428)

69. *Relief Showing the God Thoth and Pharaoh.* Egypt, Philae, probably Claudian period, A.D. 41–54. Sandstone, W. 24 in. (61 cm). Rogers Fund, 1911 (11.154.3)

70. *Crocodile.* Egypt or Rome, 1st century B.C.–1st century A.D. Red granite, L. 42½ in. (108 cm). Purchase, The Bernard and Audrey Aronson Charitable Trust Gift, in memory of her beloved husband, Bernard Aronson, 1992 (1992.13)

71. *Palm of a Ceremonial Fan.* Egypt, 1st–2nd century A.D. Bronze with gold and glass inlay, H. 4¾ in. (12 cm).

Purchase, Edward S. Harkness
Gift, 1926 (26.7.841)

72. *Shears*. Said to be from
Trabzon, northeastern Turkey
(ancient Trapezus), perhaps
1st century A.D. Bronze inlaid
with silver and probably black
copper, H. 9⅜ in. (23.7 cm).
Rogers Fund, 1939 (39.2.2)

73. *Isis-Aphrodite*. Egypt, 2nd cen-
tury A.D. Terracotta, white
engobe, and paint, H. 19½ in.
(49.5 cm). Purchase, Lila Acheson
Wallace Gift, 1991 (1991.76)

74. *Harpokrates*. Egypt, perhaps
1st century A.D. Bronze,
H. 7¼ in. (18.5 cm). Rogers
Fund, 1946 (46.2.1)

75. *Bracelet*. Egypt, probably
1st century B.C.–1st century
A.D. Gold, H. 1½ in. (3.9 cm).
Rogers Fund, 1923 (23.2.1)

76. *Group of Rings*. Egypt, proba-
bly 1st century B.C.–1st cen-
tury A.D. Gold. Left to right:
Coiled Wire Ring. H. 1 in.
(2.6 cm). Rogers Fund, 1924
(24.2.29). *Cast Ring with Bust
of Serapis*. H. 1 in. (2.7 cm).
Purchase, Edward S. Harkness
Gift, 1926 (26.7.832). *Cast
Ring with Bust of Isis*. H. 1 in.
(2.7 cm). Purchase, Edward S.
Harkness Gift, 1926 (26.7.833).
Cast Ring with Bust of Serapis.
H. 1¼ in. (3.2 cm). Gift of Mrs.
Eleanor Morgan Satterlee, 1949
(49.159.1). *Coiled Wire Ring*.
H. ⅞ in. (2.2 cm). Gift of Helen
Miller Gould, 1910 (10.130.1512)

77–79. *Mummy Mask of a Woman
with a Jeweled Garland*. Egypt,
probably Meir, ca. A.D. 60–70.
Painted plaster, cartonnage
(linen and gesso), and plant
fibers, H. 20⅞ in. (53 cm).
Rogers Fund, 1919 (19.2.6)

80. *Young Woman with a Gold
Wreath*. Egypt, ca. A.D.
90–120. Encaustic on lime-
wood, H. 16¼ in. (41.3 cm).
Rogers Fund, 1909 (09.181.6)

81. *Mummy Mask*. Egypt, 1st cen-
tury A.D. Gypsum plaster
with traces of paint, H. 6⅞ in.
(17.5 cm). Rogers Fund, 1900
(00.2.16)

82. *Group of Meroitic Vessels*.
Most from Faras, lower Nubia,
1st–3rd century A.D. Fired
and painted clay. Left to right:
H. 3¼ in. (8.2 cm); H. 9¾ in.
(24.7 cm); H. 2⅝ in. (6.7 cm);
H. 6½ in. (16.5 cm); H. 2⅞ in.
(7.2 cm). Left to right:
Rogers Fund, 1913 (13.125.34);
Rogers Fund, 1913 (13.125.43);
Rogers Fund, 1913 (13.125.35);
Rogers Fund, 1908 (08.202.47);
Rogers Fund, 1913 (13.125.37)

83. *Incense Burner*. South Arabia,
1st century B.C. Bronze,
H. 10⅞ in. (27.6 cm). Gift of
Dr. Sidney A. Charlat, in mem-
ory of his parents, Newman and
Adele Charlat, 1949 (49.71.2)

84. *Female Head*. South Arabia,
1st century B.C.–1st century
A.D. Alabaster, H. 12¼ in.
(31.1 cm). Lent by Shelby White
and Leon Levy

85. *Open Bowl*. Nabataean, Jordan
(Tawilan), 1st century A.D.
Terracotta, Diam. 8⅝ in.
(22 cm). Expedition of The
British School of Archaeol-
ogy in Jerusalem. Purchase,
H. Dunscombe Colt Gift, 1977
(1977.234.12)

86. *Dromedary and Rider*.
Nabataean, probably Jordan,
1st century B.C.–1st century A.D.
Bronze, H. 2⅜ in. (6.2 cm).
Lent by Shelby White and
Leon Levy

87. *Gravestone with Bust of a Man*.
Palmyra (Syria), 2nd century A.D.
Limestone, H. 20 in. (50.8 cm).
Purchase, 1898 (98.19.2)

88. *Gravestone with Bust of a
Woman*. Palmyra (Syria),
2nd century A.D. Limestone,
H. 20 in. (50.8 cm). Purchase,
1901 (01.25.1)

89. *Reclining Figure*. Parthian,
Mesopotamia, 1st century B.C.–
1st century A.D. Terracotta,
W. 5¼ in. (13.3 cm). Gift of
E. S. David, 1955 (55.162.2)

90. *Reclining Woman*. Parthian,
Mesopotamia, 2nd century B.C.–
2nd century A.D. Alabaster,
W. 7 in. (17.8 cm). Wolfe
Expedition, Purchase, Catharine
Lorillard Wolfe Gift, 1886
(86.16.3)

91. *Standing Woman*. Parthian,
Mesopotamia, 2nd century B.C.–
2nd century A.D. Alabaster,
H. 10⅝ in. (27 cm). Wolfe
Expedition, Purchase, Catharine
Lorillard Wolfe Gift, 1886
(86.16.1)

92. *Spout in the Shape of a Man's
Head*. Parthian, Iran, 1st–
2nd century A.D. Terracotta
with traces of glaze, H. 8¼ in.
(20.9 cm). Gift of Walter
Hauser, 1956 (56.56)

93. *Standing Man*. Parthian, Iran,
2nd century A.D. Gray stone,
H. 30¼ in. (76.8 cm). Rogers
Fund, 1951 (51.72.1)

94. *Rhyton with Forepart of a Wild
Cat*. Parthian, Iran, 1st cen-
tury B.C. Gilded silver, H. 10⅞ in.
(27.5 cm). Purchase, Rogers
Fund; Enid A. Haupt, Mrs. Don-
ald M. Oenslager, Mrs. Muriel
Palitz, and Geert C. E. Prins
Gifts; Pauline V. Fullerton
Bequest; and Bequests of Mary
Cushing Fosburgh, Edward C.
Moore, and Stephen Whitney
Phoenix, by exchange, 1979
(1979.447)

95. *Clasp with Eagle and Its Prey*.
Parthian, Iran, 1st century B.C.–
1st century A.D. Gold and
turquoise, W. 3⅜ in. (8.6 cm).
Gift of J. Pierpont Morgan,
1917 (17.190.2055)

96. *Ornament for Horse Trappings*.
Sarmatian, Western Central Asia
or Iran, 1st–2nd century A.D.
Gilded silver, vitreous material,

and garnets, Diam. 5⁷⁄₈ in. (14.9 cm). Gift of Norbert Schimmel Trust, 1989 (1989.281.35)

97, 98. *Yaksha*. India (probably Madhya Pradesh), Shunga period, ca. 50 B.C. Sandstone, H. 35 in. (88.9 cm). Anonymous Gift, in honor of Martin Lerner, 1988 (1988.354)

99. *Plaque with Royal Family*. India (West Bengal), Shunga period, 1st century B.C. Terracotta, H. 12¾ in. (32.4 cm). Purchase, Florence and Herbert Irving Gift, 1992 (1992.129)

100, 101. *Pair of Royal Earrings*. India, ca. 1st century B.C. Gold, H. 1¼ in. (3.3 cm). Gift of The Kronos Collections, 1981 (1981.398.3, 4)

102. *Weight Depicting Herakles and the Nemean Lion*. Pakistan (ancient region of Gandhara), 1st century B.C. Schist, 10¼ × 13¾ in. (26 × 34.9 cm). Purchase, Florence and Herbert Irving Gift, 1994 (1994.112)

103. *Stair Riser with Marine Deities*. Pakistan (ancient region of Gandhara), 1st century A.D. Schist, 6⅝ × 17 in. (16.9 × 43.2 cm). Rogers Fund, 1913 (13.96.21)

104. *Torso of a Bodhisattva*. Pakistan (ancient region of Gandhara), Kushan dynasty, late 1st–2nd century A.D. Schist, H. 64½ in. (163.8 cm). Purchase, Lila Acheson Wallace Gift, 1995 (1995.419)

105. *Horse Plaque*. Northwest China or Inner Mongolia, 4th–3rd century B.C. Silver with mercury gilding, H. 5 in. (12.7 cm). Rogers Fund, 1918 (18.43.8)

106. *Plaque in the Shape of a Horse*. North China, 3rd–1st century B.C. Silver with gilding, H. 3⅛ in. (7.8 cm). Gift of Ernest Erickson Foundation Inc., 1985 (1985.214.78)

107. *Belt Buckle*. North China, Xiongnu type, 3rd–2nd century B.C. Gilt bronze, H. 2¼ in. (5.7 cm). Rogers Fund, 1918 (18.33.1)

108. *Model for a Plaque*. North China, 3rd–2nd century B.C. Earthenware, W. 4 in. (10.2 cm). Rogers Fund, 1918 (18.43.2)

109. *Pair of Belt Plaques*. North China, Xianbei type, ca. 1st century A.D. Silver plate and gilt, W. of each ca. 4⅜ in. (11.1 cm). Fletcher Fund, 1924 (24.174.6, 7)

110, 111. *Short Sword (Duan Jian)*. Eastern Central Asia, ca. 4th–1st century B.C. Steel, bronze, and gold, L. 26⅜ in. (67 cm). Bashford Dean Memorial Collection, Funds from various donors, by exchange, 1998 (1998.418)

112. *Mat Weight in the Shape of a Doe*. North China, Han dynasty, 1st century B.C.–1st century A.D. Bronze, H. 2⅞ in. (7.3 cm). Gift of Mrs. John Marriott, Mrs. John Barry Ryan, Gilbert W. Kahn, Roger Wolfe Kahn (children of Addie W. Kahn), 1949 (49.136.3)

113. *Square Jar (Fang Hu)*. China, Western Han dynasty, 2nd century B.C.–early 1st century A.D. Bronze with gold and silver, H. 19 in. (48.3 cm). Lent by Charlotte C. Weber (L.1996.79.2)

114. *Basin*. China, Western Han dynasty, 2nd century B.C.–1st century A.D. Lacquered wood, Diam. 10⅜ in. (26.4 cm). Purchase, Florence and Herbert Irving Gift, 1994 (1994.44)

115. *Jar with Cover (Hu)*. China, Western Han dynasty, 2nd–1st century B.C. Earthenware with painted decoration, H. 22½ in. (57.2 cm). Purchase, Mr. and Mrs. Oscar Tang Gift, 1986 (1986.170 a, b)

116. *Female Dancer*. China, Western Han dynasty, 2nd–1st century B.C. Earthenware with pigments, H. 21 in. (53.3 cm). Charlotte C. and John C. Weber Collection, Gift of Charlotte C. and John C. Weber, 1992 (1992.165.19)

117, 118. *Mortuary Pillar*. China, late Western–early Eastern Han dynasty, 1st century B.C.–1st century A.D. Earthenware, H. 50½ in. (128.3 cm). Gift of Abby Aldrich Rockefeller, 1942 (42.25.1)

119. *Pair of Seated Figures Playing Liubo*. China, late Western–early Eastern Han dynasty, 1st century B.C.–1st century A.D. Painted earthenware, H. 13¾ in. (34.9 cm). Charlotte C. and John C. Weber Collection, Gift of Charlotte C. and John C. Weber, 1992 (1992.165.23 a, b)

Liubo Board with Pieces. China, Han dynasty, 206 B.C.–A.D. 220 Painted earthenware and bone, W. 14¼ in. (36.2 cm). Purchase, Eileen W. Bamberger Bequest, in memory of her husband, Max Bamberger, 1994 (1994.285 a–m)

120. *Tomb Panel with Relief of a Pavilion*. China (probably Shandong Province), Eastern Han dynasty, early 1st century A.D. Limestone, 31¼ × 50 in. (79.4 × 127 cm). Rogers Fund, 1920 (20.99)

121. *Bird-Shaped Vessel*. Korea, late 2nd–3rd century A.D. Earthenware, L. 14 in. (35.6 cm). Purchase, Lila Acheson Wallace Gift, 1997 (1997.34.1)

122. *Storage Jar*. Japan, Middle Yayoi period, 100 B.C.–A.D. 100. Earthenware, H. 16½ in. (41.9 cm). Gift of Florence and Herbert Irving, 1992 (1992.252.2)

123. *Storage Jar*. Japan, Late Yayoi period, A.D. 100–200. Earthenware, H. 10¾ in. (27.3 cm). The Harry G. C. Packard

Collection of Asian Art, Gift of Harry G. C. Packard, and Purchase, Fletcher, Rogers, Harris Brisbane Dick, and Louis V. Bell Funds, Joseph Pulitzer Bequest, and The Annenberg Fund, Inc. Gift, 1975 (1975.268.375)

124. *Bell (Dōtaku)*. Japan, Late Yayoi period, 1st–2nd century A.D. Bronze, H. 43½ in. (110.5 cm). Rogers Fund, 1918 (18.68)

125. *Container with Spiral Decoration*. Thailand, 300 B.C.–A.D. 200. Bronze, H. 8¾ in. (22.2 cm). Samuel Eilenberg Collection, Bequest of Samuel Eilenberg, 1998 (2000.284.53)

126. *Bracelet with Dragonflies*. Thailand, 300 B.C.–A.D. 200. Bronze, W. of armband 2¾ in. (7 cm). Samuel Eilenberg Collection, Lent by the Estate of Samuel Eilenberg

127. *Bracelet*. Thailand, 300 B.C.–A.D. 200. Bronze, W. 4¾ in. (12.1 cm). Samuel Eilenberg Collection, Lent by the Estate of Samuel Eilenberg

128. *Ring*. Thailand, 300 B.C.–A.D. 200. Bronze, H. 1¾ in. (4.5 cm). Samuel Eilenberg Collection, Lent by the Estate of Samuel Eilenberg

129. *Elephant Bell*. Thailand, 200 B.C.–A.D. 200. Bronze, H. 9 in. (22.9 cm). Samuel Eilenberg Collection, Bequest of Samuel Eilenberg, 1998 (2000.284.52)

130. *Incense Burner with Dragon's Head and Birds*. Thailand, 100 B.C.–A.D. 200. Bronze, H. 6¼ in. (15.9 cm). Samuel Eilenberg Collection, Lent by the Estate of Samuel Eilenberg

131. *Situla with Design of Ships*. Vietnam, Dongson culture, 100 B.C.–A.D. 100. Bronze, H. 8¼ in. (21 cm). Samuel Eilenberg Collection, Bequest of Samuel Eilenberg, 1998 (2000.284.60)

132. *Rubbing of Design on Situla*. Department of Asian Art

133. *Drum Model with Four Frogs*. Vietnam, Dongson culture, 300 B.C.–A.D. 200. Bronze, H. 4 in. (10.2 cm). Samuel Eilenberg Collection, Bequest of Samuel Eilenberg, 1998 (2000.284.57)

134. *Ceramic Model of a Bronze Drum*. Vietnam, Dongson culture, 100 B.C.–A.D. 100. Earthenware, H. 5¼ in. (13.3 cm). Purchase, Friends of Asian Art Gifts, 1999 (1999.156)

135, 136. *Crescent-Shaped Ax Head with Decorated Socket*. Indonesia, 220 B.C.–A.D. 200. Bronze, L. 25⅛ in. (63.8 cm). Samuel Eilenberg Collection, Bequest of Samuel Eilenberg, 1998 (2000.284.49)

137. *Typanum of a Pejeng-Type Drum*. Indonesia, 300 B.C.–A.D. 200. Bronze, Diam. 28 in. (71.1 cm). Samuel Eilenberg Collection, Bequest of Samuel Eilenberg, 1998 (2000.284.51)

138. *Lime Container*. Indonesia (East Java), 300 B.C.–A.D. 200. Bronze, H. 6 in. (15.2 cm). Samuel Eilenberg Collection, Lent by the Estate of Samuel Eilenberg

139. *Lime Container*. Indonesia (East Java), 300 B.C.–A.D. 200. Bronze, H. 6¾ in. (17.1 cm). Samuel Eilenberg Collection, Bequest of Samuel Eilenberg, 1998 (2000.284.44)

140. *Standing Male Figure*. Indonesia (Eastern Java), 300 B.C.–A.D. 200. Earthenware, H. 5⅜ in. (13.7 cm). Samuel Eilenberg Collection,, Bequest of Samuel Eilenberg, 1998 (2000.284.42)

141. *Ceremonial Object in the Form of an Ax Head*. Indonesia (Sulawesi), 500 B.C.–A.D. 300. Bronze, H. 41⅜ in. (105.1 cm). Purchase, George McFadden Gift and Edith Perry Chapman Fund, 1993 (1993.525)

142, 143. *Spouted Vessel*. Maya, Mexico or Guatemala, mid-1st century B.C.–1st century A.D. Indurated limestone, H. 5¼ in. (13.5 cm). Gift of Charles and Valerie Diker, 1999 (1999.484.3)

144. *Funerary Mask*. Colombia (Calima), Ilama period, 1st century B.C. Gold, W. 9½ in. (24.2 cm). Jan Mitchell and Sons Collection, Gift of Jan Mitchell, 1991 (1991.419.39)

145. *Seated Figure*. Tolita-Tumaco, Ecuador. 1st century B.C.–1st century A.D. Ceramic, H. 25 in. (63.5 cm). Gift of Gertrud A. Mellon, 1982 (1982.231)

146. *Drum*. Nasca, Peru, 1st century A.D. Ceramic, H. 17¾ in. (45.1 cm). The Michael C. Rockefeller Memorial Collection, Gift of Mr. and Mrs. Raymond Wielgus, 1964 (1978.412.111)

SOURCES AND SELECTED BIBLIOGRAPHY

THE YEAR ONE: EMPIRES AND TRADE ROUTES ACROSS THE ANCIENT WORLD

The Augustan Empire, 43 B.C.–A.D. 69, edited by Alan K. Bowman, Edward Champlin, and Andrew W. Lintott. *Cambridge Ancient History*, vol. 10. 2d ed. Cambridge, 1996.

Begley, Vimala, and Richard D. De Puma, eds. *Rome and India: The Ancient Sea Trade*. Madison, Wisconsin, 1991.

Casson, Lionel. *Ancient Trade and Society*. Detroit, 1984.

———. *The Periplus Maris Erythraei*. In Greek and English; commentary and translation by Casson. Princeton, 1989.

Menninger, Michael. *Untersuchungen zu den Gläsern und Gipsabgüssen aus dem Fund von Begram (Afghanistan)*. Würzburg, 1996.

Rome, the Augustan Age: A Source Book, edited by Kitty Chisholm and John Ferguson. New York, 1981. Pages 217–18 (for Virgil quotation, p. 5 above, trans. C. Day Lewis).

Rowland, Benjamin, Jr. *Ancient Art from Afghanistan: Treasures of the Kabul Museum*. Exh. cat. New York: Asia Society, 1966.

Sarianidi, Viktor I. *The Golden Hoard of Bactria: From the Tillya-tepe Excavations in Northern Afghanistan*. New York, 1985.

Schmitthenner, Walter. "Rome and India: Aspects of Universal History during the Principate." *Journal of Roman Studies* 69 (1979), pp. 90–106; pp. 90 (for Polybius quotation, p. 3 above), 97 (for Xenephon reference, p. 21 above).

Seipel, Wilfried, ed. *Weihrauch und Seide: Alte Kulturen an der Seidenstrasse*. Exh. cat. Vienna: Kunsthistorisches Museum, 1996.

Stern, E. Marianne. "Early Exports beyond the Empire." In *Roman Glass: Two Centuries of Art and Invention*, edited by Martine Newby and Kenneth Painter, pp. 141–54. London, 1991.

Temporini, Hildegard, and Wolfgang Haase, eds. *Aufstieg und Niedergang der römischen Welt: Geschichte und Kultur Roms im Spiegel der neueren Forschung*. Teil II, *Principat*, vol. 9, *Politische Geschichte*, part 2. Berlin, 1978. Especially John Ferguson and Milton Keynes, "China and Rome," pp. 581–603; and Manfred G. Raschke, "New Studies in Roman Commerce with the East," pp. 604–1361.

Twitchett, Denis, and Michael Loewe, eds. *The Cambridge History of China*. Vol. I, *The Ch'in and Han Empires, 221 B.C.–A.D. 220*. Cambridge, 1986.

THE MEDITERRANEAN WORLD: THE ROMAN EMPIRE

ROME

The Augustan Empire, 43 B.C.–A.D. 69, edited by Alan K. Bowman, Edward Champlin, and Andrew W. Lintott. *Cambridge Ancient History*, vol. 10. 2d ed. Cambridge, 1996. Especially chapters 1–4.

Blanckenhagen, Peter Heinrich von, and Alexander Christine. *The Augustan Villa at Boscotrecase*. Mainz am Rhein, 1990.

Bowman, Alan K. *Egypt after the Pharaohs, 332 B.C.–A.D. 642: From Alexander to the Arab Conquest*. London: British Museum, 1986. Especially pages 34–41, 65–77.

Cornell, Tim, and John Matthews. *Atlas of the Roman World*. Oxford, 1982.

Grose, David F. *Early Ancient Glass: Core-Formed, Rod-Formed, and Cast Vessels and Objects from the Late Bronze Age to the Early Roman Empire, 1600 B.C. to A.D. 50*. New York: Hudson Hills Press in association with the Toledo Museum of Art, 1989.

Henig, Martin, ed. *A Handbook of Roman Art: A Survey of the Visual Arts of the Roman World*. Oxford, 1983. Especially chapters 6, 10.

Isaac, Benjamin H. *The Limits of Empire: The Roman Army in the East*. Rev. ed. Oxford, 1990. Especially chapters 1, 3.

Millar, Fergus. *The Roman Near East, 31 B.C.–A.D. 337*. Cambridge, Massachusetts, 1993.

Stern, E. Marianne. *Roman Mold-Blown Glass: The First through Sixth Centuries*. Rome: "L'erma" di Bretschneider with the Toledo Museum of Art, 1995.

Wells, Colin M. *The Roman Empire*. London and Stanford, 1984; 2d ed., 1992. Especially chapters 1, 3.

Wells, Peter S. *The Barbarians Speak: How the Conquered Peoples Shaped Roman Europe*. Princeton, 1999.

Whitehouse, David. *Roman Glass in the Corning Museum of Glass*. Corning, New York, 1997.

Zanker, Paul. *The Power of Images in the Age of Augustus*. Trans. Alan Shapiro. Ann Arbor, 1988.

GAUL, BRITAIN, AND PANNONIA

Caesar, Julius. *The Gallic War*. Trans. H. J. Edwards. Loeb Classical Library. London and Cambridge, Massachusetts, 1917.

Cunliffe, Barry W. *The Ancient Celts*. Oxford, 1997.

Megaw, Ruth, and Vincent Megaw. *Celtic Art: From Its Beginnings to the Book of Kells*. London, 1989.

Moscati, Sabatino, ed., with Otto Frey et al. *The Celts*. New York, 1991.

Wells, Peter S. *The Barbarians Speak: How the Conquered People Shaped Roman Europe*. Princeton, 1999.

ROMAN EGYPT

Arnold, Dieter. *Temples of the Last Pharaohs*. New York, 1999.

Bowman, Alan K. *Egypt after the Pharaohs, 332 B.C.–A.D. 642: From Alexander to the Arab Conquest*. London: British Museum, 1986.

———. "Egypt." In *The Augustan Empire, 43 B.C.–A.D. 69*, edited by Alan K. Bowman, Edward Champlin, and Andrew W. Lintott, pp. 676–702. *Cambridge Ancient History*, vol. 10. 2d ed. Cambridge, 1996.

Walker, Susan, ed. *Ancient Faces: Mummy Portraits from Roman Egypt*. Exh. cat. New York and London, 2000.

Figures 64–67:
Russmann, Edna R. "Statue of a Ptolemaic King," and "Statue of Ptolemy XI or One of His Successors." In "Notable Acquisitions, 1981–1982," supplement to *Metropolitan Museum of Art Bulletin* 39 (1981–82), pp. 7–9.

Figure 70:
Arnold, Dorothea. "Crocodile." In "Recent Acquisitions: A Selection, 1991–1992," *Metropolitan Museum of Art Bulletin* 50 (fall 1992), pp. 8–9.

WEST AND CENTRAL ASIA

Colledge, Malcolm A. R. *The Art of Palmyra*. London and Boulder, Colorado, 1976.

———. *Parthian Art*. London and Ithaca, New York, 1977.

Hammond, Philip. *The Nabataeans: Their History, Culture, and Archaeology*. Gothenburg, 1973.

Potts, Daniel T. *The Arabian Gulf in Antiquity*. 2 vols. Oxford and New York, 1990.

Yarshater, Ehsam, ed. *The Seleucid, Parthian, and Sasanian Periods*. 2 vols. *The Cambridge History of Iran*, vol. 3. Cambridge, 1983.

Figure 94:
Ancient Art from the Shumei Family Collection, by Dorothea Arnold et al., no. 27. New York: The Metropolitan Museum of Art, 1996.

Harper, Prudence. "Parthian and Sasanian Silverware: Questions of Continuity and Innovation." *Mesopotamia* 22 (1987), p. 351.

Harper, Prudence, et al. *Egypt and the Ancient Near East*, pp. 146–48. New York, 1987.

Levi, Doro. *Antioch Mosaic Pavements*, vol. 2, pl. 30, fig. b. Princeton, 1947.

Masson, Mikhail, and Galina Pugachenkova. *The Parthian Rhytons of Nisa*, p. 39, fig. 7. Florence, 1982.

Pfrommer, Michael. *Metalwork from the Hellenized East: Catalogue of the Collection*, pp. 47ff. Malibu, California: J. Paul Getty Museum, 1993.

Figure 95:
Herzfeld, Ernst. "The Hoard of the Karen Pahlavs." *Burlington Magazine* 52 (1928), pp. 21–23.

Pope, Arthur Upham, and Phyllis Ackerman. *A Survey of Persian Art from Prehistoric Times to the Present*, 3d ed., vol. 1, *Text, Pre-Achaemenid, Achaemenid and Parthian Periods*, pp. 460, 465; vol. 4, *Text, the Ceramic Arts, Calligraphy and Epigraphy*, pl. 138a. Tehran, 1977; Ashiya, Japan, 1981.

Pugachenkova, Galina. *Pauka I Zhizn* 1 (1974) pp. 97ff.

Figure 96:
Farkas, Ann. "Sarmatian Roundels and Sarmatian Art." *Metropolitan Museum Journal* 8 (1973).

Treister, Mikhail. "About the Centers of Manufacture of Certain Series of Horse-Harness Roundels in 'Gold-Turquoise Animal Style,' of the 1st–2nd Centuries A.D." *Silk Route Art and Archaeology* 5 (1997/98), pp. 59ff., figs. 17, 18.

ASIA

SOUTH ASIA

Czuma, Stanislaw J., with the assistance of Rekha Morris. *Kushan Sculpture: Images from Early India*. Exh. cat. Cleveland, Ohio: Cleveland Museum of Art, 1985.

Dehejia, Vidya, ed. *Unseen Presence: The Buddha and Sanchi*. Mumbai, India, 1996.

Huntington, Susan, with contributions by John C. Huntington. *The Art of Ancient India: Buddhist, Hindu, Jain*. New York and Tokyo, 1985.

Lerner, Martin, and Steven Kossak. "The Arts of South and Southeast Asia." *Metropolitan Museum of Art Bulletin* 51 (spring 1994).

Liu Xinru. *Ancient India and Ancient China: Trade and Religious Exchanges*. Delhi, India, 1988.

Rosenfield, John. *The Dynastic Arts of the Kushans*. Berkeley, 1967.

Zwalf, Wladimir. *A Catalogue of the Gandhara Sculpture in the British Museum*. 2 vols. London: British Museum, 1996.

EAST ASIA

Barnes, Gina L. *The Rise of Civilization in East Asia: The Archaeology of China, Korea, and Japan*. London, 1999.

Bunker, Emma C., with Trudy S. Kawami, Katheryn M. Linduff, and Wu En. *Ancient Bronzes of the Eastern Eurasian Steppes from the Arthur M. Sackler Collection*. New York, Arthur M. Sackler Foundation, 1997.

The Chinese Bronze of Yunnan. Foreword by Jessica Rawson. London and Beijing, 1983.

Ebrey, Patricia Buckley. *The Cambridge Illustrated History of China*. Cambridge, 1996.

Nelson, Sarah M. *The Archaeology of Korea*. Cambridge, 1993.

Pearson, Richard, et al. *Ancient Japan*. Exh. cat. Washington, D.C.: Arthur M. Sackler Gallery, Smithsonian Institution, 1992.

Pirazolli-tSerstevens, Michele, *The Han Civilization of China*. Translated by Janet Seligman. Oxford, 1982.

Powers, Martin J. *Art and Political Expression in Early China*. New Haven, Connecticut, 1991.

Rawson, Jessica, ed. *Mysteries of Ancient China: New Discoveries from the Early Dynasties*. London: British Museum, 1996.

Watt, James, C. Y. "The Arts of Ancient China." *Metropolitan Museum of Art Bulletin* 48 (summer 1990).

Figures 110, 111:
Bunker, Emma, et al. *Ancient Bronzes of the Eastern Eurasian Steppes from the Arthur M. Sackler Collections*. New York, 1997.

Hong, Yang, ed. Weapons in Ancient China , pp. 173–82. New York and Beijing, 1992.

Richardson, Thom. "China and Central Asia." In *Swords and Hilt Weapons*, pp. 172–85. New York, 1989.

Figure 116:
Erickson, Susan N. "Twirling Their Long Sleeves, They Dance Again and Again: Jade Plaque Sleeve Dancers of the Western Han Dynasty." *Ars Orientalis* 24 (1994), pp. 39–63.

SOUTHEAST ASIA

The Bronze Dông Son Drums: A Collective Work of Archaeologists. Compiled by Hà Thúc Cân; contributions by Nguyên Van Huyên et al. Hanoi, 1989.

Higham, Charles. *The Bronze Age of Southeast Asia*. Cambridge, 1996.

———. *The Archaeology of Mainland Southeast Asia from 10,000 B.C. to the Fall of Angkor*. Cambridge, 1989.

Kempers, A. J. Bernet. *The Kettledrums of Southeast Asia: A Bronze Age World and Its Aftermath*. Modern Quaternary Research in Southeast Asia, vol. 10. Rotterdam, 1988.

Lerner, Martin, and Steven Kossak. "The Arts of South and Southeast Asia." *Metropolitan Museum of Art Bulletin* 51 (spring 1994).

Smith, Ralph B., and William Watson, eds. *Early South East Asia: Essays in Archaeology, History, and Historical Geography*. New York, 1979.

Tarling, Nicholas, ed. *The Cambridge History of Southeast Asia*, vol. 1, *From Early Times to c. 1800*. Cambridge, 1992.

Wolters, O. W. *Early Indonesian Commerce, A Study of the Origins of Srivijaya*. Ithaca, New York, 1967.

Figure 131:
Guangzhou shi wenwu guanli weiyuanhui et al. *Xihan Nanyuewang Mu* (Nanyue King's Tomb of the Western Han), 2 vols. Beijing, 1991.

THE AMERICAS

Coe, Michael D. *The Maya*. 6th ed. New York, 1999.

Donnan, Christopher B. *Ceramics of Ancient Peru*. Exh. cat. Los Angeles: Fowler Museum of Cultural History, University of California at Los Angeles, 1992.

Labbé, Armand J. *Shamans, Gods, and Mythic Beasts: Colombian Gold and Ceramics in Antiquity*. Exh. cat. New York: American Federation of Arts, 1998.

Pasztory, Esther. *Pre-Columbian Art*. Cambridge, 1998.

Stone-Miller, Rebecca. *Art of the Andes: From Chavín to Inca*. London, 1995.

INDEX

PHOTOGRAPH CREDITS

Photographs were in most cases provided by the Photograph Studio, The Metropolitan Museum of Art, New York. Additional information on photograph sources is as follows:

Photograph by John C. Huntington, © John C. Huntington: figure 5

Erich Lessing /Art Resource, NY: figures 3, 4, 8

© R. & S. Michaud: figure 1

Scala / Art Resource, NY: figure 2

SEF / Art Resource, NY: figure 7

Courtesy of Shelby White and Leon Levy: figures 84, 86

The maps on the endpapers and on pages 15, 24–25, 102–3, 128–29, and 192 were made by Anandaroop Roy.

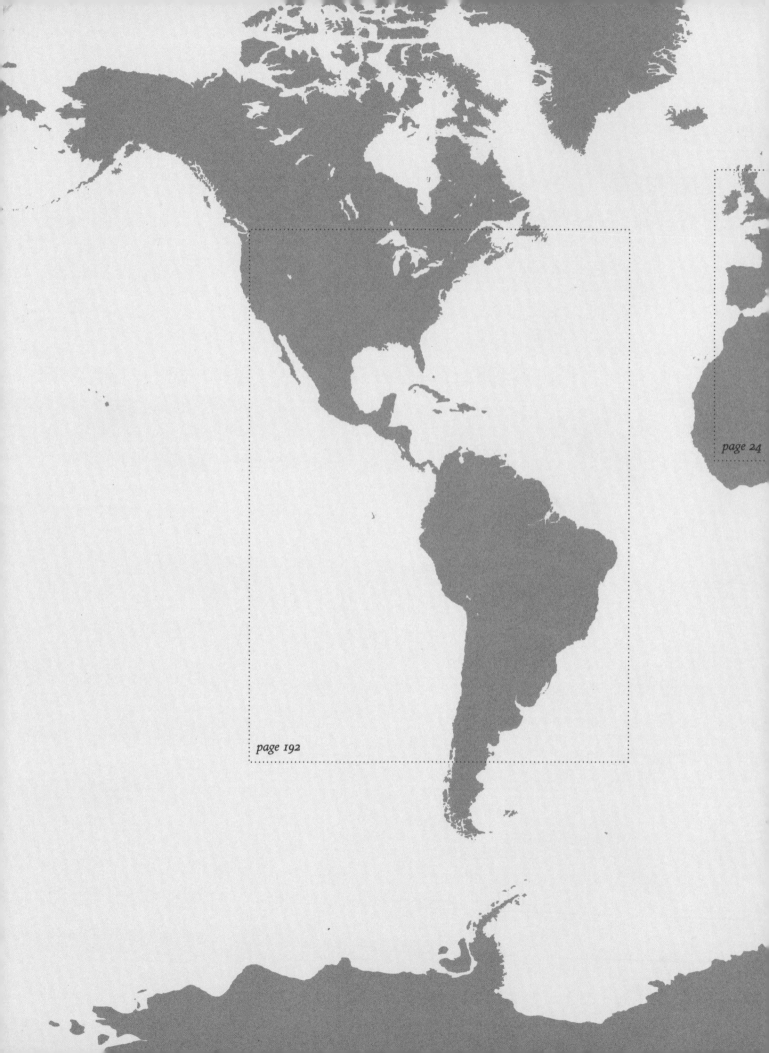

page 24

page 192